DANTE GABRIEL
ROSSETTI

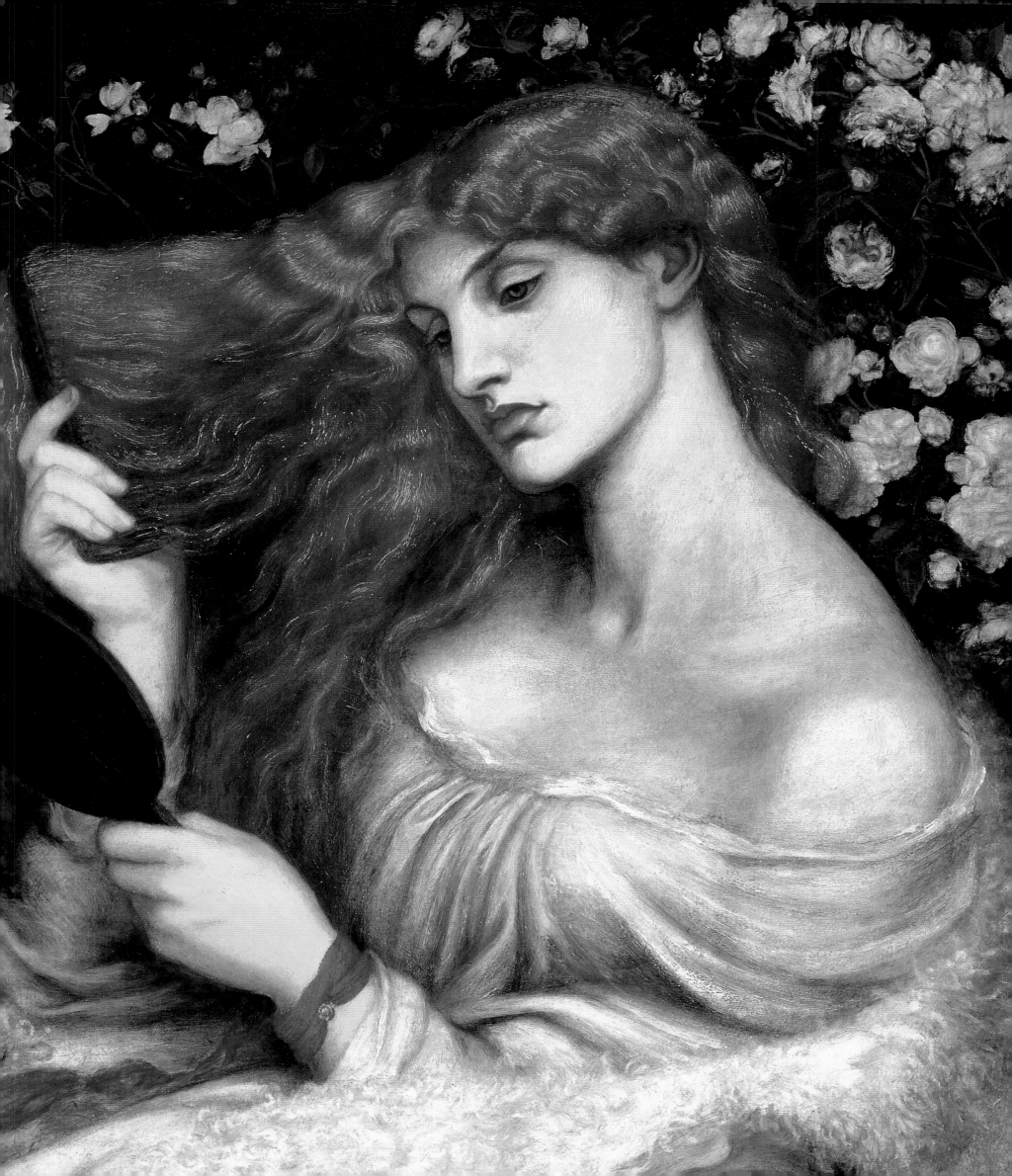

DANTE GABRIEL
ROSSETTI

ALICIA CRAIG FAXON

ABBEVILLE PRESS PUBLISHERS NEW YORK

EDITOR: Nancy Grubb
PRODUCTION EDITOR: Amy Handy
DESIGNER: Renée Khatami
PRODUCTION MANAGER: Dana Cole
PICTURE RESEARCHER: Lisa Peyton

Front jacket: Detail of Proserpine, *1877*
See plate 212

Back jacket: The Merciless Lady, *1865*
Watercolor on paper, 12¼ x 12⅜ in.
Peter Nahum, London

End papers: William Morris (1834–1896)
Marigold, *1875*
Wallpaper specimen, color print from wood block
Victoria and Albert Museum, London

Frontispiece: Detail of Lady Lilith, *1868*
See plate 220

First edition

Library of Congress
Cataloging-in-Publication Data

Faxon, Alicia Craig.
 Dante Gabriel Rossetti/Alicia Craig Faxon.
 p. cm.
 Bibliography: p.
 Includes index.
 ISBN 0-89659-928-0
 1. Rossetti, Dante Gabriel, 1828–1882.
 2. Artists—England—Biography. 3. Pre-
Raphaelites—England. I. Rossetti, Dante
Gabriel, 1828–1882. II. Title.
N6797.R58F38 1989
759.2—dc19 88-37101
[B] CIP

CONTENTS

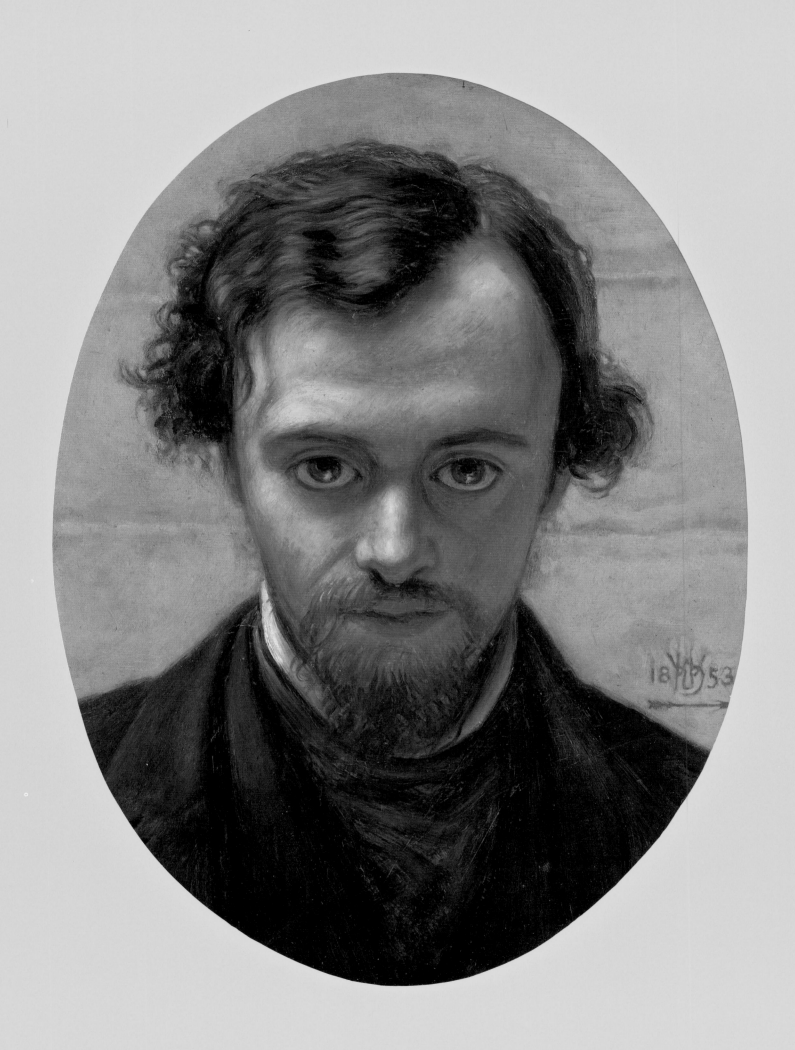

FOREWORD

From an early age I was aware that I was descended from the "Rossettis." I was rather vague as to how, just as I didn't quite know how they had distinguished themselves, though I knew the connection was something to be proud of. Christina was fairly easy to place, for she was a poet, and some of her poems, such as *Goblin Market* and *Sea-Horses*, which we had been made to learn by heart, were in the anthologies we used at primary school. Then she had written the words (or rather the music had been written to her words) to a popular Christmas carol, *In the Bleak Mid-Winter*. Though I did not dare say so, I found it a little dismal and personally favored the more jolly carols.

Dante Gabriel Rossetti was more difficult to gauge, for his name was altogether too exotic and foreign sounding, especially as my family insisted on pronouncing *Rossetti* with the soft *s* as the Italians do, instead of with the hard *s* favored by Anglo-Saxons. When out of hearing of the family, I naturally conformed to the English pronunciation: England was at war with Italy at the time, and anything or anybody in the slightest way connected with Italy was anathema to my schoolfellows. My illustrious ancestry earned me many a baiting.

Rossetti was a poet-painter or painter-poet, but his poems, except for one or two of the ballads, such as *The White Ship* and *The King's Tragedy*, were much more difficult than Christina's to understand. At the time his paintings were unfamiliar to me, as I had seen no originals and very few

1. William Holman Hunt (1827–1910)
Dante Gabriel Rossetti, c. 1870
Oil on panel, 11½ x 8½ in.
Birmingham City Museum and Art Gallery,
Birmingham, England

reproductions. The various pictures that my grandmother Mrs. Rossetti Angeli had inherited from her father, William Michael Rossetti (Dante Gabriel's brother), were safely stored away in the vaults of the Tate Gallery. They had been removed from 3 Saint Edmund's Terrace, the house that had belonged to William, because of the continual bombing that London was then being subjected to, and none too soon either, for shortly afterward the house was seriously damaged by a V-1 bomb—a Doodlebug, as they were called. The volunteers who had the job of clearing the house of rubble and of all the books, china, furniture, and objets d'art asserted that in all their war experience this was by far the worst house they had encountered because there had been so much in it.

It was only later that I became familiar with my grandmother's various drawings, studies, and family portraits—both by Dante Gabriel Rossetti and by her grandfather Ford Madox Brown. Hers was the haunting self-portrait by Lizzie Siddal, as was the small drawing of Dante Gabriel's rocking horse, which he had executed at the age of about four and thus surprised the milkman into exclaiming to the servant, "I saw a baby making a picture."

I must have been about ten or eleven when my grandmother confronted me with two photographs: one represented her father, William, as an elderly man and the other, her uncle Dante Gabriel. She asked me point-blank which of the two I preferred. As any child would have been, I was naturally drawn to the benign, gentle face of the patriarchal William and found Dante Gabriel (who at the time of the photograph was already a sick man) altogether too moody and forbidding. However, wanting to ingratiate myself with my grandmother, and not knowing her precise relationship to either but being aware that she thought highly of artistic and poetic ability, I lied and pointed to the photograph of Dante Gabriel. I was told that I was a fool, which served me right for lying.

My grandmother spent much time, energy, and ink defending the memory of her uncle. As she wrote with much truth in her entertaining book, *Dante Gabriel Rossetti: His Friends and Enemies*, "It is not excessive to say that no distinguished man of English art or letters of the nineteenth century has been so repeatedly and so unaccountably attacked as Dante Gabriel Rossetti." This is all the more surprising since he had not openly flouted the moral code of his contemporaries. Moreover, apart from the notorious attack by Thomas Maitland (alias Robert Buchanan), who afterwards retracted, it is more recent biographers who have treated him most harshly.

One of my grandmother's last forays into the field of polemics on behalf of her uncle was a long letter to the London *Times*, in which she wittily and caustically trounced someone she thought guilty of having written "a lot of lies" about her uncle. The director of the *Times* found her letter so entertaining that he exclaimed, "This woman deserves a two-column obituary," and forthwith sent someone to interview her. I was present on this occasion and found my grandmother in a state of great glee at the idea of being interviewed for her obituary. As she was eighty-seven at the time, the interview was soon to come in handy.

My grandmother did not remember her uncle personally, as she was a very young child when he died. Toward the end of his life he was a very sick man, almost a recluse, and the company of children would hardly have been welcomed by him. There's a letter to his assistant, Henry Treffry Dunn, in which he writes, "There was an alarm of the Euston Square baby—nurse and all being shot here, but I took prompt measures and it has blown over." The child, my grandmother's eldest sister, Olive, was convalescing from some child's illness, and her parents must have asked if Dante Gabriel could house the child and her nurse, so that she could have the benefit of the sea air at Bognor Regis, considered a panacea in those days. But evidently Rossetti didn't feel like putting up with her or putting her up.

This brings up the question of the relationship between Dante Gabriel and his brother, William. In Edith Sitwell's not exaggerated description, William was "that saintly and sweet character whose whole life was given to his family, to providing for their needs and bearing their worries, William who scarcely allowed himself the right to individual happiness." Dante Gabriel, on the other hand, had all the artist's self-centeredness. As William tersely put it, "The very core of his character was self-will, which easily shelved into wilfullness."

Then there were the money relations between them. Usually it was the generous and careful William, often with a much smaller income (first as an official and later as a pensioner of the Inland Revenue), who came to the rescue of his no less generous but improvident brother. It was young William who, when his income at the Excise Office was the family's chief support, found the ten shillings for Dante Gabriel to buy a priceless William Blake notebook from an attendant at the British Museum. On the rare occasions of reciprocal need, Dante Gabriel did come to the rescue of his brother, as when William was robbed of all his money during a trip abroad. Moreover, Dante Gabriel was well aware of what he owed his brother. When William was about to marry, he wrote to his future sister-in-law,

Lucy Madox Brown: "What return can I ever make now for all that my dear brother gave me so freely in early days, at a time when it is still a mystery to me how he could manage to give at all? To him and to your father I owe more in life than to any other man whatever." In 1872, when William had done so much and suffered so much because of his brother's illness (and, it may be added, because of Christina's), Dante Gabriel wrote to him: "I know well how much you have suffered on my account; indeed perhaps your suffering may have been more acute than my own dull, nerveless state during the past months. Your love, dear William, is not less returned by me than it is sweet to me, and that is saying all."

What my grandmother knew about her uncle was necessarily secondhand, but she could call to mind numerous firsthand anecdotes where Aunt Christina was concerned. When she knew her, Christina was usually neatly but never fashionably dressed in black. On one occasion she took her nephew and nieces for a walk in the direction of a London street called the Seven Sisters; the street was not known to her, but the name was poetic, and she was curious to see it. Great was their disappointment when the street turned out to be both commonplace and dingy and altogether unworthy of its name. On another occasion, when my grandmother had been guilty of a childish outburst of temper, Aunt Christina gently reproved her, telling her that she would have to learn to control her temper as Christina had done and recalling how, having been scolded for some fault, she had seized a pair of scissors and ripped open her arm. Then there was the famous time when Christina's strict observance of truth (*veracity*, they termed it in the family) gave rise to comedy. She was shown a very plain baby by a proud mama who obviously expected Christina to make some admiring comment. Christina was incapable of telling a lie, but at the same time she was a kind woman and didn't want to hurt the mother's feelings, so she got out of the difficulty by exclaiming, "What a baby!"

This strict, unswerving regard for truth was common to all four Rossetti children, Dante Gabriel included, and had been instilled by their high-minded mother, Frances Polidori, whom they all adored. Another saying that has entered the family lexicon is attributable to William's almost too literal respect for truth. A mother and daughter of his acquaintance called on him rather earlier than was consonant with the social code of the day and were taken aback to find the master of the house (who was the least sluggish of men) still in his nightshirt. Very much embarrassed, the two ladies started to beat a hasty retreat, murmuring as they went: "We fear we have called at rather an awkward moment. Would you oblige us by tell-

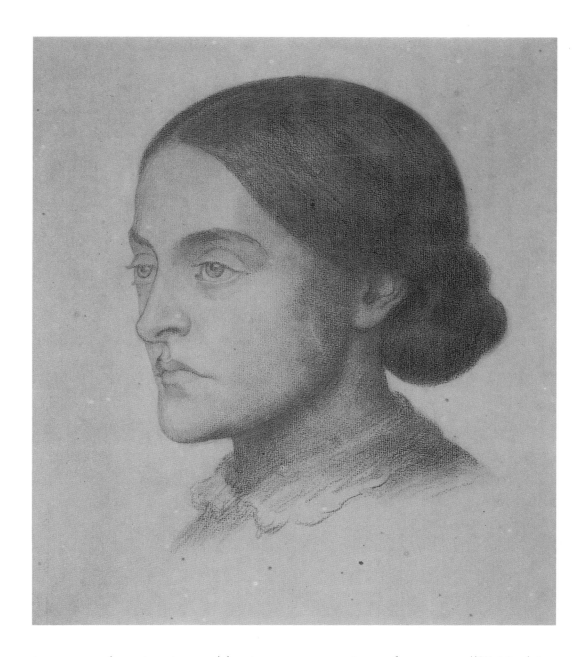

ing us at what time it would suit your convenience for us to call?" Nothing daunted, William replied, "All times are equally inconvenient." To this day, when one member of the family asks another to do a favor at his or her convenience, the answer is invariably "All times are equally inconvenient."

Dante Gabriel was perhaps too much a man of the world to be quite so literal about the truth, but whatever else has been said of him, he has not been accused of being a liar. When Ernest Chesneau referred to him as the head of the Pre-Raphaelite school, Rossetti wrote a disclaimer and loyally sustained William Holman Hunt's and the young John Everett Millais's greater right to the title.

The most famous episode, which had been kept a secret in the family till my grandmother chose to divulge it in her book on Dante Gabriel Ros-

setti, concerned the scribbled message he had found pinned to his wife's nightgown after her death from an overdose of laudanum. The first friend Rossetti rushed off to fetch was Ford Madox Brown, who immediately took the note and burned it. On it Lizzie had written, "Take care of Harry." Harry was her weak-minded brother, and it seems Rossetti did assist one or more of her brothers till his death, and after his death William continued the assistance. The story of the note was told by Brown to his daughter Lucy, and she in turn recounted it to her eldest daughter, Olive, my grandmother's sister.

My grandmother's chief aim in recounting in full the episode of the note was to put an end to the various false versions and insinuations about the circumstances of Lizzie's death and about the last message she was supposed to have left. Above all, she hoped to scotch the garbled account put forward by Violet Hunt in her book, *Wife of Rossetti*. According to Hunt, Lizzie's last message had been "My life is so miserable that I wish for no more of it." My grandmother would probably have considered it beneath her to refute Hunt's obvious fictions (which that lady herself admitted were based on hearsay and sources "chiefly oral"), had they not found credence. My grandmother's version of the events was accepted, albeit often reluctantly, as biographers and propounders of theories and theses all too often resent what they consider unwarranted intrusion by members of the family.

The word *dichotomy* has often been used by those writing on Rossetti. It has been applied to his twofold talent as a painter and poet and to the two sides of his nature reflected in his painting. Some critics consider that the spiritual side of Rossetti is manifest in the Lizzie-inspired drawings and watercolors of his first period, which were so much appreciated by John Ruskin; to these they oppose the later oil paintings of his so-called sensual women. This divided allegiance has its advantages and disadvantages, and Rossetti's sonnet in *The House of Life*, "Lost on Both Sides," has sometimes been related to his own experience. Finally, there is his double cultural heritage. My grandmother, rightly or wrongly, always considered that a great deal of the animus toward Rossetti was due to the fact that he wasn't a true-blooded Englishman, for although he had been born and educated in England, he was three quarters Italian. This meant that on the one hand he felt at home with Dante and the early Italian poets and was able to make fine translations of the *Vita nuova* and the early Italian poets at a young age. Many of the subjects of his paintings were inspired by Italian literature. On the other hand, he had a great appreciation of English literature

and had read widely, though not systematically. But a dual cultural heritage can also have its disadvantages, producing a certain disorientation and alienation from both cultures.

Rossetti considered himself an Englishman; he never visited the country of his forefathers. When he was abroad, his insular English side came uppermost. As a young man he wrote to William with disgust at what he saw in a Paris cabaret. Dante Gabriel considered that the million Frenchmen in Paris would hardly make up one good Englishman, and he despised Brussels for its citizens' servile aping of the French. Nonetheless, Ruskin saw him as "a great Italian lost in the Inferno of London," and Mrs. Millais objected to what she considered her dear son's "sly, Italian" friend.

Dante Gabriel's father, Gabriele Rossetti, was an Italian patriot exiled from the kingdom of Naples and a compiler of vast tomes on Dante. His mother, Frances Polidori, though English in appearance, education, upbringing, and her devotion to the Church of England, had an Italian father, Gaetano Polidori. Dante Gabriel's English great-grandfather,

13

William Pierce, had been anything but pleased when his daughter Anna Maria married a foreigner in the person of Gaetano Polidori, who before coming to England had been secretary to the poet Vittorio Alfieri. Pierce's indignant surprise may therefore be well imagined when his favorite granddaughter, Frances Polidori, flew in the face of Providence by marrying another Italian, Gabriele Rossetti. What would the poor man's feelings have been if he could have foreseen the future and learned that his granddaughter's granddaughter (Mrs. Rossetti Angeli) would marry another Italian and that the latter's granddaughter (myself) would marry yet another one?

Perhaps this double cultural heritage had its most unsettling effect on Frances Polidori's favorite brother, John. Though born and educated in England, he felt himself more Italian and was all for the cause of Italian liberty. For a short time he was Lord Byron's traveling physician, but his ambitions were more literary than medical. He committed suicide at the age of twenty-six as the result of gambling debts he couldn't pay. Dante Gabriel (in a letter to his friend William Allingham) speaks with sympathy of this uncle of his, who had died before he was born: "He was my mother's favourite brother, and I feel certain her love for him is a proof that his memory deserves some respect." The portrait of him, which for a long time was a treasured family possession, shows him as a strikingly handsome young man, more Byronic than Byron in appearance. William Michael Rossetti gave the portrait to the National Portrait Gallery; but we retained a photograph of it, and I remember admiring his looks as a child and making rather a hero out of him.

The most vivid memory I retain of my grandmother is of her toward the end of her life, as she reclined on what is known in the family as the "Shelley Sofa"; it is the sofa the poet had slept on the night before he was drowned off the coast of Leghorn. Edward J. Trelawny, who liked William very much and appreciated his critical work on Shelley, had given it to him as a mark of his esteem and affection. There my grandmother would lie, immersed in her memories of people long dead and the past, which must have seemed so much more real, alive, and interesting than the prosaic present. However, this didn't prevent her from taking an intelligent and generous interest in what was going on around her and the world in general.

In her youth, together with her brother and sister, she had been an advocate of social justice, an ardent and active anarchist and iconoclast (luckily not of the family pictures). In this she took after her grandfather Ford Madox Brown, who was by way of being a conservative socialist, and

also after her father, William, who wrote in his *Reminiscences*: "The love of freedom which in my father took its course towards constitutional monarchy, and in myself towards theoretic republicanism, launched my children on the tumultuous waters of anarchism." Even the mild William waxed quite violent, at least in words, when it came to denouncing kings and tyranny, and it was Dante Gabriel who advised him to tone down his Democratic Sonnets with a view to publication. Dante Gabriel never took much interest in politics. William attributed this to his having heard too much talk about politics and liberty in his childhood; political refugees from Italy were heartily welcomed by the Rossetti household on Charlotte Street, and the discussions on Italy and freedom were heated and unending. From time to time they would be interrupted by the master of the house, Gabriele Rossetti, who would declaim his patriotic verses in a beautiful tenor voice. In William's words, his father's poems "were received with sonorous eulogy, founded at least as much on political or national as on literary considerations."

Symptomatic of Dante Gabriel's attitude toward politics is an anecdote recounted by the author and statesman Lord John Morley. On a visit to Rossetti he asked his opinion about a general election then in progress and was rather taken aback when, after a pause, Rossetti replied that no doubt one side or the other would get in and that it would make little difference which. Morley later confessed that he had forgotten which side did get in and what difference, if any, it had made.

Helen Guglielmini

INTRODUCTION

ante Gabriel Rossetti. Even the name is extravagant, evoking both Italy's greatest poet and the angel of the Annunciation. It well suited Rossetti, for he was an extravagant man—in his art, in his poetry, and in his emotions. Brilliant, witty, generous, and loyal, he was irresistible to friends and to lovers. His prodigious art ranged from the crowded, detailed canvases of his early years, through the jewellike brilliance of his medieval period, to the sensuous, symbolic women of his late works. He plundered the past for his painted and poetic images, but his art was always uniquely his own, instantly recognizable and unforgettable.

Rossetti immortalized the women he loved by creating a new ideal of feminine beauty: remote yet alluring, they flaunted untamed tresses and bodies unfettered by either Victorian corsets or Victorian standards of doll-like prettiness. The three greatest loves of Rossetti's life—his auburn-haired wife, his voluptuous blonde mistress, and his raven-haired lover—all looked completely different, and he portrayed them all faithfully. Nonetheless, a distinctive type of Pre-Raphaelite woman emerged from his paintings and established an unorthodox new female ideal. Just as Rossetti developed a new style of beauty, he also presented unusual heroines: Beatrice, Lucrezia Borgia, Mary Magdalene, Joan of Arc, Lilith, Proserpine, Astarte Syriaca, and Mnemosyne, goddess of memory. Interpreting these mythic women as contemporary icons, he created an oddly effective fusion of ageless beauty and sensuous immediacy.

Painting was Rossetti's primary profession, but poetry came more easily to him than the rigors of putting an image on canvas. He was a pains-

5. A Sea Spell, 1877
Oil on canvas, 42 x 35 in.
The Harvard University Art Museums
(Fogg Art Museum),
Cambridge, Massachusetts;
Gift of Grenville L. Winthrop

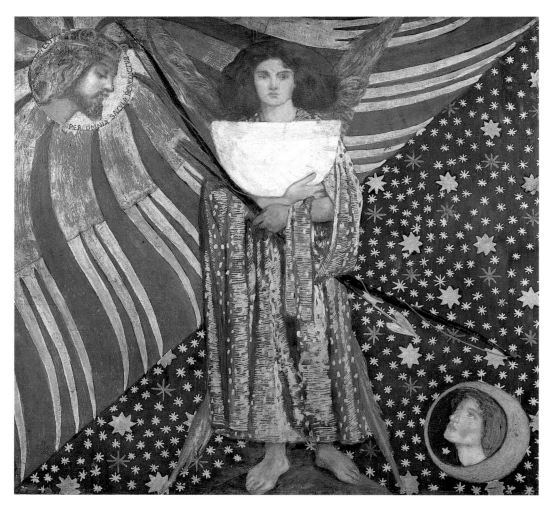

6. Dantis Amor, 1860
Oil on panel, 29½ x 32 in.
Tate Gallery, London

taking craftsman in both modes, working and reworking his material to perfect it. Obviously, his literary and artistic gifts complemented each other; from the time of his first oil painting, *The Girlhood of Mary Virgin* (plate 34), he wrote poems to accompany his paintings. (Except for a work specifically commissioned after an earlier poem, *The Blessed Damozel*, plate 231, he never created paintings to go with his poems, though many of his images refer to writings by others.) Rossetti's art is especially rich in literary references, and most of his literary output features vivid visual images. A number of specific prototypes—both literary and artistic—for Rossetti's images have never before been identified, and the artist himself might not have admitted to them, as he placed a high value on originality. The identification of these sources in the pages that follow casts new light on Rossetti's process of creation and, ultimately, on the meaning of some of his most compelling images.

Before embarking on an exploration of Rossetti's art, certain misconceptions about his career as an artist must be challenged. Most of these have arisen from the lack of detailed study of his artistic career and from

the repetition of generalizations not supported by documentary evidence. The first of these misconceptions is that Rossetti could not adequately draw the nude figure because he did not continue his education through the Royal Academy Life School. It is quite true that Rossetti abandoned the Academy before attaining the Life School; but, at the urging of Ford Madox Brown, whom he had selected as teacher and mentor, he did attend the Maddox Street Evening Academy in 1848. There students drew from the living model four evenings a week, between seven and ten.[1] This process was described by William Holman Hunt (never one to praise unduly) as Rossetti's application to "regularly executed, conscientious, although rigid, transcripts of the nude."[2]

Rossetti also learned, during a brief apprenticeship to Hunt, the academic technique of creating a painting from preliminary studies of nude figures. This is evident from sketches such as Rossetti's nude study (plate 37) for the Virgin in *Ecce Ancilla Domini!* (*The Annunciation*) (plate 39) and his study of a shepherd (plate 117) for *The Seed of David* (plate 118). His brother, William, also referred to this customary practice: "Gabriel got the paper stretched for the nude cartoon he intends to make for his picture of the Passover."[3] In December 1850 Rossetti returned to life classes at another drawing academy, the North London School of Design,[4] demonstrating his commitment to mastering drawing from the nude. Nude studies for his works from 1849 through 1876 show that he continued the practice throughout his career. His numerous informal nude sketches[5] and a few finished drawings of the nude, such as his curious late work *The Question* (plate 7), as well as the preliminary sketches for his paintings, demonstrate his skillful competence as a draftsman of the nude. However, Rossetti made very few finished drawings of nudes. For one thing, he did not wish to be accused of "Ettyism" (after William Etty, a contemporary painter who specialized in nudes). Another reason was the prejudice of his patrons, such as Leonard Rowe Valpy and various conservative provincial businessmen, against the nude figure as being unsuitable for a Victorian household.

Another major misconception about Rossetti's career as an artist is that he never exhibited any of his works after 1850. Hunt stated, "The effect of rancorous criticism upon Rossetti was such that he resolved never again to exhibit in public, and he adhered to this determination to the end...."[6] This view has continued to the present in the description of Rossetti as "a man who never exhibited in public after the age of twenty-one" and the statement that "Rossetti never exhibited after his initial Pre-Raphaelite exhibition in 1849."[7] In fact, Rossetti's works were shown in

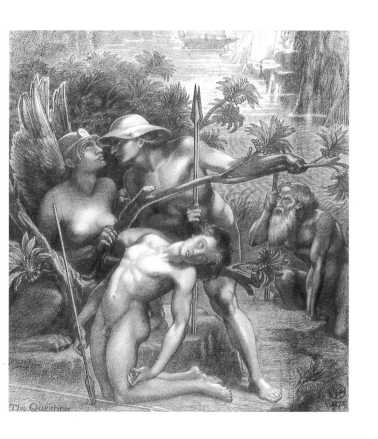

7. The Question, 1875
Pencil on paper, 18¾ x 16 in.
Birmingham City Museum and Art Gallery,
Birmingham, England

at least eighteen documented exhibitions between the years 1849 and 1881.[8] Virginia Surtees records in her catalogue raisonné thirty-two instances of works being shown during Rossetti's lifetime.[9] In three cases, works were exhibited by owners without his knowledge; in two other cases, in 1864 and 1878, he gave an owner permission to show one of his paintings. Rossetti also proposed several exhibitions of his works that never took place, as in a letter to Charles Augustus Howell of November 11, 1872: "I want to talk over several things very seriously. One is the getting up a collection of some dozen or so of my latest and best things and exhibiting them in the Spring. What is your opinion about this?"[10]

Rossetti's exhibition record has been obscured by his own negative pronouncements on the public exhibition of his work without his permission. He refused permission to exhibit his works several times, and he also expressed himself forcefully on the artist's right to limit exhibition of his works and to retain copyright—a very modern concept. Writing to William Graham on May 5, 1879, Rossetti insisted:

> One great reason for my wishing to abstain absolutely for the present from exhibiting, is, that as soon as I have your Found completed, I shall look round me and consider what prospects there would be for a gathering of my own; and till then I should consider the putting forward of any work of mine as seriously staling my materials beforehand. Pardon this long-standing mood of reticence but the position of an Artist at my age, and who has preserved hitherto one rule of non-exhibition needs the greatest circumspection as to any step in the other direction. I consider that much depends for me on the privilege of retaining control over the public production of my pictures.[11]

Here Rossetti conveniently overlooked his actual exhibition record and nurtured the legend of the secluded creator whose works were shown only to a privileged few. He was perhaps more honest in his letter of January 27, 1877, to C. E. Hallé, secretary of the Grosvenor Gallery, refusing an invitation to exhibit there: "What holds me back is simply that lifelong feeling of dissatisfaction which I have experienced from the disparity of aim and attainment in what I have all my life produced as best I could."[12] There is no doubt that Rossetti was deeply sensitive to criticism and endured his share of it during the early years of his career, particularly because of his association with the much maligned Pre-Raphaelite Brotherhood. This reinforced his reluctance to exhibit his work, especially in London, where

the "Mohawk" style of scalping artists in print was much in style (leading periodicals were nicknamed the *Contemptuous Review* and *Blackguards' Magazine*).

No large retrospective of Rossetti's work took place until after his death, when his works were shown in 1883 at the Burlington Fine Arts Club, the Royal Academy of Arts, and the Rossetti Gallery. This proved to be such a revelation of his concentrated power, his mastery of his material, and his abiding imagination that many of his friends regretted that he could not have enjoyed such a triumph during his lifetime. However, the artist had exhibited enough of his work throughout his career for those interested to know and be influenced by it (see chapter 11).

One of Rossetti's solutions to the challenge of staying in the public eye despite his limited number of exhibitions was to control not only the dissemination of his works of art but also the criticism of them. Two members of the original Pre-Raphaelite Brotherhood had become art critics: his brother, William, and his old friend F. G. Stephens. His brother would obviously be seen as too partisan to be useful, but Rossetti entered into a mutually advantageous alliance with Stephens, who was art critic at the *Athenaeum*: Stephens had exclusive rights to describe Rossetti's latest major paintings in his studio, and Rossetti had control over what Stephens wrote. Rossetti used Stephens's writing to get a number of his own ideas and interpretations of his work into print.

Another major misconception about Rossetti's performance as an artist has concerned the role played by replicas or copies in his oeuvre. In the nineteenth century replicas of art works were as common as editions of sculpture and prints are now. Many nineteenth-century sculptures were replicated in large editions of both marble and bronze, and the replicas were often in sizes different from the original; oil paintings were also replicated, though not as frequently. Because Rossetti made replicas of a number of his works, both in watercolor and in oil, he has been accused of turning out copies wholesale, and it has been implied that he could only repeat himself because his originality had failed. In most cases it was actually the artist's patrons who begged replicas of works that had already been sold. For example, William Graham wrote to Rossetti on January 12, 1871, requesting a replica of *Beata Beatrix* (plate 147): "I know that the labour of repeating, apart from the delight of invention and the surprise of discovery, is especially hard to your temperament. . . . {However,} the *Beatrice*, from the first day I saw it, has appealed to my feeling altogether above and beyond any picture I ever saw, and the *love* for it has only deepened. . . ."[13]

Rossetti hated to do replicas because he felt they were a waste of his creative talent, but he usually needed the money they would bring and also the goodwill of his steady patrons. In some instances, as expressed in his letter to Frederick Leyland of December 22, 1871, the labor of doing a commissioned replica was too distasteful, and he refused: "I believe I duly apologized for breaking off our engagement about the Palmifera replica. But in fact I find these replicas more and more impracticable. I told you of my engagement to do one of Beatrice for Mr. Graham. This I attempted to carry out while in the country this summer and almost died of it. . . . New pictures for the future, always, say I. Besides I know I am outgrowing my former self to some extent, as one should in ripening years, and had much better be doing new things only."[14]

Some works that have been called "replicas" of Rossetti paintings are in fact later versions of the same theme, often in different sizes or media than the first work on the subject, with different compositions and palettes. For example, Virginia Surtees has catalogued two versions of *The Damsel of the Sanct Grael*.[15] The first, done in 1857, is a small watercolor (13⅞ by 4⅝ inches) now owned by the Tate Gallery. Showing a slight, full-length figure, probably modeled by Elizabeth Siddal, it is somewhat muddy in character and not among Rossetti's most compelling works. The second (plate 8), catalogued as a replica, is an oil painting from 1874, seventeen years after the watercolor. The model, Alexa Wilding, is portrayed as a half-length figure. Richly patterned and painted with maturity of design and movement, this is in no way a "replica" of the original watercolor.

Another area of Rossetti's art that has lent itself to ambiguity, if not actual misrepresentation, is his fidelity to nature. Rossetti himself encouraged the legend that he totally disregarded nature as a model, except for one or two painful instances as a young Pre-Raphaelite artist. Hunt, in his amusing reminiscence of Rossetti's painting outdoors at Knole Park during the autumn of 1850, set the tone for Rossetti's supposed difficulties with nature: "I ran up occasionally to see him, and found him nearly always engaged in a mortal quarrel with some particular leaf which would perversely shake about and get torn off its branch when he was half way in its representation. Having been served thus repeatedly, he would put up with no more of such treatment, and left canvas, box and easel for the man to collect when at dusk the barrow came for my picture, he stalking back to the lodgings to write and to try designs. . . ."[16] (Hunt neglected to say that it was raining most of the time, and that Rossetti got wet enough during several days spent working outdoors that he had to send home for changes of cloth-

8. The Damsel of the Sanct Grael, *1874*
Oil on canvas, 36¼ x 22¾ in.
Private collection

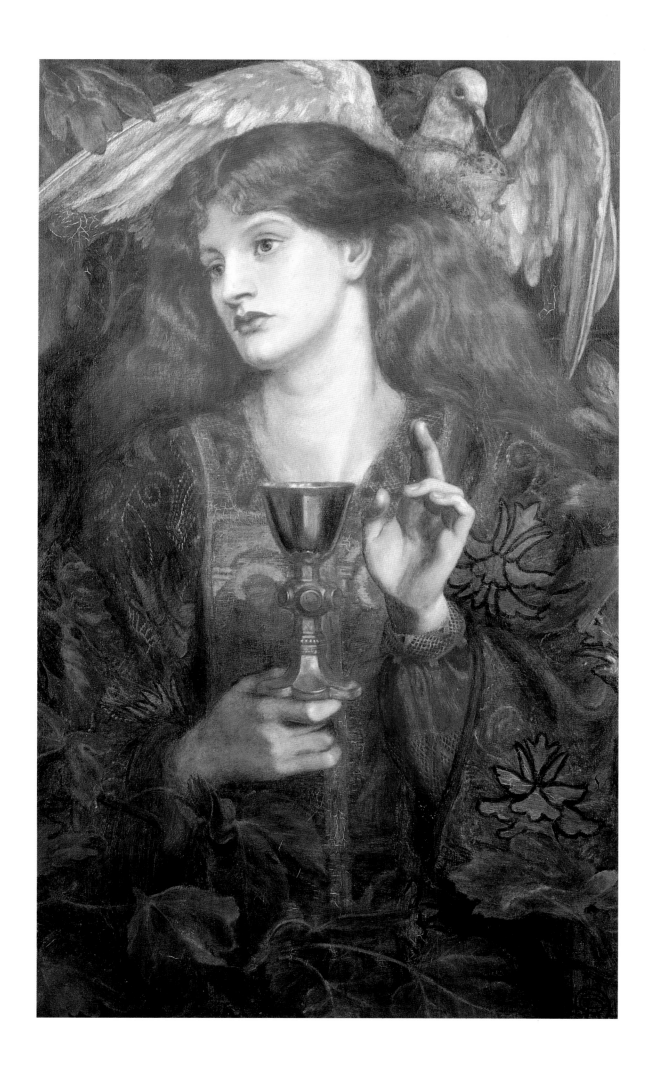

ing.) Possibly after this experience, Rossetti wrote to his artist friend Jack Tupper about 1850:

> *Though as to Nature, Jack,*
> *(Poor dear old hack!)*
> *—Touching sky, sun, stone, stick, and stack,—*
> *I guess I'm half a quack.* [17]

Twenty years later Rossetti expressed an even stronger view on nature's lack of charm for him: "Nothing but the most absolute calm and enjoyment of outside Nature could account for so much gadding hither and thither on the soles of his two feet. Fancy carrying about grasses for hours and days from the field where Burns ploughed up a daisy! Good God, if I found the daisy itself there {referring to Robert Burns's poem *To a Mountain Daisy*}, I would sooner swallow it than be troubled to carry it twenty yards." [18] Yet despite his own offhanded comments, Rossetti certainly did not neglect or misrepresent nature in his paintings. Admittedly, he was not a painstaking plein-air landscapist like his mentor Ford Madox Brown or his Pre-Raphaelite brothers William Holman Hunt and John Everett Millais. In several instances he took landscape backgrounds from sketches by other artists—for example, using for the landscape of *La Pia de' Tolomei* (plate 188) sketches of the swamps of Maremma supplied by Charles Fairfax Murray. Rossetti also employed photographs as source material, using them for the architectural details in the background of *The Salutation of Beatrice* (1880–81). [19] In both of these cases, Rossetti was not able to paint the actual landscape in Italy, and since he wished to present an authentic scene, he obtained on-the-spot transcriptions of it. In a number of other paintings he included landscapes based on his own observations from nature, such as the Thames and Kelmscott Manor in *Water Willow* of 1871 [20] and Knole Park in *The Bower Meadow* (plates 9, 210). And this is, of course, the artist who transcribed a brick wall in Finchley brick by brick and a calf hair by hair for his painting *Found* (plate 52) in 1854. He was painstaking in his search for perfect floral and arboreal models for his paintings, as numerous letters throughout his career attest. As late as 1880, while painting *The Day Dream* (plate 218), he repeatedly observed and transcribed the growth of a sycamore tree in his garden at 16 Cheyne Walk, writing in a sonnet to accompany the painting:

> *The thronged boughs of the shadowy sycamore*
> *Still bear young leaflets half the summer through.*

These lines record an observation he had made for himself as he continued from week to week to pluck branches from the tree to be studied for his picture.[21]

Rossetti's late works, a stunning procession of beautiful women painted from 1868 to 1882, reveal an artist of imagination and brilliance at the height of his powers, an artist so in control of his materials he could make his brush express whatever he wanted. Yet these paintings have often been described as decadent, immoral, ugly, and alarming. Were they the culmination of Rossetti's artistic expression or a regression from his earlier,

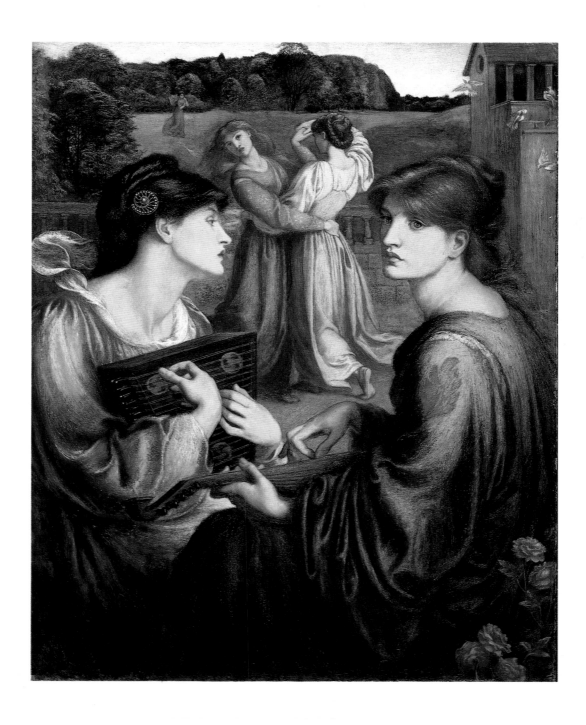

9. The Bower Meadow, 1872
Oil on canvas, 33½ x 26½ in.
Manchester City Art Galleries,
Manchester, England

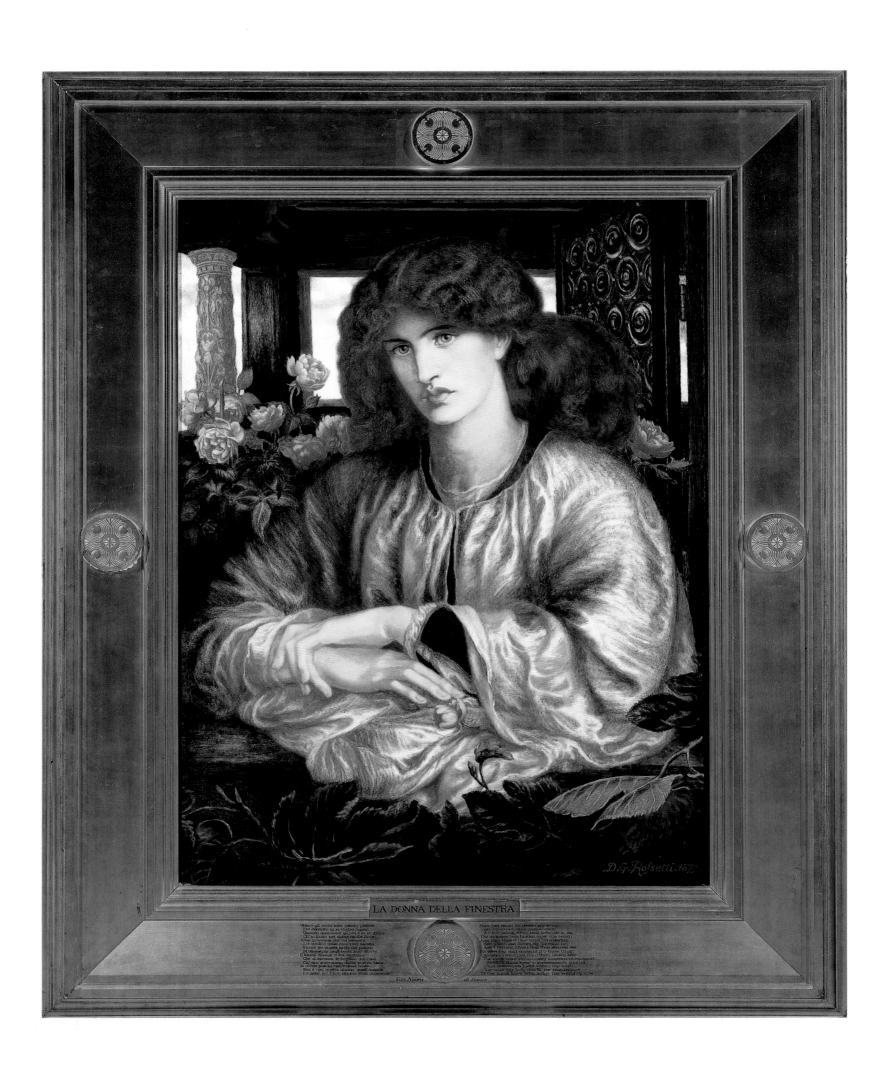

a number of friends, primarily other artists, who were often the target of his impish sense of humor. About 1858—when he and some of those companions founded the Hogarth Club as a place to meet and to exhibit their work—Rossetti initiated the practice of making extemporaneous limericks with his friends (probably inspired by the publication of Edward Lear's *Book of Nonsense*). According to his contemporaries, he excelled at the form—the more difficult the name to be rhymed, the more he enjoyed it. His limericks about his friends and associates were his best efforts, aptly mixing truth with nonsense.[29] J. W. Inchbold, for example, was inclined to make unannounced and lengthy visits:

> *There is a mad Artist named Inchbold*
> *With whom you must be at a pinch bold:*
> > *Or else you may score*
> > *The brass plate on your door*
> *With the name of J. W. Inchbold.*

Rossetti blithely skewered his friend James Abbott McNeill Whistler:

> *There's a combatitive Artist named Whistler*
> *Who is, like his own hog-hairs, a bristler:*
> *A tube of white lead*
> *And a punch on the head*
> *Offer varied attractions to Whistler.*

And he even turned the weapon on himself:

> *There is a poor sneak called Rossetti;*
> *As a painter with many kicks met he—*
> *With more as a man—*
> *But sometimes he ran,*
> *And that saved the rear of Rossetti.*

To sum up Dante Gabriel Rossetti is almost impossible: he was innovative yet traditional, unconventional yet vulnerable to the opinions of others, spiritual in his art yet earthy in his life and loves. He owed many of his traits to the merging of an Italian past with an English present. His art was also nurtured and encouraged by his family, which remained one of his strongest influences throughout his entire career.

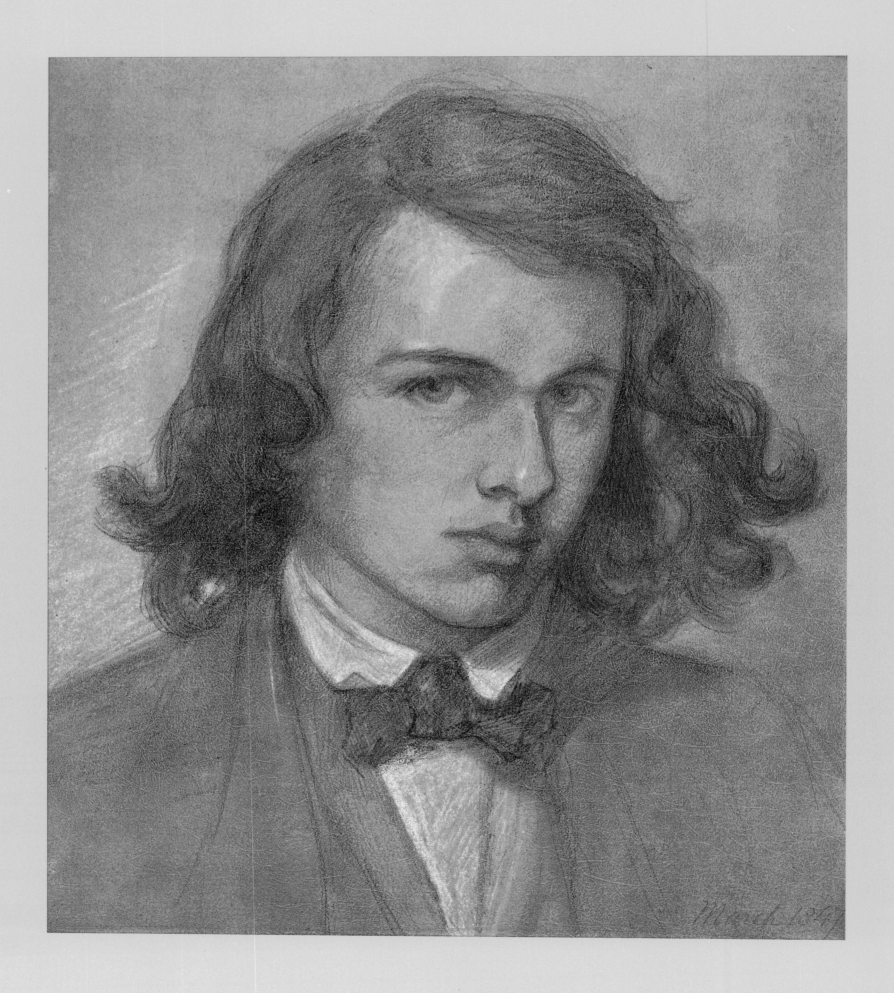

March 1847

THE EARLY YEARS

Dante Gabriel Rossetti came from a heritage more Italian than English, his father being from Abruzzi, his mother being half Tuscan and half English. His father, Gabriele Rossetti, was born in Vasto d'Ammone in Abruzzi, the third son of a blacksmith.[1] A promising scholar, Gabriele was sent to the University of Naples by the Marchese of Vasto, but he left after only one year when the Bourbon king was overthrown and replaced by Bonaparte rulers. Gabriele knew many of the Bonaparte family members and supported them enthusiastically; when the government changed again in 1821 he was sent into exile for having written a poem in favor of the preceding regime's constitution. Managing to escape to Malta, he then made his way to England, where he arrived in 1824. Two years later, at the age of forty-three, he married Frances Polidori, the second daughter of Gaetano Polidori, a Tuscan who had married an Englishwoman. Almost seventeen years younger than her husband, Frances had worked as a governess and was a resourceful and courageous woman greatly loved by all her children. Four children were born of the union: Maria Francesca, in 1827; Gabriel Charles Dante, in 1828; William Michael, in 1829; and Christina Georgina in 1830. Gabriele became a professor of Italian at King's College in 1831, with an annual income of ten pounds supplemented by tutoring fees. The family lived first at 38 Charlotte Street, in London, moving to a slightly larger house at 50 Charlotte Street in 1836.

It was a house full of children and of visiting compatriots—many, like Gabriele, political exiles. It was also a place of literary activity, with Gabriele writing abstruse philosophical books in Italian and finding secret

13. Self-Portrait, March 1847
Pencil heightened with white
on paper, 7½ x 7¾ in.
National Portrait Gallery, London

meanings in the works of that earlier Italian writer in exile, Dante Alighieri. Everyone in the family, except Mrs. Rossetti, wrote and published at least one book; and Christina Rossetti became famous as a major poet, producing such well-known works as *Goblin Market* (1862), *The Prince's Progress* (1866), *Sing-Song* (1872), *A Pageant* (1881), *Time Flies* (1885), and *Verses* (1893). Dante Gabriel's grandfather, Gaetano Polidori, had a private printing press in Park Village East and encouraged his grandchildren by printing several of their works, including Dante Gabriel's *Sir Hugh the Heron* in 1843 and Christina's *Verses* in 1847.

It was clearly an intellectual family atmosphere. Financial practicality was of so little concern that Gabriele had no bank account, keeping all the family funds in a box at home—a practice Dante Gabriel continued. Mrs. Rossetti said of her family, "I always had a passion for intellect, and my wish was that my husband should be distinguished for intellect, and my children too. I have had my wish,—and I now wish that there were a little less intellect in the family so as to allow for a little more common sense!"[2] William, who had common sense, was reputedly his mother's favorite, but Dante Gabriel was his father's; Gabriele wrote to his wife in 1832 referring to "my dear Gabriel whom I seemed to love immensely more than any of my other children."[3] Dante Gabriel later used his father's crest as his own and had its motto, "Frangas non flectas" (Bend, do not break), stamped on his notepaper.

Dante Gabriel grew up speaking both English and Italian; he also learned French and German at home and some Latin and a bit of Greek at school. He was a voracious consumer of all types of literature, particularly those with a romantic bent, including the *Arabian Nights*, Dante, Shakespeare, Robert and Elizabeth Barrett Browning, Monk Lewis, Thomas Percy's *Reliques of Ancient English Poetry* (1765), Sir Henry Taylor's *Philip van Artevelde* (1834), Sir Walter Scott's novels and poetry, Charles Robert Maturin's *Melmoth the Wanderer* (1820), Johann Wolfgang von Goethe's translations of the *Iliad* and the *Odyssey*, Percy Bysshe Shelley, Edgar Allan Poe, Alexandre Dumas, Victor Hugo, Robert Burns, Lord Byron, and Alfred, Lord Tennyson. When he was only sixteen, Rossetti started writing his own works and translating others into English, including Gottfried August Bürger's *Lenore* (1773), the *Niebelungenlied,* and Hartmann von Aue's *Henry the Leper*—all highly romantic tales. He haunted the British Museum Reading Room in search of early Italian lyrics; and in 1845 he began his translations of the early Italian poets and Dante's *Vita nuova* (c. 1293), which were eventually published, in revised form, in 1861. The

14. *Fratelli Alinari*
Gabriele Rossetti, *n.d.*
Photograph of a drawing
Delaware Art Museum, Wilmington;
Bancroft Archives

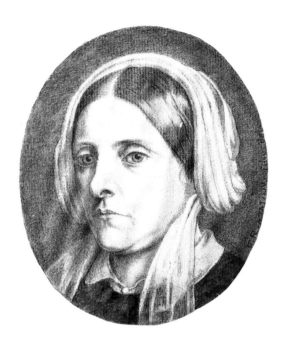

15. Mrs. Gabriele Rossetti, *1854*
Pencil on paper, 6 x 4¾ in.
The National Trust, Wightwick Manor,
Wolverhampton, England

16. *Lucy Brown Rossetti (1843–1894)*
Maria Rossetti as an Anglican Nun,
c. 1873–76
Pencil on paper
Private collection

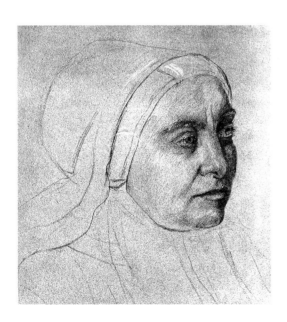

young Rossetti also wrote such medieval-style masterpieces as *Roderick and Rosalba, A Story of the Round Table* (1840), which he illustrated himself. His *Sir Hugh the Heron* has a heroine named Beatrice and a hero who bears a curious likeness to Dante Gabriel in later life, especially in his cry, "Lady, I love thee to excess: oh yield to my desire!" The first versions of Rossetti's poems *The Blessed Damozel* and *Jenny* were begun by the time he was eighteen, although they were later revised over and over again for publication.

The literary influences on Rossetti's early years have been studied in detail, but his artistic beginnings have not been similarly investigated. Part of his artistic talent and encouragement may have come from his father, who as a young man had illustrated his poems with sepia pen sketches. Another role model may have been Filippo Pistrucci, a family friend described by William as "the man of most natural kindliness of heart that I ever knew."[4] Pistrucci did a miniature portrait of Dante Gabriel in 1834 and two later portraits as well. It must have been a compelling experience for a six-year-old child to sit still for so long and then see his own features and bright auburn hair so accurately replicated. Pistrucci was also the author and illustrator of *Iconologia ovvero imagini di tutte le cose principia . . .*, an impressive two-volume book published in Milan in 1819; this iconology with brightly colored plates was in Gabriele's library and may have influenced Rossetti's later paintings.

Other artistic exemplars may have been the Maenza family, with whom Rossetti went to stay in Boulogne, France, when he was fifteen. Giuseppe Maenza taught sketching and watercolor painting, and his son, Filippo (nicknamed Peppino), was studying to be an artist. Just four years older than Rossetti, he was already an accomplished draftsman and made a full-length sketch of Dante Gabriel in November 1843.[5] Rossetti greatly admired Filippo, writing to his mother on October 20, 1843: "I find that Peppino's tastes coincide in every respect with mine. He draws splendidly and is very fond of poetry, especially Byron."[6]

The young Rossetti may also have been influenced by Friedrich August Moritz Retzsch, whose outline engravings of Goethe's *Faust* were known to him as early as 1843. Rossetti was also aware of Retzsch's *Galerie zu Shakespeares dramatischen Werken* (1847) and may have borrowed elements from plate 10 of the *Hamlet* sequence for *The First Madness of Ophelia*, a watercolor of April 1864. A copy of Retzsch's *Umriss zu Göthes Faust* (1836), which may have inspired Rossetti's early *Faust* drawings, was in his library at the time of his death.[7]

Another early influence on Rossetti may have been his 1847 purchase of a manuscript by William Blake, offered to him for ten shillings by an attendant at the British Museum. Like Rossetti, Blake had been both a poet and an artist, and his denunciation of the idols of the Royal Academy, such as Rubens, Rembrandt, Correggio, and Sir Joshua Reynolds, reinforced Rossetti's own rebellion against its conventions. Rossetti was also captivated by Blake's evocation of a mystical world and by his brilliant and expressive use of color. In his chapter on the artist in Alexander Gilchrist's *Life of William Blake* (1863), Rossetti lauded Blake's "most original prismatic system of colour—in which tints laid on side by side, each in its utmost force, are made by a masterly treatment to produce a startling and novel effect of truth."[8]

Besides the literary and artistic influences on Rossetti, there was another important factor in the life of the young artist—his religious training. His father, though nominally a Roman Catholic, was actually an agnostic who questioned the doctrines of the Church. Frances Rossetti was a devout Anglican who brought up all four children in her own religion. They were regularly taken to Trinity Church on Marylebone Road and then, after 1838, to Christ Church on Albany Street. The latter was founded by the Reverend W. Dodsworth, who had close ties to Edward Pusey and Cardinal Newman and the High Church practices of the Oxford Movement. In 1850 Dodsworth became a Roman Catholic, and the Rossetti family began attending Saint Andrew's on Wells Street. William Rossetti eventually became an agnostic, but Maria ended her days as an Anglican nun, and Christina's poetry is deeply rooted in Anglican theology, morality, and language. Dante Gabriel called himself an "Art Catholic," both in painting and in poetry. Two of his early paintings, *The Girlhood of Mary Virgin* (plate 34) and *"Ecce Ancilla Domini!" (The Annunciation)* (plate 39), deal with the life of the Virgin. Although religious subject matter is less prominent in his later art and literature, he did continue using religious iconography and symbolism, though often in a secular context.

After tutelage at home by their mother, both Dante Gabriel and William started formal schooling at an establishment on Foley Street run by the Reverend Mr. Paul. In 1837 they went to King's College School, where, as sons of a professor, one was admitted free and the other at a reduced rate. The drawing master at King's College was John Sell Cotman, a watercolorist and draftsman particularly famous for his landscapes and architectural drawings. From about 1842 to 1844 Dante Gabriel, having decided to be an artist, attended Cary's Academy of Art (popularly known

as Sass's), where young artists acquired the skills needed to qualify for the Royal Academy Schools. In the summer of 1844, having produced the three required drawings—an anatomical figure, a skeleton, and an antique figure—Rossetti entered the Antique School of the Royal Academy, which was the first step before progressing to the Life School and then to the Painting School. F. G. Stephens described Rossetti's appearance at the time: "Rather below the middle height, and with a slightly rolling gait, Rossetti came forward among his fellows with a jerky step, tossed the falling hair back from his face, and, having both hands in his pockets, faced the student world with an insouciant air which savoured of defiance, mental pride and thorough self-reliance."[9]

Dante Gabriel's appearance at this time is also recorded in a plaster medallion by the sculptor John Hancock (plate 17), of which William Rossetti remarked: "There is considerable truth in this profile, though. I think it makes my brother look more harsh and haggard of contour than he ever was; the thinness of his face and person at that time conduces to this result, aided by the profusion of wild elf-locks in which he then indulged."[10] Rossetti's self-portrait of the next year (plate 13) shows a more direct, full-face treatment, with somewhat softened contours and long, flowing hair. Although his eyes are fastened steadily on the mirror image, the effect of the gaze is both reflective and romantic, the whole suggesting a rather Byronic self-image.

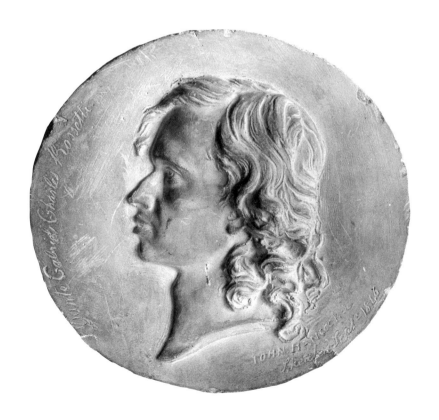

17. John Hancock (1808–1890)
Dante Gabriel Charles Rossetti, *1846*
Plaster medallion
The National Trust, Wightwick Manor,
Wolverhampton, England

"The appearance of my brother was to my eye rather Italian than English He was five feet seven and a half The complexion, clear and warm, was also dark, but not dusky or sombre. The hair was dark and somewhat silky; the brow grandly spacious and solid; the full-sized eyes bluish-grey."[11] About Rossetti's early character, his brother testified, "He liked to do what he himself chose, and, even if he did what someone else prescribed, he liked to do it more or less in his own way."[12] "The very core of his character was self-will, which easily shelved into willfulness. As his self-will was sustained by very high powers of intellect and of performance, he was not only a leader but a dominator all his life long."[13] "He assumed the easy attitude of one born to dominate—to know his own place and to set others in theirs."[14] His friend William Allingham testified: "We are late, but Rossetti *won't* hurry. He says in a conclusive tone: 'I never do anything I don't like.'"[15] One other important ingredient in Rossetti's character can be inferred from his letter of November 21, 1865, to his friend James Smetham, "What you lack is simply ambition, i.e. the feeling of pure rage and self-hatred when any one else does better than you do."[16]

While Dante Gabriel was at art school, important changes were taking place in his family. His father's health had broken down so completely by 1843 that he was forced to resign his professorship, and his wife began giving Italian lessons in his stead. With Dante Gabriel training to be an artist, William was forced to become the family's main wage earner, though he had wanted to become a doctor. On February 6, 1845, he became a clerk at the Excise Office, a job he worked at, with appropriate promotions, all his life. Maria became a governess to Lord Charles Thynne's family, while ill health saved Christina from a similar fate. In 1854, after almost a decade of declining health and near blindness, Gabriele Rossetti died. His favorite son later wrote a poem, *Dantis Tenebrae* (1861), in which he memorialized his father's transmission of Dante's influence to him; it ends with the poignant line "On thy bowed head, My Father, fell the Night."

Rossetti's early works as an artist were mainly drawings illustrating literature that had caught his fancy. One of the earliest is *The Raven: Angel Footfalls* (plate 18), a pen-and-wash drawing that illustrates Edgar Allan Poe's lines "Then, methought, the air grew denser, perfumed from an unseen censer / swung by seraphim whose foot-falls tinkled on the tufted floor." The scene is vividly portrayed—the man seated in an armchair looking fixedly at a group of angels passing by—but narrative action is not the point; what the artist represents is a moment of heightened awareness.

18. The Raven: Angel Footfalls, *c. 1847*
Pen and wash on paper, 9 x 8½ in.
Victoria and Albert Museum, London

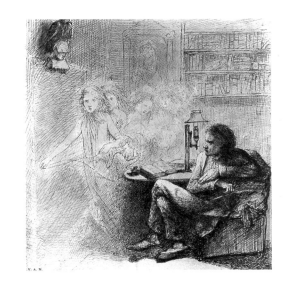

This is also true of two other drawings of this period illustrating works by Poe, *Ulalume* (plate 19) and *The Sleeper* (plate 20). In all these drawings Rossetti depicts a moment when mortal and spiritual worlds intersect: in *The Sleeper* "ghosts go by" looking at the young girl asleep at the window, while in *Ulalume* an angel appears:

> *In terror she spoke, letting sink her*
> *Wings till they trailed in the dust—*
> *In agony sobbed, letting sink her*
> *Plumes till they trailed in the dust—*
> *Till they sorrowfully trailed in the dust.*

It would be hard to overestimate the influence of Poe on the young Rossetti, an influence that may have extended to his poems. *The Sleeper* (1831) is about a sleeping young woman referred to as a "poor child of sin"; Rossetti's poem *Jenny* is about a sleeping young prostitute. Poe's poem *To One in Paradise* (1834) describes an earthly lover dreaming of his beloved

in heaven, while Rossetti's poem *The Blessed Damozel* (first published in the *Germ* in 1850) is about the opposite situation, of the beloved in heaven dreaming of her earthly lover.

Some of Rossetti's most dramatic early drawings relate to Goethe's *Faust*. His interpretations are very different from Retzsch's; the figures are smaller and of different proportions, fewer figures are used, and a deeper space is shown, with a stronger three-dimensionality. Rossetti conveys inner states of turmoil rather than portraying large set pieces of romantic action. His emphasis, as in *Faust: Margaret in the Church* (plate 21), is on

21. Faust: Margaret in the Church, 1848
Pen and brown ink on paper,
7⅛ x 4⅞ in.
Tate Gallery, London

the figure of Margaret rather than Faust or Mephistopheles. Another of this series, *Faust: Gretchen and Mephistopheles in the Church*, is closer to a Retzsch illustration of the devil in church.[17] Rossetti's drawing was circulated in a portfolio by the Cyclographic Society (a sketching club that was a predecessor of the Pre-Raphaelite Brotherhood), and it earned favorable comments from Millais and Hunt.

By 1848 Rossetti was at a crossroads. He wrote poetry continually and, although he often sketched subjects of his own choosing, he hated and shirked the discipline of the Royal Academy Schools. Which career should he choose to make his living: art or literature? He asked the well-known poet Leigh Hunt this question when he sent him a number of his poems to evaluate. "If you paint as well as you write," replied Hunt in a letter of March 31, 1848, "you may be a rich man, or at all events, if you do not wish to be rich, may get leisure enough to cultivate your writing. But I need hardly tell you that poetry, even the very best . . . is not a thing for a man to live upon while he is in the flesh, however immortal it may render him in spirit."[18]

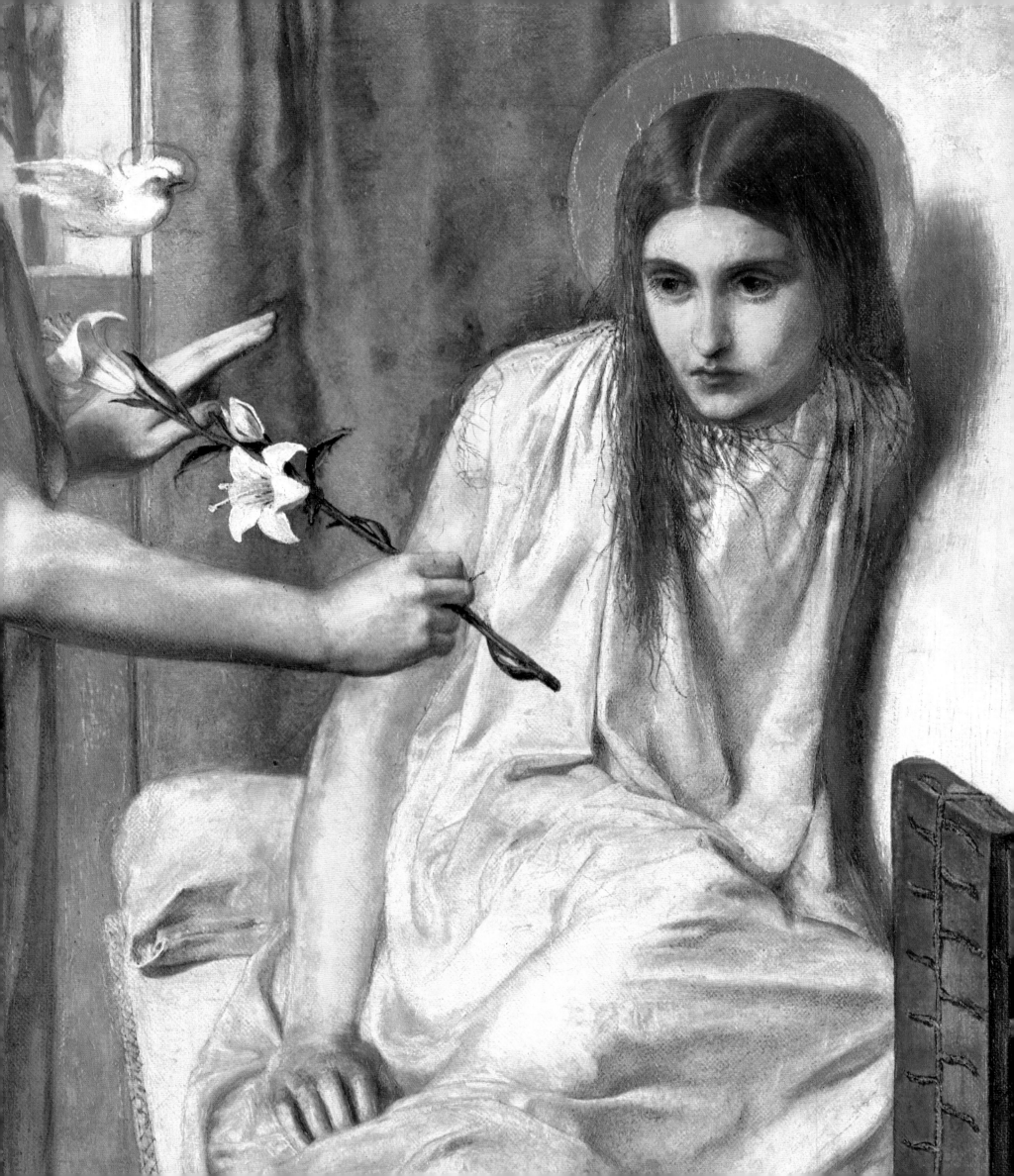

THE PRE-RAPHAELITE BROTHERHOOD

ante Gabriel Rossetti made up his mind to become an artist. But in 1848 he was still only in the Royal Academy Antique School, with years of training in the Life School and the Painting School stretching out ahead of him before he would be a fully trained artist, ready to paint in oils, to exhibit, and to sell his work. The mechanical and uninspired teaching at the Antique School was far from any of the ideas he wanted to embody in his own art. He was a negligent student, easily bored with academic routine and often cutting class to write poetry or to look up old romances and prints in the British Museum. Another course of training was open to him: he could apprentice in an established artist's studio, which would offer the advantage of working with someone he admired. Accordingly, in March 1848, he wrote the following letter to Ford Madox Brown, an artist only seven years older than himself:

Sir,

I am a Student in the Antique School of the Royal Academy. Since the first time I ever went to an Exhibition (which was several years ago, and when I saw a picture of yours from Byron's Giaour), I have always listened with avidity if your name happened to be mentioned, and rushed first of all to your number in the Catalogues. . . . It is not therefore to be wondered at, if, wishing

22. Detail of "Ecce Ancilla Domini!"
(The Annunciation), 1850
See plate 39

41

to obtain some knowledge of colour (which I have as yet scarcely attempted), the hope suggests itself that you may possibly admit pupils to profit by your invaluable assistance. If, such being the case, you would do me the honor to inform me what your terms would be for six months' instruction, I feel convinced that I should then have some chance in Art.

I remain, Sir,
Very truly yours,
Gabriel C. Rossetti.[1]

The young Rossetti had seen Brown's cartoons for the Houses of Parliament fresco competition in 1844 and 1845. The first of these, *The Body of Harold Brought before William the Conqueror* (City Art Gallery, Manchester, England), is quite similar in composition to Eugène Delacroix's *Entry of the Crusaders into Constantinople* (1840, Musée d'Orsay), which Brown probably saw during his Paris sojourn from 1840 to 1843. From 1845 to 1851 Brown was working on *The Seed and Fruits of English Poetry* (plate 24), which he had started in Rome; when he received Rossetti's letter in 1848, he was preoccupied with *The First Translation of the Bible into English* (City Art Gallery and Museum, Bradford, England).

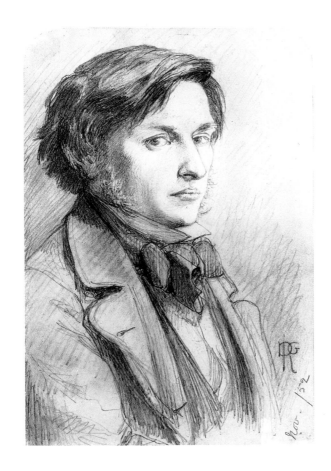

23. Ford Madox Brown, *November 1852*
Pencil on paper, 6½ x 4¼ in.
National Portrait Gallery, London

Brown had not yet received much recognition, and at first he thought the letter was a piece of mockery. Having gone down to 50 Charlotte Street to demand an explanation, he soon discovered that Rossetti genuinely admired his work and he took him on as a pupil, refusing to accept any tuition. He initiated Rossetti into working in oils by having him paint a still life of pickle jars, which the young artist found extremely boring and very far from the romantic and literary subject matter that intrigued him. Within a few months Rossetti found another teacher more sympathetic to his desires, but he kept Brown as a lifelong supporter, advisor, and friend.

Rossetti's new tutor in the mysteries of oil painting was William Holman Hunt, only one year older than Rossetti but already an advanced student at the Royal Academy. They had seen each other casually as students, having met when Rossetti was sketching a figure from a cast of Lorenzo Ghiberti's *Gates of Paradise* at the Academy. Rossetti had caught Hunt's attention when he loudly praised Hunt's *Flight of Madeleine and*

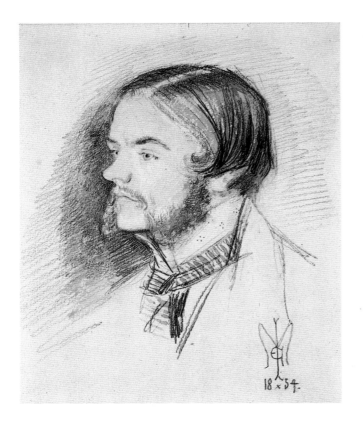 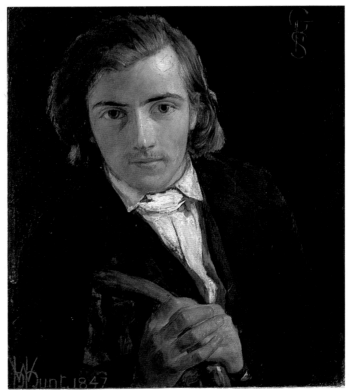

Porphyro (Guildhall Art Gallery) at the 1848 Royal Academy exhibition. When Rossetti asked Hunt to accept him as an apprentice, he also sought assurance that he could learn to paint from a subject of his own choice, rather than pickle jars. Rossetti volunteered to pay half the rent on a shared studio, and Hunt, who had wanted studio space but could not afford it, agreed to take Rossetti on as a pupil. In August 1848 they moved into a studio on Cleveland Street, where Rossetti became the model for the main figure in Hunt's painting *Rienzi* (1848–49, private collection, England), and Hunt taught Rossetti to paint.

Hunt recalled in 1905: "I led him through the portals of original picture painting in oil. . . . Had he not been very closely, thoughtfully, and affectionately guided by me, hour by hour, in my studio for seven or eight months . . . he could not have appeared as a painter in 1849, and not even in 1850, if ever."[2] Hunt had earlier acknowledged, in 1886: "I gained many advantages by our partnership. Rossetti had then perhaps a greater acquaintance with the poetical literature of Europe than any living man. His storehouse of treasures seemed inexhaustible. If he read twice or thrice a long poem, it was literally at his tongue's end, and he had a voice rarely equalled for simple recitations. Another gain was in the occasional visits of F. M. Brown . . . who kindly gave me advice when he had ended his counsel to Rossetti. . . ."[3]

Above, left
25. John Everett Millais (1829–1896)
Portrait of William Holman Hunt, 1854
Pencil and watercolor
on paper, 8 x 7 in.
Ashmolean Museum, Oxford, England

Above, right
26. William Holman Hunt (1827–1910)
F. G. Stephens, 1846–47
Oil on panel, 7¹⁵⁄₁₆ x 6 ⅞ in.
Tate Gallery, London

According to Hunt, the term *Pre-Raphaelite Brotherhood* originated when he and a fellow student and friend, John Everett Millais, were criticizing Raphael's *Transfiguration* and other students proclaimed that they must then be "Pre-Raphaelites," a designation that Millais and Hunt laughingly accepted.[4] The Pre-Raphaelite Brotherhood (PRB) was founded in September 1848 at 83 Gower Street, the Millais family house where Millais had his studio. There were seven founding members: Hunt, Millais, Rossetti, James Collinson, William Rossetti, F. G. Stephens, and Thomas Woolner. If the *Pre-Raphaelite* came from Hunt and Millais, the *Brotherhood*

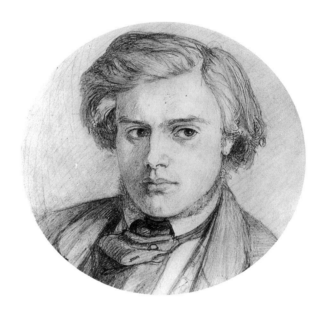

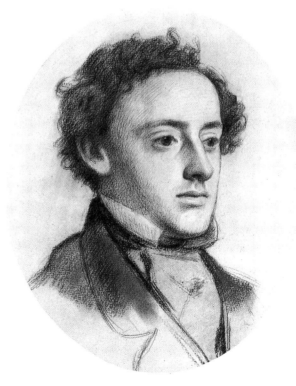

came from Rossetti, steeped from childhood in ideas about the Masons, Carbonari, and other secret societies. Rossetti had brought in his brother; the sculptor Thomas Woolner; and Christina Rossetti's beau, James Collinson, who was proclaimed a "stunner" in painting. Hunt contributed his friend F. G. Stephens, later to become an eminent art critic.

The catalyst that precipitated the Pre-Raphaelite Brotherhood was, according to Hunt, a set of engravings by Carlo Lasinio of the Campo Santo frescoes in Pisa, painted by various masters of the early Renaissance (plate 29).[5] "Millais, Rossetti and myself were all seeking for some sure ground, some starting point for our art which would be secure, if it were ever so humble. As we searched through this book of engravings, we found in them, or thought we found, that freedom from corruption, pride and disease for which we sought. Here there was at least no trace of decline, no conventionality, no arrogance. Whatever the imperfections, the whole

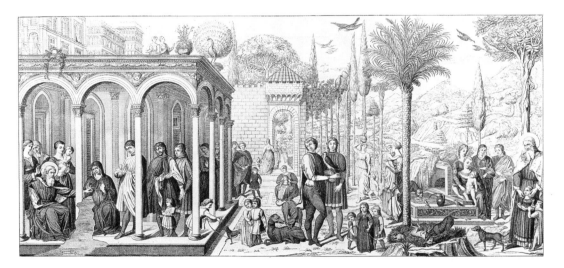

spirit of the art was simple and sincere—was, as Ruskin afterwards said, 'eternally and unalterably true.'"[6] Although these engravings now seem rather stiff and dull, they suggested a new style to supplant the High Renaissance conventions that had been debased into shopworn repetitions by the Royal Academy. Rossetti captured the attitude of the group in his caricatures of Millais saying "Slosh" (the ultimate PRB condemnation) and Hunt responding, "Of course" (plates 30, 31).

The creed of the Pre-Raphaelite Brotherhood was perhaps most succinctly enunciated by William Rossetti, who became secretary of the Brotherhood:

1. *To have genuine ideas to express;*
2. *To study Nature attentively, so as to know how to express them;*
3. *To sympathize with what is direct and serious and*

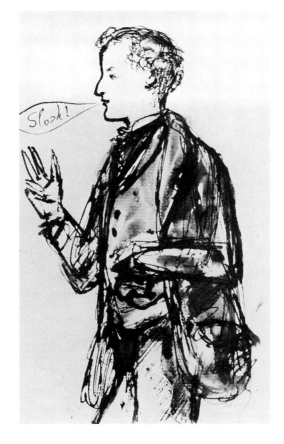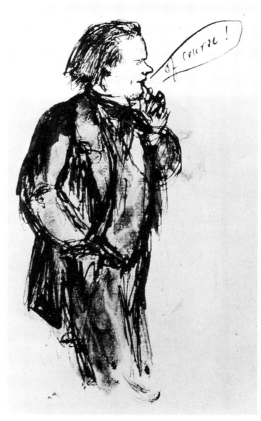

heartfelt in previous art, to the exclusion of what is conventional and self-parading and learned by rote;

4. *and most indispensible of all, to produce thoroughly good pictures and statues.*[7]

The PRB favored three main areas of subject matter: first, Christian doctrine and medieval life; second, scenes from contemporary life, often expressing moral values founded on religious belief; and third, scenes from literature, particularly Shakespeare and such nineteenth-century poets as Keats, Tennyson, Coventry Patmore, and Sir Henry Taylor. These subjects were certainly not unique to the PRB, but their style, their models, and their painting techniques set them apart from most of their peers. What set them even further apart, as Robert Rosenblum has pointed out so perceptively,[8] is the fact that the Pre-Raphaelite Brotherhood was the first group of artists to see themselves as an avant-garde cadre rebelling against the dominant art of their time. Articulate about their aims and methodology, this band of seven brethren laid out a revolutionary, antiestablishment manifesto in their magazine, the *Germ*.

Especially evident in the Pre-Raphaelites' early paintings is their interest in spiritual and moral issues. Rossetti's earliest oils have religious

subjects—*The Girlhood of Mary Virgin*, 1848–49, and *"Ecce Ancilla Domini!" (The Annunciation)*, 1850—as do Hunt's *A Converted British Family Sheltering a Christian Missionary* (1850, Ashmolean Museum); Collinson's *Renunciation of Queen Elizabeth of Hungary* (1851, Johannesburg Art Gallery); and Millais's *Christ in the Carpenter's Shop* of 1850 (plate 36). The PRB also used biblical typology in their paintings to refer symbolically to events in the past and to foreshadow others.[9]

The PRB was born in 1848, a year of revolution throughout Europe and a year of political reform in England.[10] The Pre-Raphaelites' interest in contemporary social and moral issues is evident in many of their secular subjects. Millais did a series of drawings in 1853 on the evils of gambling and of marriage for money or rank; and Brown's *The Last of England* and *Work* (both 1852–65, Birmingham City Museum and Art Gallery) comment on the difficulties of finding employment and on the resulting forced emigration. Another major social problem was the prevalence of prostitution, particularly in urban areas, a problem addressed in such paintings as Hunt's *Awakening Conscience* (plate 32) and Rossetti's *Found* (plate 52). As Alistair Grieve has indicated, a disguised as well as an overt treatment of social problems can be found in Pre-Raphaelite drawings and paintings. For example, Millais's *Lorenzo and Isabella* (plate 33) indirectly decries Victorian marriages based on economic considerations, and Hunt's *Rienzi* obliquely addresses the Italian struggle for self-rule and the need for better government in England.[11]

The greatest revolt of the Pre-Raphaelite Brotherhood was, as Hunt put it, "to eschew all that was conventional in contemporary art"[12] This meant representing a religious event, for example, in a simple, devout, and natural fashion, refusing to idealize the figures with graceful gestures and elegant robes or to generalize the backgrounds. It also meant a divergence from academic technique. To emulate the early Renaissance practice of painting frescoes on a white prepared ground, the Pre-Raphaelites used a ground of white lead and varnish, often painting on it while it was still damp (as in fresco technique), which heightened and brightened their colors. They mixed their pigments with resinous varnish as well as oil, which kept the colors fresh long enough for the artists to complete the detailed study from nature they advocated. This method was not unique to the PRB—it had been employed occasionally by such artists as J.M.W. Turner, William Mulready, William Etty, and Sir David Wilkie—but the Pre-Raphaelites used it more consistently as a device to show precise detail and brilliant coloration, very much as the early Flemish painters Jan van Eyck

Top
32. William Holman Hunt (1827–1910)
The Awakening Conscience, *1854*
Oil on canvas, 30 x 22 in.
Tate Gallery, London

Bottom
33. John Everett Millais (1829–1896)
Lorenzo and Isabella, *1848–49*
Oil on canvas, 40½ x 56¼ in.
Walker Art Gallery, Liverpool,
England

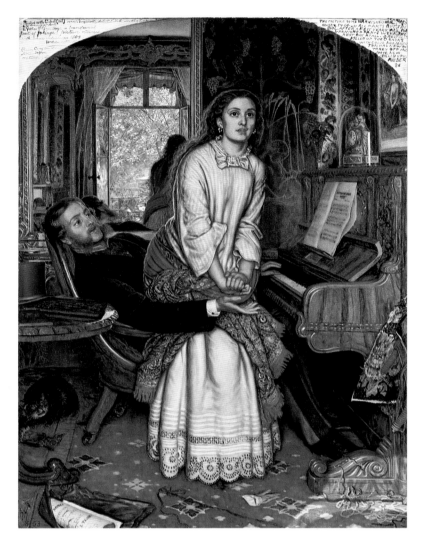

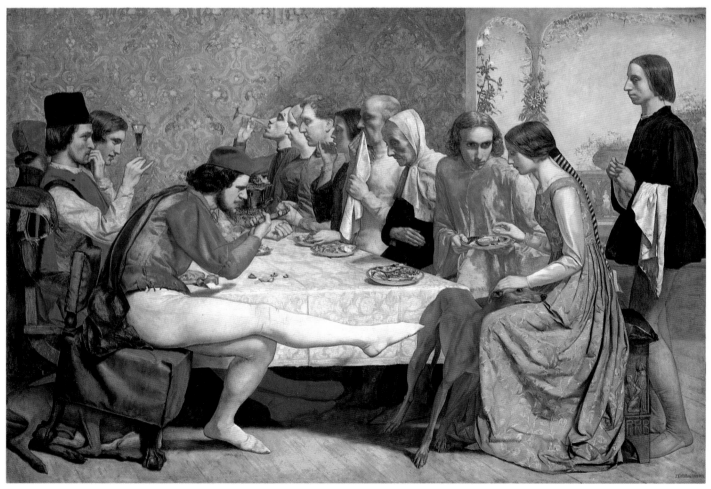

and Hans Memling, whom they greatly admired, had done. Rossetti, in particular, intensified the impact of his colors, especially in his watercolors, by juxtaposing complementary hues, as propounded in Michel-Eugène Chevreul's color theories and as in Delacroix's late painting and the works of the Impressionists.

The literary bias of the PRB was so strong that a French reviewer wrote sardonically: "In France these revolutionaries would have contented themselves with upholding the same ideal and frequenting the same café. In England, where three admirers of Shakespeare or of Browning cannot meet without forming a Shakespeare reading party, or a society for the explanation of Browning, the Pre-Raphaelites formed themselves into a Brotherhood."[13] The Brotherhood, however, had a different motive and style in using a literary basis for their works. Whereas many contemporary artists employed literary models for their narrative, sentiment, or melodrama, the Pre-Raphaelites tried to capture the "charged moment" when a spiritual state was illuminated.

Many of the Pre-Raphaelites and their friends were published poets as well as artists. It is not surprising, therefore, that the brethren decided to found a magazine to expound their views on art and to reproduce examples of their poetry and etchings. After much debate, *The Germ: Thoughts towards Nature in Poetry, Literature, and Art* was finally adopted as its title, and the first issue was published in January 1850. In the next issue Stephens, writing under the pen name of John Seward, defended Pre-Raphaelitism in an essay entitled "The Purpose and Tendency of Early Italian Art." In it he elucidated the Pre-Raphaelite practice of painting ordinary people from everyday life rather than professional models with the perfect proportions demanded by academic canons: "The consequence of this {academic} direction of taste is that we have life-guardsmen and pugilists taken as models for kings, gentlemen and philosophers. The writer was once in a studio where a man, six feet two inches in height with atlantean shoulders, was sitting for King Alfred. That there is no greater absurdity than this will be perceived by anyone that has ever read the description of the person of the king given by his historian and friend Asser."[14] Not only were the Pre-Raphaelite models supposed to look like the person portrayed, with non-idealized features and unstudied poses, they were also to have some affinity to the supposed character of the personage. This goal, and the often unaffordable expense of hiring professional models, led to the brethren's frequent use of each other and their friends as models.

Another type of model was extremely important to the Pre-Raphael-

ites: the art of the past they admired and sought to emulate. That is why Rossetti's trip to the Continent was to have such lasting influence on his work. He and Hunt each sold paintings in 1849, and with the proceeds they embarked for Paris on September 27, then went on to Brussels, Antwerp, Ghent, and Bruges for an orgy of picture viewing. Writing home to his brother in a letter of October 4, 1849, Rossetti praised the work of Paul Delaroche, Joseph-Nicolas Robert-Fleury, Hippolyte-Jean Flandrin, Jean-Auguste-Dominique Ingres, Ary Scheffer, and François-Marius Granet, and mentioned Delacroix and Théodore Géricault. At the Louvre he admired works by van Eyck, Leonardo da Vinci, a copy of a fresco by Fra Angelico, Titian, and "several wonderful Early Christians whom nobody ever heard of, {and} some tremendous portraits by some Venetian whose name I forget."[15] A second visit to the Louvre produced raves about a wonderful head by Raphael, the *Concert Champêtre* by Giorgione, and *Ruggiero and Angelica* (1819) by Ingres.[16] Works in the Louvre by Mantegna, Giorgione, and Ingres inspired several poems by Rossetti.

In Brussels, Hunt and Rossetti saw works by van Eyck and Peter Paul Rubens, and in Bruges they encountered works by van Eyck and Memling at the Hospital of Saint John and at the Royal Academy.[17] In Ghent they discovered more work by van Eyck, especially the monumental Ghent altarpiece of 1432 in the church of Saint Bavon. The works that interested the young artists generally had an emphasis on line, glowing colors, minutely rendered detail, and crowded compositions set in a fairly shallow space—characteristics already evident in the Pre-Raphaelite style.

It has been said, with a certain amount of truth, that the Pre-Raphaelite Brotherhood had little real knowledge of artists before Raphael; but there were a number of Flemish and Italian paintings in British public and private collections that Rossetti would have seen. At the National Gallery, which opened in 1838, could be seen van Eyck's *Arnolfini Wedding Portrait* (1434), a Giovanni Bellini, a Perugino, two Francesco Francias, and Lorenzo Monaco's *Coronation of the Virgin*. Numerous line engravings were available, as were reproductions in such books as Alexander Lindsay's *Sketches of the History of Christian Art* (1847); Anna Jameson's *Sacred and Legendary Art* (1848), which Rossetti owned;[18] and publications by the Arundel Society, founded in 1848.

The first work to be exhibited as a Pre-Raphaelite painting, bearing the mysterious initials *PRB*, was Rossetti's *Girlhood of Mary Virgin* (plate 34), accompanied by two explanatory sonnets. It was shown at the third annual *Free Exhibition*, Hyde Park Corner Gallery, which opened

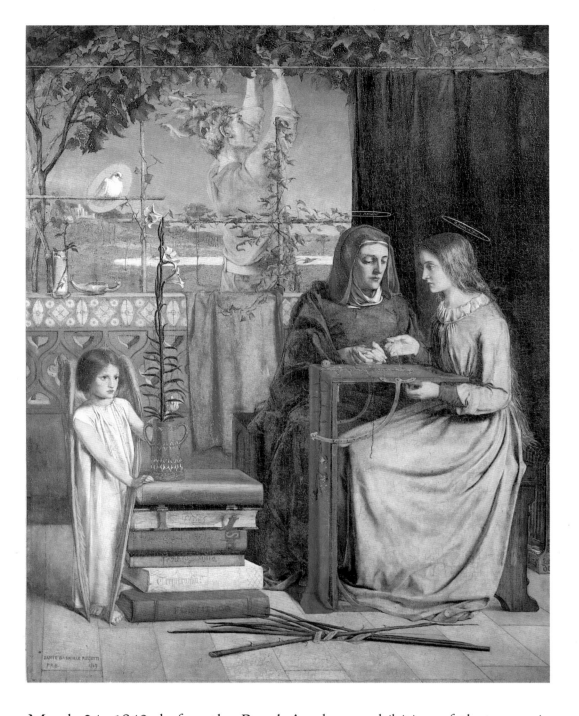

Left
34. The Girlhood of Mary Virgin, 1848–49
Oil on canvas, 32¾ x 25¾ in.
Tate Gallery, London

35. Canticum canticorum
(detail of Folio VIr, IB46), 1465
Woodcut, 9⅞ x 7¼ in.
The British Library, London

March 24, 1849, before the Royal Academy exhibition of that year, in which Hunt and Millais showed their own PRB paintings. The unjuried *Free Exhibition* was Rossetti's first public exhibition; he had probably feared rejection by the Academy's selection committee. His first mentor, Ford Madox Brown, had shown his own work at earlier *Free Exhibitions*, which set a precedent for the younger artist.

The Girlhood of Mary Virgin is an unusual image, in subject, setting, and symbolism. Although the Virgin's mother, Saint Anne, is shown super-vising her daughter's embroidery, this is not one of the traditional Educa-

tion of the Virgin scenes familiar in art from Giotto on.[19] Rossetti used his mother as a model for Saint Anne and his sister Christina for Mary. A handyman, Old Williams, took the part of Saint Joachim tending the grapevine in the background. As in Millais's *Christ in the Carpenter Shop* (plate 36), ordinary people are shown in an ordinary setting, suggesting the humble origins of the Holy Family. Both Millais and Rossetti may have been influenced in subject matter by John Rogers Herbert's *Our Savior Subject to His Parents at Nazareth*, shown at the Royal Academy in 1847 and now at the Guildhall Art Gallery, London.

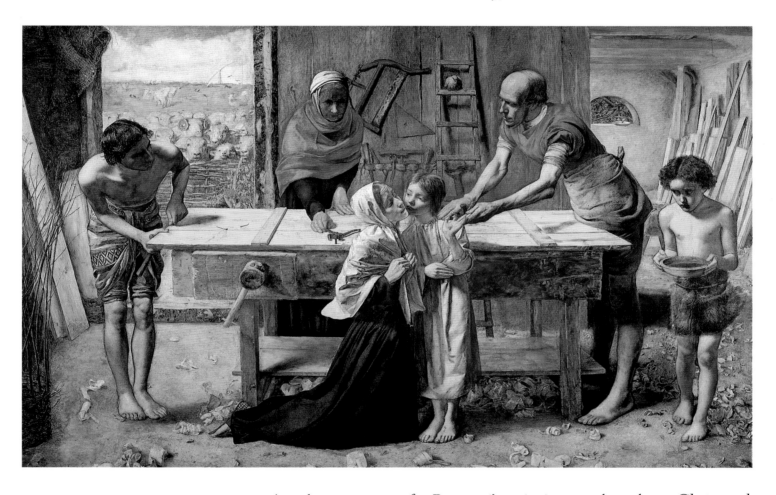

36. John Everett Millais (1829–1896)
Christ in the Carpenter's Shop
(Christ in the House
of His Parents), *1850*
Oil on canvas, 34 x 55 in.
Tate Gallery, London

Another prototype for Rossetti's painting may have been *Christ and Mary before a Grape Arbor*, a woodcut from the block book *Canticum canticorum* of 1465 (plate 35), which he could have seen in the British Museum.[20] In the woodcut, as in the painting, Christ and Mary are seated in front of a grape arbor, an unconventional setting for such a scene. The grapevine suggests Christ's sacrifice as symbolized by the wine of the Eucharist and exemplifies Rossetti's use of biblical typology to foreshadow events. A number of other details carry symbolic meaning. The books on the left are bound in the colors traditionally associated with certain virtues:

white for Temperance, red for Fortitude, blue for Faith, green for Hope, and gold for Charity; these hues also refer to those of High Church ecclesiastical vestments and altar decorations. The dove represents the presence of the Holy Spirit, the red robe beneath the cruciform trellis foretells Christ's passion, the rose and the lily are symbols of the Madonna, and the palms and thorny branch in the foreground refer to Christ's martyrdom.

Such abundance of symbolic detail was characteristic of Pre-Raphaelite painting. It established a very specific sense of place and time; and, as in Flemish fourteenth- and fifteenth-century painting, it reinforced the significance of the event taking place. For Victorian spectators, the proliferation of detail also testified to the artist's hard work and technical expertise, satisfying a counting-house mentality that delighted in the accumulation of material goods.

The Girlhood of Mary Virgin—produced under Hunt's tutelage in the Cleveland Street studio shared by the two artists—was painted in oil on a white ground with watercolor brushes. As in many of Rossetti's early paintings, his ambition outran his mastery of his craft. The complicated composition gave him hours of anguish, and he had great difficulty with the perspective of the background. When he applied to Brown for advice on his problems with the Virgin's drapery, the older artist described him as being in "an almost maudlin condition of profanity. . .lying howling on his belly in my studio."[21]

The Girlhood of Mary Virgin was singled out by several reviewers for notice among the five hundred paintings in the exhibition. The *Art Journal* of April 1849 (page 147) noted: "The picture is the most successful as a pure imitation of early Florentine art that we have seen in this country. The artist has worked in austere cultivation of all the virtues of the ancient fathers." The *Athenaeum* review of April 7, 1849 (page 362), read: "It is pleasant to turn from the mass of the commonplace to a manifestation of true mental power, in which art is the exponent of some high aim Such a work is . . . from one young in experience—new to fame—Mr. G. D. Rossetti. He has painted *The Girlhood of Mary Virgin*, a work which for its invention and for many parts of its design would be creditable in any Exhibition."

The Girlhood of Mary Virgin was purchased for eighty pounds by the Dowager Marchioness of Bath, a lady of High Church sympathies (Rossetti's aunt and frequent source of funds, Charlotte Polidori, was a governess and later a companion for her family). The marchioness had initially offered sixty pounds, but Rossetti shrewdly stuck to his catalog price and

42. *Lorenzo Ghiberti and workshop*
East doors of the Florentine Baptistery,
1425–52

a Lute (from Shakespeare's *Richard III*, act 1, scene 1). This had then evolved into a representation of the Borgia family, with Fanny Cornforth as the model for Lucrezia, surrounded by her father, Pope Alexander VI, and her brother Cesare.[33]

Rossetti also sought subject matter in the works of Dante, which were almost Holy Writ in the Rossetti family. One of the earliest results of his search was a pen-and-ink drawing, *The Salutation of Beatrice* (plate 41), done in 1849–50. It depicts, at left, Dante's meeting with Beatrice on earth (*La Vita nuova*, canto 3) and, at right, their meeting in Eden (*Paradise*, canto 30). The two scenes are divided by a narrow central panel with an angel holding a sundial whose shadow falls on nine, the hour when Beatrice died, on July 9, 1290. The source for the unusual format of two square panels divided by a narrow one may be a plaster cast of Lorenzo Ghiberti's east doors of the Florentine Baptistry (plate 42), which Hunt saw Rossetti drawing as a student at the Royal Academy.[34] The angularity of Rossetti's drawing also suggests a stylistic source in Carlo Lasinio's engravings of the Campo Santo, Pisa, so beloved by the Pre-Raphaelite Brotherhood. It most resembles the *Maledizione di Cam* (plate 29) in terms of division of space and elements of composition: both works have an

arched porch on the left, upright vertical elements in the center, and a landscape area on the right.

In 1855 Rossetti painted *Beatrice Meeting Dante at a Marriage Feast, Denies Him Her Salutation* (plate 43). It was one of Rossetti's first watercolors, possibly the very first, in which he combined bright greens and blues,[35] complemented by the red of Dante's robe and the gold dress of the little girl offering him a flower.

Rossetti projected ten illustrations to Dante's *Vita nuova*, as he wrote to his godfather on November 14, 1848,[36] although he did not do them all. And his most successful one, *The First Anniversary of the Death of Beatrice* (plate 44), was not on that list. It shows Dante drawing a picture of an angel in memory of Beatrice. The watercolor illustrates the pas-

45. Albrecht Dürer (1471–1528)
The Birth of the Virgin, c. 1502–3
Woodcut, 11⅝ x 8¼ in. (image)
Museum of Fine Arts, Boston

sage from *La Vita nuova* translated by Rossetti as "On that day on which a whole year was completed since my lady had been born into the life eternal, I betook myself to draw the resemblance of an Angel upon certain tablets." He is interrupted by visitors, who try to comfort him. The model for the young woman was Elizabeth Siddal, whom Rossetti had met in late 1849 or early 1850. Old Williams was the model for the elderly man, and Dante's features are probably taken from William Rossetti.

One of Rossetti's finest watercolors of this period, it captures the play of sunlight in the interior and contrasts the dark gown of Dante with the glowing reds of the window curtain, the red mantle of the elderly gentleman, and the red wall in the background. Details of the interior suggest Northern sources: the mirror may have been taken from Memling's *Virgin and Child* in the Bruges Academy, which Rossetti saw in 1849, and the fan-shaped brush, towel, basin, and round cistern in the left background may have come from Dürer's *Birth of the Virgin* (plate 45), a woodcut from his Life of the Virgin series, published in 1511.[37]

46. Giotto Painting the Portrait of Dante,
c. 1859
Watercolor and pencil on cream paper,
18 x 21¾ in.
The Harvard University Art Museums
(Fogg Art Museum),
Cambridge, Massachusetts;
Bequest of Grenville L. Winthrop

Below
47. Giorgione Painting, *c. 1853*
Pen and brown ink and ink wash
on paper, 4⅜ x 7 in.
Birmingham City Museum and Art Gallery,
Birmingham, England

Right
48. Fra Angelico Painting, *c. 1853*
Pen and brown ink and ink wash
on paper, 7 x 4⅜ in.
Birmingham City Museum and Art Gallery,
Birmingham, England

Rossetti did a series of drawings at this time of artists painting. The first of these, *Giotto Painting the Portrait of Dante*, was done in 1852, and he returned to the subject about 1859 in another watercolor (plate 46). Rossetti described the 1852 watercolor in a letter to Thomas Woolner of January 8, 1853: "The main incident is that old one of mine, of Giotto painting Dante. . .with the figures of Cimabue, Cavalcante, Beatrice, and some other ladies. . . . I have thus all the influences of Dante's youth—Art, Friendship and Love—with a real incident embodying them."[38] In the 1859 version only three figures appear: Giotto at right, Dante in red in the center, and a man in a dark green tunic on the left.[39] Two pen-and-ink-and-wash drawings of about 1853, *Fra Angelico Painting* (plate 48) and *Giorgione Painting* (plate 47), are less complete in conception but are interesting as celebrations of two of Rossetti's artist heroes and as glorifications of the role of the artist.

In 1853 Rossetti paid homage to Sir Henry Taylor's *Philip van Arte-velde* (act 5, scene 1) in a pen-and-ink drawing entitled *Hesterna Rosa* (plate 49); he did a watercolor of the same scene in 1865. Hesterna Rosa ("yesterday's rose") is the woman on the left, turning her head in shame and weariness. The ape on the far right—generally a symbol of sin or lust and certainly appropriate to this scene of an orgy—may have been taken from

49. Hesterna Rosa, *1853*
Pen and ink on paper, 7½ x 9¼ in.
Tate Gallery, London

Dürer's engraving of about 1497–98, *The Virgin with the Monkey*, where the monkey in chains represents sin overcome.

The theme of the fallen woman was to be treated in a modern setting in Rossetti's *Found* (plate 52), which he began drawings for in 1853 (plate 50). *Found* is perhaps *the* problem picture of Rossetti's career. He had thought of painting this subject even before he did the first drawing and had started a poem on the subject, *Jenny*, as early as 1846. The painting was commissioned by Francis MacCracken in 1854, then given up in 1855, partly, as Rossetti wrote to Hunt on January 30, 1855, because he was afraid it would be seen "to follow in the wake of your 'Awakened Conscience,'"[40] even though he had begun working on the idea before Hunt's painting was exhibited at the Royal Academy in 1854. Rossetti took up the painting again in November 1859 for his patron James Leathart, at which time the head of Fanny Cornforth was probably painted in.[41] It was again abandoned by Rossetti in 1867, only to be commissioned anew by William Graham in 1869; Rossetti worked on it sporadically, but never finished it.

The subject of the painting is the plight of the fallen woman, a common theme in Victorian novels, poems, and plays. The woman with her face to the wall has come to the city to make her fortune; failing to support herself (a very common occurrence), she has been degraded into prostitution. The farmer bringing his calf to market finds his former fiancée and tries to reclaim her, but she responds, in the words of the Rossetti poem on the painting, "Leave me—I do not know you—go away!" At the bottom of the first drawing on the subject is the inscription "I remember thee: the kindness of thy youth, the love of thy betrothal," from Jeremiah 2:2. Also on

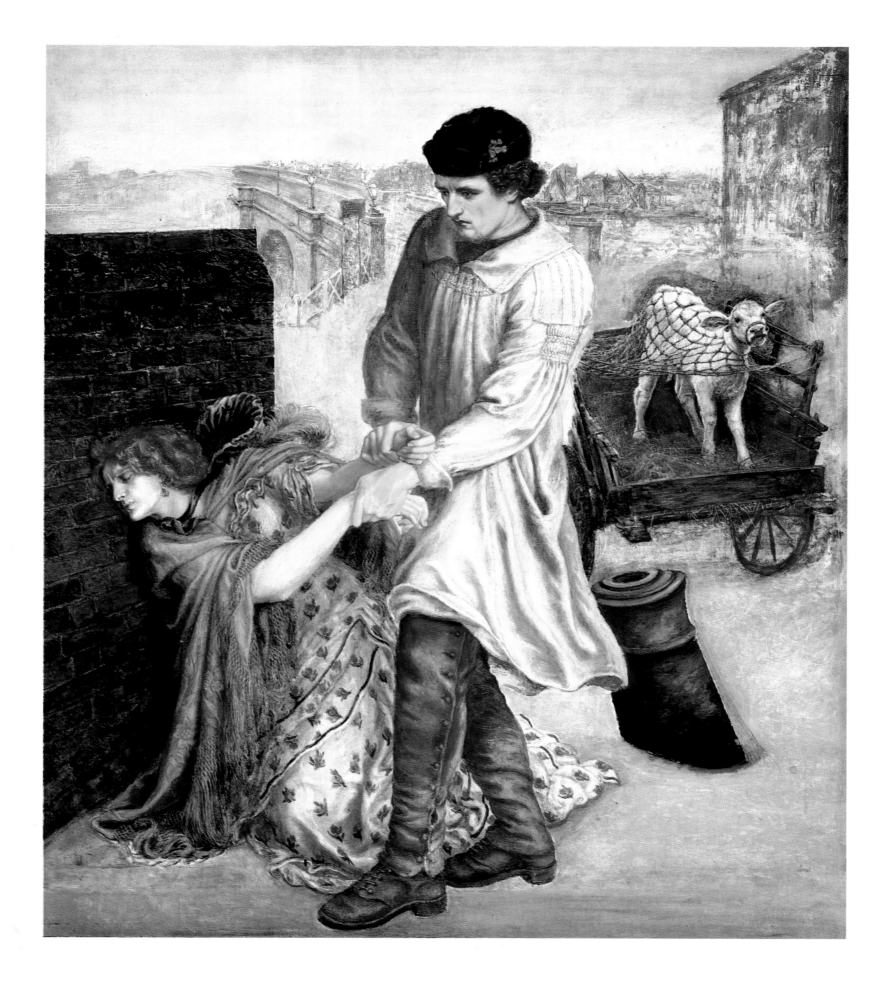

that drawing is an inscription on a tombstone above the brick wall in the graveyard (eliminated from the final painting), which reads, "There is joy. . . .The Angels in he. . .one sinner that," referring to Luke 15:7 and 10, regarding the joy in heaven over one sinner who repents.

The minute painting of the wall was done in Chiswick in October 1854, and the netted calf, in Finchley in November and December of the same year. Rossetti wrote of his problems in painting the calf: "As for the calf, he kicks and fights all the time. . .and the view of life induced at his early age by experience in art appears to be so melancholy that he punctually attempts suicide by hanging himself at 3½ daily p.m."[42]

The model in the painting was Fanny Cornforth (née Sarah Cox), who was born in Steyning, Sussex, in 1824. Her first meeting with Rossetti has been variously dated to 1846, 1854, and 1856; she herself said she met Rossetti about 1856. Her first securely dated appearance in one of his paintings is in *Bocca Baciata* (plate 159), begun in 1858 and finished the next year. It may be presumed that she entered Rossetti's life after 1853, as she does not appear in the first drawing of *Found*, done that year. She was an appropriate model for the fallen woman, for she was Rossetti's mistress-"housekeeper" on and off for years. They separated in 1860—the year of his marriage to Elizabeth Siddal and hers to Timothy Hughes—then were reunited after the deaths of their spouses; Cornforth left him in 1879 to marry John Bernard Schott. She managed to appropriate a number of his paintings and drawings, as well as other objects that took her fancy, and she was thoroughly disliked by several of Rossetti's friends and assistants. However, she has had her defenders: "She amused and satisfied a part of him which craved and found no satisfaction elsewhere. She appealed to his hearty good humor and love of robust jocularity. She was the perfect antidote to his Gothic fancies, his sighing after blessed damsels in abstract heavens, for she was real—flesh and blood. She was a relief from the strains of artistic creation."[43]

Rossetti wrote to William Graham on May 5, 1879, "I referred to it {*Found*} above as one without which I should not attempt an exhibition on account of its *furnishing* a refutation (I trust) to what is so often alleged against poetic painting such as I follow commonly to the best of my ability,—I mean the charge that a painter adopts the poetic style simply because he cannot deal with what is real and human."[44] However, since he was never able to finish the work, it may be conjectured that the accusation was, in part, accurate. There was another force at work as well: the ambivalence of Rossetti's feelings about the subject of the painting and

how it could be interpreted. Unlike many of his contemporaries, Rossetti was quite aware that for every fallen woman there must be a fallen man, as his poem *Jenny* makes quite clear:

> *Yet, Jenny, looking long at you,*
> *The woman almost fades from view,*
> *A cipher of man's changeless sum*
> *Of lust, past, present and to come.*

His friend Thomas Hall Caine testified to Rossetti's attitude: "For the poor women themselves, who, after one false step, find themselves in a blind alley in which the way back is forbidden to them, he had nothing but the greatness of his compassion. The pitiless cruelty of their position often affected him to tears."[45] It moved him to acts of charity as well: it was not unusual for Rossetti to drop all the coins in his pocket into the lap of a woman begging or sleeping in the street.

Linda Nochlin, in her article "Lost and *Found*: Once More the Fallen Woman," has interpreted the painting as Rossetti's comment on being an artist as well: "In this light, the fallen 'fair woman' might be considered . . . an aspect of the artist himself. . . . Rossetti made explicit the analogy between an artist and a prostitute in a letter to Ford Madox Brown of 1873: 'I have often said that to be an artist is just the same thing as to be a whore, as far as dependence on the whims and fancies of individuals is concerned.'"[46]

CRITICISM, SUCCESS, AND DISSOLUTION

A rt critics and others continued to be remarkably pugnacious in their abuse of the Pre-Raphaelite Brotherhood. The *Athenaeum* of May 22, 1852, commented: "Mr. Hunt, who has an 'oath in heaven' to tell 'the whole truth and nothing but the truth,' carries anti-eclecticism to the absurd. Like Swift, he revels in the repulsive. These rustics are of the coarsest breed—ill favoured, ill fed, ill-washed." *Punch* reviewed Millais's *Christ in the Carpenter's Shop* (plate 36) under the title "Pathological Exhibition at the Royal Academy (noticed by Our Surgical Advisor)" and concluded, "It will be a pity if this gentleman does not turn his abilities—which, in a mechanical way, are great—to the illustration of COOPER's Surgical Dictionary and leave the testament alone."[1] Charles Dickens, in his famous article "Old Lamps for New Ones" in the June 15, 1850, issue of *Household Words*, jovially called for a Pre-Newtonian Brotherhood not bound by the laws of gravity, a Pre-Galileo Society of those refusing to revolve around the sun, and a Pre-Chaucer Brotherhood opting for an ancient style of spelling.

The criticism was so cutting that several of the young artists could not sell their paintings, and Rossetti, failing to find a buyer for *"Ecce Ancilla Domini!" (The Annunciation)* (plate 39), actually looked into getting a job as a railroad telegrapher in 1851. As his brother remarked, "Luckily for all parties concerned—including maybe the railway passengers—it very rapidly

53. The Meeting of Dante and Beatrice
in Paradise, 1853–54
Watercolor on paper, 11½ x 9⅞ in.
Fitzwilliam Museum, Cambridge, England

came to nothing."[2] Hunt and Millais did something more practical: they asked their friend Coventry Patmore to enlist the aid of John Ruskin, the most influential art critic of the day. In the summer of 1847 Hunt had read Ruskin's *Modern Painters* and had been deeply influenced by it. Years later he commented in a letter to Ruskin of November 7, 1880: "All that the Pre-Raphaelite Brotherhood had of Ruskin came from this reading of mine. Rossetti was too absorbed with Dante . . . and Millais never read anything, altho' he had a real genius in getting others to tell him the results of their reading and their thoughts thereon."[3]

The works of Millais and Hunt at the Royal Academy exhibition of 1851 were pointed out to Ruskin by William Dyce, a member of the Academy who was friendly to the Pre-Raphaelite Brotherhood. Ruskin came to the artists' defense, even though he knew none of them personally (he did not meet Rossetti until 1854), by writing two letters to the *Times* on May 13 and May 30, 1851, which were printed as a pamphlet in August of that year. He also offered to buy Millais's *Return of the Dove to the Ark* (it was already sold to Thomas Combe; now in the Ashmolean Museum) and found a buyer for Hunt's *Two Gentlemen of Verona* (Birmingham City Museum and Art Gallery). In his letter of May 13 Ruskin wrote, "The mere labour bestowed on these works, and their fidelity to a certain order of truth (labor and fidelity which are altogether indisputable), ought at once to have placed them above the level of mere contempt. . . ." Defending them against the charge of rendering perspective incorrectly, he continued, "There is not one single error in perspective in four out of the five pictures in question . . . and I will undertake, if need be, to point out and prove a dozen worse errors in the perspective in any twelve pictures, containing architecture, taken at random from among the works of popular painters of the day." He concluded his letter of May 30 by saying, "I wish them all heartily good-speed, believing in sincerity that if they temper the courage and energy which they have shown in the adoption of their systems with patience and discretion . . . they may, as they gain experience, lay in our England the foundations of a school of art nobler than the world has seen for 300 years."

Ruskin continued to defend the PRB, as in his influential "Lectures on Architecture and Painting," delivered at Edinburgh in November 1853:

> *I thank God that the Pre-Raphaelites are young and that strength is still with them and life, with all the war of it, still in front of them. Yet Everett Millais, in this year, is of the exact age at which Raphael*

Viola in his painting *Twelfth Night* (plate 58). (She is the figure in the red tunic at far left—Viola disguised as a page; Deverell portrayed himself as Duke Orsino and Rossetti as the jester Feste singing on the right.) Rossetti probably met Siddal at Deverell's studio the next day. Rossetti as Feste in the painting was shown singing:

> *Come away, come away, death,*
> * And in sad cypress let me be laid.*
> *Fly away, fly away, breath,*
> * I am slain by a fair cruel maid.*
> * (Twelfth Night, act 2, scene 4)*

Deverell's choice of verse to illustrate seems to prefigure his own early death in 1854 and the fateful conjunction of love and death in Rossetti and Siddal's relationship.

William Rossetti described Elizabeth Siddal as

> *a most beautiful creature, with an air between dignity and sweetness . . . tall, finely-formed, with a lofty neck, and regular yet somewhat uncommon features, greenish-blue unsparkling eyes, large perfect eyelids, brilliant complexion, and a lavish heavy wealth of coppery-golden hair. . . . She seemed to say—"My mind and my feelings are*

my own, and no outsider is expected to pry into them." That she had plenty of mind is a fact abundantly evidenced by her designs and water-colours and by her verses as well. Indeed, she was a woman of uncommon capacity and varied aptitude.[14]

Siddal became the favorite model of the Pre-Raphaelite Brotherhood, posing for Hunt's *A Converted British Family Sheltering a Christian Missionary* (1850) and for Sylvia in his *Valentine Rescuing Sylvia from Proteus* (1850–51, Birmingham City Museum and Art Gallery). She served as the model for Millais's *Ophelia* (plate 59), one of his finest paintings. To recreate the effect of the drowning woman, Millais had Siddal pose fully clothed in a bathtub of water heated by lamps; the lamps went out during the course of the sitting and Siddal contracted a severe cold. Millais saw Siddal as the perfect model for Ophelia; and Siddal herself wrote a poem, *A Year and a Day* (1855–57), in which she appears to identify with Ophelia:

The river ever running down
Between its grassy bed
The voices of a thousand birds
That clang above my head
Shall bring me to a sadder dream
When this sad dream is dead.[15]

Millais testified that by the time he was painting *Ophelia*, "D. G. Rossetti had already fallen in love with her, struck with her 'unworldly simplicity and purity of aspect.'"[16] William thought they were engaged by 1852.[17]

Siddal first sat for Rossetti for the preparatory sketches made in 1851 for his watercolor *The Return of Tibullus to Delia* of about 1853.[18] Whether Rossetti got the idea for the pose from seeing Siddal assume this attitude naturally or whether he positioned her this way intentionally is not known, but the resulting drawing (plate 60) is extraordinarily erotic. A beautiful and evocative piece of draftsmanship, the drawing has a purity of form and delicacy of modeling that make it more successful than the resulting watercolor. (The pose may later have inspired Rossetti's oil *Beata Beatrix*, plate 147.) Rossetti also used Siddal as a model for Ophelia in several drawings; he did not show her alone, as in the Millais painting, but with the figure of Hamlet, who seems to be imploring her as she turns away from him.

Rossetti claimed Siddal as his main model from 1852 on, and he sent out clear signals that he wanted no competition (as he was to do with all his primary female models). In Siddal's case, however, this was more than a business arrangement between painter and model. Not only was she his

model in many works between 1852 and 1862, but she also became a colleague as artist and as writer.

In August 1852 Siddal was reported to be doing her first art work, and soon she was working on her own compositions in the studio that Rossetti took on November 22, 1852, at 14 Chatham Place.[19] In January 1853 she started her first drawing to be completed, *We Are Seven* (location unknown; from a poem by William Wordsworth), and on August 25, 1853, she was beginning a picture from Tennyson and a self-portrait (private collection).[20] On December 15 she completed her first subject from Tennyson, *The Lady of Shalott* (plate 61). This drawing, probably the first

finished drawing by any Pre-Raphaelite on a theme from Tennyson, is highly significant. William Rossetti reported that Tennyson was Siddal's favorite poet and that she had discovered his poems on a piece of paper used to wrap butter.[21] Her drawing of the Lady of Shalott may have influenced Hunt's choice of this poem to illustrate for Edward Moxon's *Tennyson*. Siddal's rendition of the Lady of Shalott is the only Pre-Raphaelite image of this poem to show a correct weaving technique, with the upright loom reflected in a round mirror so that the pattern, which is woven from the wrong side, can be seen by the weaver. (Her metaphor of the artist as weaver was to become a potent one for the Pre-Raphaelites, especially Hunt.) The crucifix in Siddal's *Lady of Shalott*, placed between the weaver

Left
61. Elizabeth Siddal (1829–1862)
The Lady of Shalott, *December 15, 1853*
Pen and black ink and sepia ink and
pencil on paper, 6½ x 8¾ in.
Jeremy Maas

Opposite, left
62. Elizabeth Siddal (1829–1862)
Saint Cecily and the Angel, *n.d.*
Pen and black ink on paper
Private collection

Opposite, right
63. Elizabeth Siddal (1829–1862)
Lady Clare, *n.d.*
Pen and sepia ink on paper,
approximately 7 x 5 in.
Fitzwilliam Museum, Cambridge, England

and the natural world viewed through the window, may signify the sacrifice of the artist in creating a work of art.

From 1853 on Siddal worked on a number of drawings after Tennysonian themes, including sketches for *Jephthah's Daughter* (taken from Tennyson's *A Dream of Fair Women*, first published in 1842) and several drawings on the subject of King Arthur and the weeping queens from Tennyson's *Palace of Art*. Her sketch showing three figures in a boat (Ashmolean Museum) may have given Rossetti the idea for his illustration of the same subject for Moxon's *Tennyson*. Siddal did a number of drawings on the theme of Saint Cecily and the angel (plate 62) from Tennyson's *Palace of*

Art, which may have influenced Rossetti's portrayal of the saint's pose. She also made several representations of Tennyson's *Lady Clare* (plate 63), probably between 1853 and 1857. The subject is a marriage between a noble lord and a poor girl—rather pertinent to the Rossetti-Siddal relationship. The preliminary sepia drawing shows an assured grasp of composition, the figures not elongated as in the watercolor version.

Another theme from Tennyson inspired Siddal's *Saint Agnes' Eve*, which exists in two versions dated 1856, one an ink drawing (Ashmolean Museum) and the other a gouache (National Trust, Wightwick Manor, Wolverhampton, England). Siddal cooperated with Rossetti on *Sir Galahad at the Shrine of the Holy Grail*, a watercolor of about 1855–57, now in

a private collection. The inscription reads "EES inv. EES & DGR del.," which means that the composition was invented or created by Siddal and executed by Rossetti and her. In this connection, it is interesting to note that Rossetti took this subject to illustrate for the Moxon *Tennyson* and later did a watercolor of it as well. The angel on the right bears a striking resemblance to Siddal herself.

In 1853–54 Siddal painted a self-portrait in oil in tondo (round format) against a dark background (private collection, England), which has a haunting charm. In 1854 she produced several finished drawings, including *Two Lovers* (plate 64) and *Pippa Passes* (Ashmolean Museum), the latter from the poem by Robert Browning. The figures are emphatically linear, very typical of Pre-Raphaelite drawing conventions.

Siddal created representations of a number of ballads, including *Sir Patrick Spens* (plate 65) and *Clerk Saunders* (plate 66), which she did several versions of in 1857, as well as *The Lass of Lochroyan*, the *Gay Gosshawk* (1854, private collection), and Rossetti's own ballad, *Sister Helen* (1854, private collection). These may all have been intended as illustrations to a proposed book of ballads by William Allingham. *Sir Patrick Spens* shows

64. *Elizabeth Siddal (1829–1862)*
Two Lovers, *1854*
Pen and brown ink on paper,
9⅜ x 11¾ in.
Ashmolean Museum, Oxford, England

80

women waiting by the sea in an expressive composition of jewellike colors. *Clerk Saunders* illustrates a rather gruesome story of a young man who made love to a girl, was killed by her brothers, and then appeared to her as a ghost. The composition was first planned as a woodcut for Allingham's book, and the watercolor was exhibited at *The Pre-Raphaelite Exhibition* of 1857. Siddal's version unerringly captures the doleful dirge of the ballad. Of this work, Rossetti wrote appreciatively to Brown in a letter of May 23, 1854, "Her power of designing even increases greatly, and her fecundity of invention and facility are quite wonderful, much greater than mine."[22]

During her decade as an artist Siddal produced over one hundred paintings and drawings, working in oil, watercolor, gouache, pen, and pencil. She was essentially self-taught, with tutelage from Rossetti early on and classes at the School of Art in Sheffield in 1857.[23] Many of her preliminary sketches are crude or awkward, but her finished works have great

imagination and evocative power. She was obviously influenced by Rossetti, but in certain cases, especially her works from Tennyson, her ideas influenced him. Algernon Charles Swinburne commented on her originality of style, adding, "Gabriel's influence and example {were} not more perceptible than her own independence and freshness of inspiration."[24] Christina Rossetti's poem of 1856 best sums up Siddal's importance to Dante Gabriel Rossetti:

One face looks out from all his canvases
One selfsame figure sits or walks or leans:
We found her hidden just behind those screens,
That mirror gave back "all her loveliness"
A queen in opal or in ruby dress,
A nameless girl in freshest summer-greens,
A saint, an angel—every canvas means
The same one meaning, neither more nor less.

He feeds upon her face by day and night,
And she with true, kind eyes looks back on him,
Fair as the moon and joyful as the light;
Not wan with waiting, nor with sorrow dim;
Not as she is, but was when hope shone bright;
Not as she is, but as she fills his dream.

FOUR

MEDIEVALISM

67. *Detail of* Saint George and
Princess Sabra, *1862*
See plate 87

uring the 1850s the most avant-garde movement in Victorian England could be called a "progress into the past": the revival of medievalism in literature, religion, architecture, and the decorative and fine arts. Like all nineteenth-century attempts at reconstructing the past, this was essentially a new creation, using an imaginary past to comment on an all-too-real present. The Middle Ages created by the Pre-Raphaelites, Tennyson, and others never existed except in the nineteenth-century imagination. It provided an escape from a material to a spiritual realm, a glorification of collaborative efforts in an era preoccupied with the survival of the fittest, an image of an ordered society in a time of social disorder, a romantic vision of glowing colors and fantastic raiment to outshine the drabness of Victorian fashion. Medievalism's manifestations were literary, in the highly influential novels of Sir Walter Scott and in the interest in ballads and tales of an earlier age; religious, in the Oxford Movement's revival of pomp and ritual; architectural, in the Gothic Revival, especially as promoted by Ruskin and A.W.N. Pugin; and artistic, in William Dyce's decoration of the Houses of Parliament and the paintings and illustrations by the Pre-Raphaelites.

There was a strong motivation to produce art that was authentic in its historical details. For example, Millais clambered up the scaffolding in Merton College Chapel to sketch medieval stained-glass windows for use in his *Mariana* (1851, Makins Collection). Hunt's painstaking search for

accuracy in his religious paintings sent him to the Holy Land; Rossetti, not much of a traveler, went only as far as the British Museum.

For Rossetti, medievalism provided a transition from material based on biblical sources to subjects from Dante, Malory, and Tennyson, which had religious overtones. That he made much of this material into representations of great love stories was due to his own interpretation and desires, not to the sources themselves. His view of the Middle Ages came from such early works as Sir Thomas Malory's *Morte d'Arthur* (1470), Dante's *Vita nuova* (c. 1293) and *Divine Comedy* (1321), French manuscripts of the *Romance of Lancelot du Lac*, Jean Froissart's fourteenth-century *Chronicles*, and old ballads from Thomas Percy's *Reliques of Ancient English Poetry* (1765). Some of his literary sources were modern: Sir Walter Scott's romances, Sir Henry Taylor's *Philip van Artevelde* (1834), Henry Wadsworth Longfellow's *Golden Legend* (1851), and poems by Keats, Tennyson, and Browning.

Rossetti's imagery also came from a number of pictorial sources, including medieval illuminated manuscripts, woodcuts, paintings, and other contemporaneous interpretations of the Middle Ages. His Continental tour with Hunt in 1849 furnished him with an encyclopedia of images that was augmented by long hours spent at the British Museum from 1847 on and by works in the National Gallery, Dulwich Collection, Bodleian Library, South Kensington Museum (founded in 1848), and a number of special exhibitions.[1] Illuminated manuscripts were also available to him from the private collections of John Ruskin (begun in 1850), William Burges, and William Morris.

Rossetti also used secondary sources, such as Lasinio's Campo Santo engravings; C. A. Stothard's *Monumental Effigies of Great Britain* (1817); Camille Bonnard's *Costumes historiques des XIIe, XIIIe, XIVe, et XV siècles* (1829–30), Arundel Society prints; reproductions from such books as Anna Jameson's *Sacred and Legendary Art* (1848), which Rossetti owned; and other art books by Ruskin, Alexis Rio, Lord Lindsay, Henry Shaw, and Henry Noel Humphreys.[2] Rossetti was also, of course, exposed to the strong medievalizing tendency in contemporary English paintings, particularly the designs entered in competition for the Houses of Parliament fresco commissions, which he saw in 1843, 1844, and 1845.[3]

Medieval illuminated manuscripts inspired certain stylistic conventions in Rossetti's works of the 1850s, such as the crowding of forms into a shallow space, the use of diapered backgrounds and elaborate patterns, the avoidance of classical perspective, the emphasis on jewellike colors, and

the wealth of symbolic detail. Many of his watercolors of this time are small, like their medieval prototypes, with angular, unidealized figures. He used manuscript illuminations and early prints as models for his figure types and poses, as well as for their costumes and accessories; he also used them as sources for his overall compositions and for the specific incidents he chose to portray. Illuminated manuscripts held a special fascination for him because of their relationship of words to images—a relationship of great interest to one who often wrote verses to accompany his paintings and took the subjects for his paintings from literary sources.

Arthur's Tomb (plate 68), Rossetti's watercolor of 1855, is usually seen as marking the start of his medieval period. The source of this subject was Robert Southey's translation of Malory's *The Byrth, Lyf and Actes of King Arthur,* published in 1817. The scene shown is the final parting of Lancelot and Guinevere after the death of Arthur, when Lancelot says, "For I take record of God in you have I had myn ertheley joye . . . whe for madame I praye you kysse me once and never more. . . . Nay sayde the quene that shal I never doo, but abstayne you from such thynges, and so

they parted."[4] The source makes no mention of a tomb, which was probably added by Rossetti to dramatize the lovers' final meeting. The sarcophagus has reliefs detailing the Temptation and Fall of Adam and Eve, and Lancelot's knighting by Arthur. It has been suggested that the reliefs are derived from a woodcut of the tomb of Adonis in the Aldine edition of *Hypnerotomachia Poliphili* (1499), which the young Rossetti frequently perused in the family library and later purchased for himself.[5] Another possible source, also in Rossetti's possession,[6] was Stothard's *Monumental Effigies of Great Britain*, which represents a number of medieval sarcophagi with recumbent figures of knights and ladies. A source for the pose of the figures may be a representation of the first kiss of Lancelot and Guinevere in some version of an early fourteenth-century *Lancelot du Lac*, a French illuminated manuscript now in the Morgan Library, New York, which Rossetti may have used in ironic contrast to their tragic parting. The brilliant colors resemble the glow of a manuscript illustration, as does the cramped and shallow space. The artist's translation of the fall of the Round Table into the love story of Lancelot and Guinevere has caused one modern commentator to remark drily, "Rossetti's Arthurian pictures and designs would give one the impression that Malory was a great erotic poet like Dante instead of a romancer idealizing chivalry."[7] John Ruskin purchased the watercolor in 1855 for twenty pounds, although Rossetti had originally asked only fifteen pounds for it.

Rossetti was also capable of borrowing from his contemporaries. *Francesca da Rimini* (plate 69), by his Pre-Raphaelite mentor and friend William Dyce, may have served as a model for Rossetti's *Paolo and Francesca da Rimini*. The placement and poses of Rossetti's two main figures, the open book, the joined hands, and the fervent kiss—both in the study in the British Museum (plate 70) and in the left panel of the Tate Gallery's watercolor (plate 71)—exactly duplicate Dyce's painting. Rossetti had seen Dyce's designs submitted to the Houses of Parliament competition and would have been attracted both by the medievalizing style and by the subject of his *Francesca da Rimini*, from canto 5 of Dante's *Inferno*. Rossetti's preliminary sketches show that he tried more than one pose before deciding on the one used by Dyce.[8] The choice of pose might have resulted from unconscious recollection, but the final paintings seem too close for mere coincidence. A possible literary source, besides Dante, may have been the play *Francesca da Rimini* (1815) by Silvio Pellico, which Rossetti saw in 1850, with the actress Adelaide Ristori in the leading role.[9] *Arthur's Tomb* and *Paolo and Francesca da Rimini* share the theme of illicit love:

Opposite, top left
69. William Dyce (1806–1864)
Francesca da Rimini, 1837
Oil on canvas, 56 x 69¼ in.
National Gallery of Scotland, Edinburgh

Opposite, top right
70. *Paolo and Francesca Study*, c. 1855
Pencil on paper, 8⅝ x 6¾ in.
The British Museum, London

Opposite, bottom
71. *Paolo and Francesca da Rimini*, 1855
Watercolor on paper, 9¾ x 17½ in.
Tate Gallery, London

when Paolo and Francesca kissed, they were reading about the love of Lancelot and Guinevere—"and then they read no more."

On September 27, 1855, Rossetti did a sketch, *Tennyson Reading "Maud"* (plate 72), at Robert and Elizabeth Barrett Browning's house at 13 Dorset Street, Marylebone; he made two copies of it (one of which is now lost) and gave the original to his host. That evening Browning read his poem *Fra Lippo Lippi* and Tennyson read *Maud*, complaining bitterly about how the reviewers had treated it. Rossetti had known Browning since 1851 and greatly admired both his and his wife's poetry. His portrait of Browning (plate 73), also from 1855, is more formal than his Tennyson sketch, but they share a youthful directness.

In 1854 Tennyson's publisher, Edward Moxon, decided to do an illustrated version of the writer's *Poems*, a collection originally published in 1842. On January 23, 1855, Rossetti wrote to his friend William Allingham: "The other day Moxon called on me, wanting me to do some blocks for the new Tennyson. The artists already engaged are Millais, Hunt, Landseer, Stanfield, Maclise, Creswick, Mulready, and Horsley. The right names would have been Millais, Hunt, Madox Brown, Hughes, a certain lady, and myself," obviously associating Elizabeth Siddal with the project.[10] He did five woodcuts for the book: two for *Palace of Art*; one for *The Lady of Shalott*, which he begged from Hunt, who had planned to do two on this theme; one each for *Mariana in the South* and *Sir Galahad*. All were medieval subjects, chosen so he could, as he put it, "allegorize on one's own hook on the subject of the poem, without killing, for oneself and everyone, a distinct idea of the poet's."[11]

The Tennyson illustrations were not Rossetti's first venture into woodcut design. In 1854 he had made several drawings of *The Maids of Elfen-mere*, one of which was engraved for Allingham's *Day and Night Songs* (plates 74, 75). The drawing seen here is a variant rather than the final version, but the comparison still makes clear the great difference between Rossetti's delicate draftsmanship and the harsh lines of the engraving done by the Dalziel Brothers, then the leading firm of wood engravers. Rossetti wrote to Allingham on March 17, 1855: "That woodblock! Dalziel has made such an incredible mull of it in the cutting that it cannot possibly appear."[12] He blamed the engraver for insensitivity to his design, but Edward Dalziel remarked, with some justice: "This drawing was a remarkable example of the artist being altogether unacquainted with the necessary requirements in making a drawing on wood for the engraver's purpose. In this Rossetti made use of wash, pencil, colored chalk, and pen and ink,

72. Tennyson Reading "Maud," *1855*
Pen and brown ink and black ink and
gray wash on paper, 8¼ x 6 in.
Birmingham City Museum and Art Gallery,
Birmingham, England

73. Robert Browning, *1855*
Watercolor on paper, 4¾ x 4⅛ in.
Fitzwilliam Museum, Cambridge, England

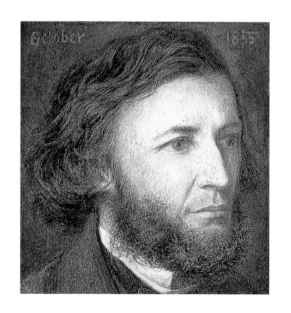

Left
74. The Maids of Elfen-mere *(Illustration*
to The Maids of Elfen-mere*), 1854*
Pencil and pen and ink on paper,
5 x 3¼ in.
Yale Center for British Art,
New Haven, Connecticut;
Paul Mellon Fund

Right
75. The Maids of Elfen-mere, *1857*
Wood engraving, 5 x 3 in. (image)
Museum of Fine Arts, Boston;
The John H. and Ernestine A. Payne Fund

Page 92, top left
76. *John Everett Millais (1829–1896)*
Saint Agnes' Eve, *1857*
Wood engraving, 3¾ x 2⅞ in. (image)
Museum of Fine Arts, Boston;
The John H. and Ernestine A. Payne Fund

Page 92, top center
77. *William Holman Hunt (1827–1910)*
Lady of Shalott, *1857*
Wood engraving, 4⅛ x 4⅛ in.
Museum of Fine Arts, Boston;
John H. and Ernestine A. Payne Fund

Page 92, top right
78. The Lady of Shalott, *1857*
Wood engraving, 3⁵⁄₁₆ x 3¹⁄₁₆ in.
Victoria and Albert Museum, London

producing a very nice effect, but the engraved production of this many-tinted drawing, reduced to the stern realities of black and white by printer's ink, failed to satisfy him."[13] Arthur Hughes, a Pre-Raphaelite follower and fellow illustrator, defended Dalziel: "He took a great deal of trouble, but Rossetti was as impatient as a genius usually is. He wanted to crowd more into a picture than it could hold"[14] (a not-uncommon Pre-Raphaelite failing and one shared with the crowded compositions of manuscript illuminations). Despite Rossetti's condemnation of the finished wood engraving, it was to be one of the most influential illustrations of the nineteenth century. It made a convert of the young Edward Burne-Jones, who called it the most beautiful illustration he had ever seen, and it was admired by a number of illustrators, including Hughes, Frederick Sandys, and Walter Crane.

Rossetti finally agreed to do woodblock illustrations for the Moxon *Tennyson* in 1856 and shrewdly managed to convince the publisher to give him thirty pounds for each illustration, rather than the twenty-five received by all the others. He was characteristically slow in upholding his side of the bargain, however; he was a year late in completing his work, thus delaying the whole book until delivery of his final illustration in February 1857. So frustrating was the whole enterprise that a rumor that "Rossetti killed Moxon" circulated when the publisher died soon after *Tennyson* finally appeared in 1857.

The artist had the same trouble with the Dalziels as before. He wrote to William Bell Scott in February 1857 that he had

> designed five blocks for Tennyson, some of which are still cutting and maiming. . . . After a fortnight's work my block goes to the engraver, like Agag, delicately, and is hewn to pieces before the—Lord Harry!
>
> Address to the D___l Brothers
> O woodman, spare that block,
> O gash not anyhow;
> It took ten days by clock
> I'd fain protect it now.
> Chorus, wild laughter from Dalziel's workshop.[15]

For Rossetti's *Lady of Shalott* (plate 78), he decided to go back to the earliest records of the story. In his search for the original, he discovered a *Lancelot du Lac* (Add MSS 10292, 10293, and 10294), which had been in the British Museum since 1836. Together the manuscripts contain 748 miniatures, dating from about 1316–20, and all from the same atelier, which was probably French.[16] One miniature (plate 80) shows Lancelot leaning over the body of "la damoisele de Scalot" in a pose that is undoubtedly the source of Rossetti's preliminary drawing for *The Lady of Shalott* (plate 79). Not only the poses of the principal figures but also the water in the background and the crowd of onlookers in the final version echo the organization of the fourteenth-century illustration. In using this as a source, Rossetti, in effect, went one step further than Tennyson in authenticity, as Tenny-

son's main source was Malory's book, first printed by William Caxton in 1485. Rossetti's Lancelot may have had a personal significance for him: the knight is shown gazing at the dead Lady of Shalott, just as Rossetti would gaze at beauty, especially feminine beauty, and transform it into art.

The manuscript in the British Museum suggested the composition for another of Rossetti's Moxon illustrations, *King Arthur and the Weeping Queens* (plates 82, 83) for *The Palace of Art*. Folio 91v (plate 81) tells "How the King's Knights put him down on earth" and shows a group of knights surrounding the recumbent Arthur. Rossetti's illustration is very similar to this composition; for example, the crowns of several of his queens borrow

Above
82. King Arthur and the Weeping Queens, *1857*
Wood engraving, 3¹⁄₁₆ x 3⅝ in.
Victoria and Albert Museum, London

❧

Right
83. King Arthur and the Weeping Queens, *1856–57*
Pen and brown ink on paper, 3¼ x 3⅝ in.
Birmingham City Museum and Art Gallery, Birmingham, England

❧

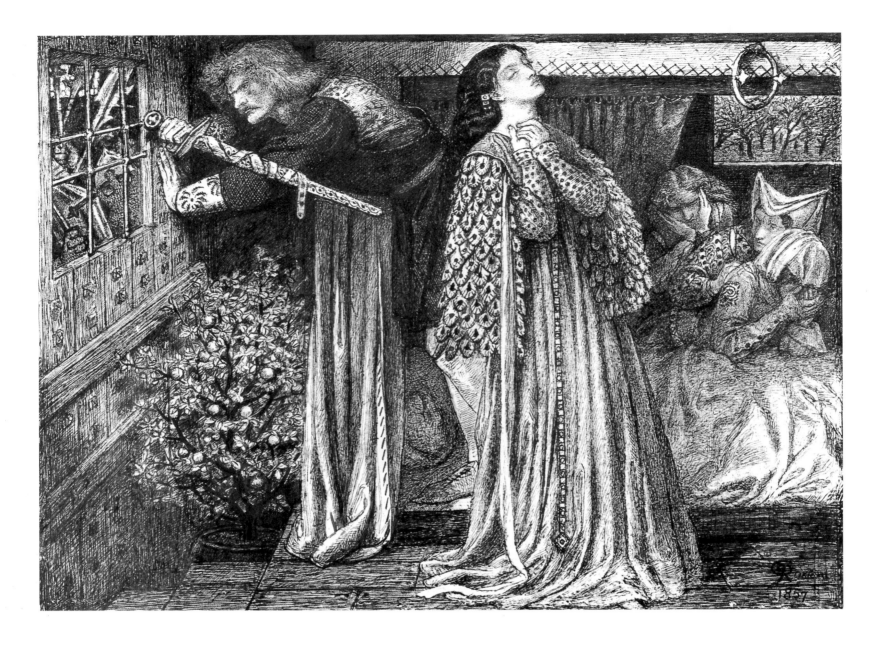

the cross and other details from Arthur's crown in the manuscript. Rossetti later used this manuscript for ideas for several other compositions. One of them was *Sir Launcelot in the Queen's Chamber* (plate 84), which relates to a miniature in which Lancelot kills a knight while the queen looks on anxiously (plate 85). Another of the miniatures (plate 86) shows a knight and a lady within a castle; it is very close in composition to Rossetti's watercolor *Saint George and Princess Sabra* (plate 87).

Although the Pre-Raphaelites tended to see themselves as Galahads questing for the Holy Grail, their lives more closely resembled that of Lancelot. Respectable Millais fell in love with Ruskin's wife; pious Hunt married his deceased wife's sister (against British law at that time); idealis-

Opposite, top
84. Sir Launcelot in the Queen's Chamber, *1857*
Pen and black ink and brown ink
on paper, 10¼ x 13⅜ in.
Birmingham City Museum and Art Gallery,
Birmingham, England

Opposite, bottom
85. Lancelot du Lac *(Folio 69v,*
Add MS 10294), c. 1316–20
The British Library, London

Above
86. Lancelot du Lac *(Folio 210v,*
Add MS 10293), c. 1316–20
The British Library, London

Right
87. Saint George and Princess Sabra, *1862*
Watercolor on paper, 20⅝ x 12⅛ in.
Tate Gallery, London

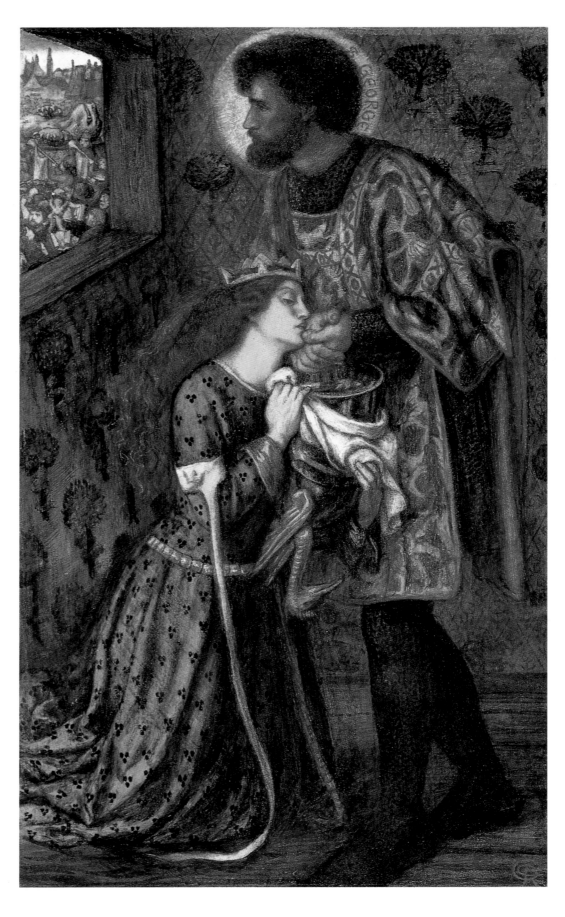

tic Rossetti conducted a liaison with his best friend's wife. Their romances echoed Lancelot's illicit passion for Guinevere in a most un-Victorian way.

One of Rossetti's most sensuous images for Moxon's *Tennyson* was his *Saint Cecilia* (plate 90) for *The Palace of Art*. It purportedly illustrates these lines:

> *Or in a clear-wall'd city on the sea*
> *Near gilded organ-pipes, her hair*
> *Wound with white roses, slept St. Cecily;*
> *An angel look'd at her.*

However, the angel is obviously doing more than looking. George Somes Layard described the angel as "a great voluptuous human being, not merely

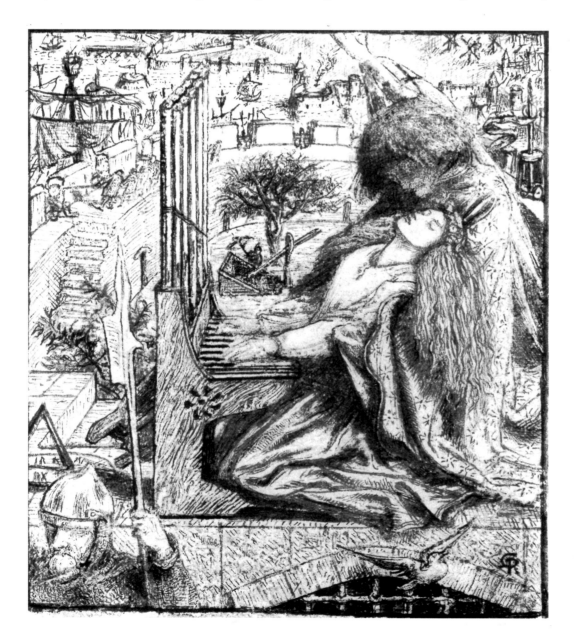

Above
88. Saint Cecilia, 1856–57
Pen and brown ink and black ink
on paper, 5 x 4 in.
Ashmolean Museum, Oxford, England

89. Saint Cecilia, 1856–57
Pen and brown ink on paper, 3⅞ x 3¼ in.
Birmingham City Museum and Art Gallery,
Birmingham, England

90. Saint Cecilia, 1857
Wood engraving, 3⅝ x 3¹⁄₁₆ in.
Victoria and Albert Museum, London

kissing (a sufficient incongruity in itself) but seemingly munching the fair face of the lovely martyr."[17] Preliminary drawings for the wood engraving show that "munching" was not Rossetti's intention, but the kiss certainly was. One drawing (plate 89) shows the angel merely looking at the saint, but another (plate 88) does have the angel actually kissing her. Although the main source for the pose is a drawing by Elizabeth Siddal,[18] the kiss was added by Rossetti. His use of the kiss is the first of his attempts to represent the union of the mortal and the divine through love, a theme to be expressed in his *House of Life* sonnets and late paintings. *Saint Cecilia* may anticipate Rossetti's *Beata Beatrix* (plate 147), done between 1862 and 1870; the closed eyes, free-flowing hair, walled city, sundial, and dove appear in both, as does the rapt pose of ecstasy.[19]

A contemporary, Harry Quilter, summed up Rossetti's Moxon illustrations by saying, "The artist has pierced to the heart of deep emotions, but to this must be added that the deep emotions to which they have pierced are rather those of the earthly idealism of Rossetti than the spiritual ideal of Tennyson."[20] By contrast, the artist's depiction of Mariana compulsively clutching her lover's letters exactly conveys the sentiment of Tennyson's *Mariana in the South* (plate 91). Passion is again stressed over religion, but here that emphasis seems appropriate. The wood engraving follows Rossetti's original drawing more faithfully, possibly because he was able to get his favorite engraver, William James Linton, to cut the block for this plate and for *Sir Galahad*. John Christian has shown that Rossetti used the background at the left of Dürer's *Birth of the Virgin* (plate 45) as the right background in *Mariana in the South*.[21] This was undoubtedly in-

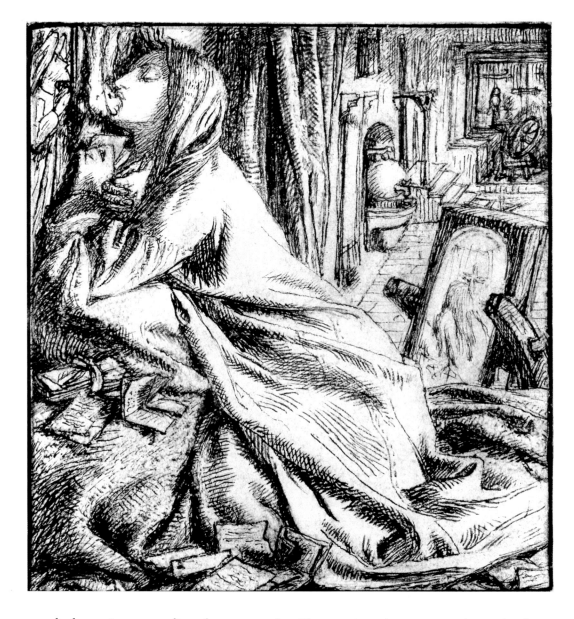

91. Mariana in the South, *1856–57*
Pen and pencil on paper, 3⅝ x 3⅜ in.
Birmingham City Museum and Art Gallery,
Birmingham, England

tended to give a medieval aura to the illustration, but it may have had an additional motive. Dürer was a great favorite of John Ruskin's, who owned and generously loaned a number of his prints. He was fond of exhorting artists to copy Dürer while also asserting that they couldn't possibly equal Dürer's performance. In his *Elements of Drawing* (1857), based on lectures given at the Working Men's College where Rossetti also taught, Ruskin said: "Provide yourself, if possible, with an engraving of Albert Dürer. This you will not be able to copy; but you must keep it beside you, and refer to it as a standard of precision in line."[22] Ruskin frequently criticized the imperfections of Rossetti's drawings (Rossetti referred to this as "sticking pins in me for a couple of hours"[23]), and it may be that Rossetti made a flawless copy of Dürer's entire, minute background just to show Ruskin that he could.

98

92. Sir Galahad at the Ruined Chapel, 1859
Watercolor on paper, 11½ x 13½ in.
Birmingham City Museum and Art Gallery,
Birmingham, England

Rossetti's last wood engraving for Moxon, *Sir Galahad*, employs a sophisticated pattern of dark and light to represent seen and unseen worlds. The lack of perspective and multitude of details make the knight appear to be part of a historiated capital in an illuminated manuscript. Rossetti successfully translated this representation into a watercolor that is radiant with luminous color (plate 92). Here the artist balanced the burnished red-golds against dark green areas in the background, producing one of his finest watercolors in terms of both color and composition.

The Moxon *Tennyson* was not a success financially or artistically. In part this was due to the incongruous mix of banal or dated works by Edwin

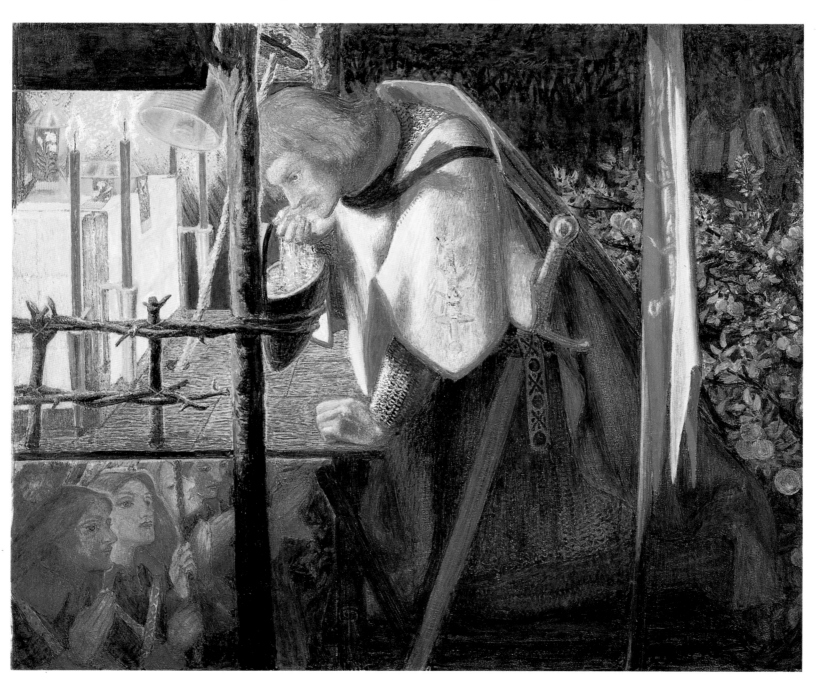

Landseer, William Mulready, and Thomas Creswick with more innovative images by Hunt, Millais, and Rossetti. The Pre-Raphaelite illustrations set a standard for excellence and originality well into the twentieth century, and it is a pity that Rossetti's original suggestion of the ideal illustrators—Hunt, Millais, Brown, Hughes, Siddal, and himself—was not heeded, for these artists were sympathetic to Tennyson's romanticism and medievalism and would have captured the spirit as well as the letter of the text.

In March 1855 Mrs. Tennyson wrote to Moxon asking to have Siddal's work included in the edition,[24] but he refused, no doubt because she was not well enough known. Although Siddal drew and painted themes from Shakespeare, the Bible, Browning, Keats, Wordsworth, Rossetti, and Old Scottish and English ballads, her greatest inspiration was Tennyson, and her contributions would certainly have enlivened the Moxon *Tennyson*. Her skill in interpreting chivalric subjects is amply demonstrated by *Lady Affixing a Pennant to a Knight's Spear* (plate 93). The brilliant colors glow as in a page from an illuminated missal or an illustration to Froissart.

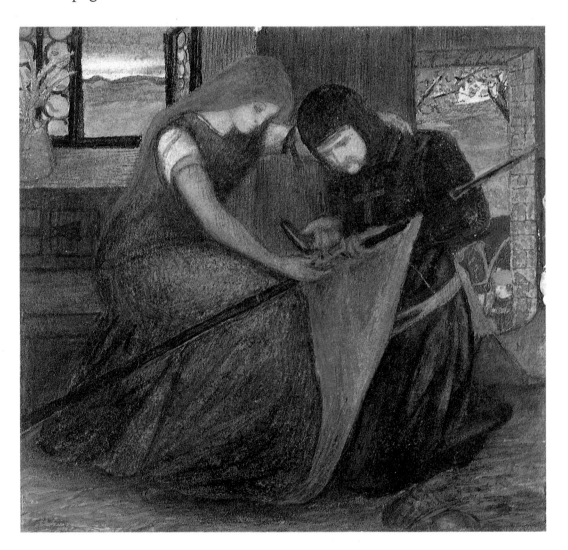

93. Elizabeth Siddal (1829–1862)
Lady Affixing a Pennant to a Knight's Spear, *1856*
Watercolor on paper, 5⅝ x 5⅝ in.
Tate Gallery, London

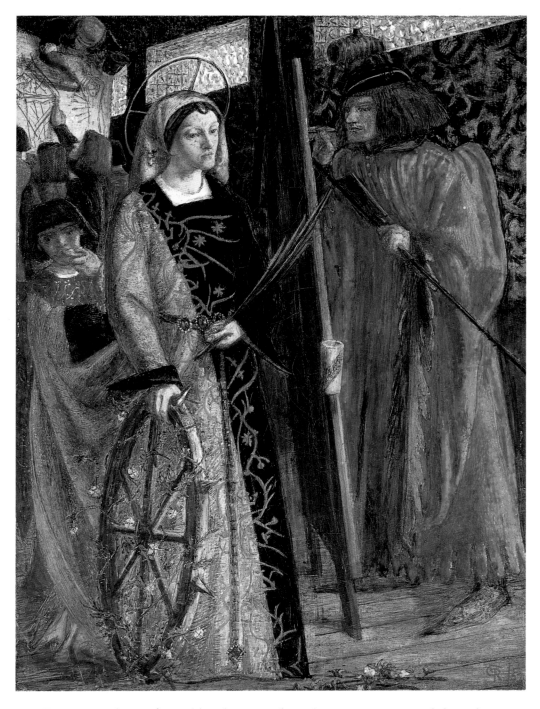

Rossetti also referred back to medieval manuscript models in his one oil painting from this period, *Saint Catherine* (plate 95), commissioned by Ruskin. Siddal served as the model, posing in the studio with the symbols of the saint's martyrdom—the wheel and the palm. This is a representation of the art of painting rather than of martyrdom, a secular version of Saint Luke painting the Virgin, which Rossetti invented to accompany his portraits of Giotto (plate 46), Fra Angelico (plate 48), and Giorgione (plate 47). In one of the manuscripts in Ruskin's collection, the *Beaupré Antiphonary*, there is a representation of Saint Catherine before Maxentius

101

102

(plate 94), which may have given Rossetti the idea for the subject, although his treatment is quite different. The pose of Rossetti's saint is very similar to one in the *Hastings Hours*, a much-copied manuscript in the British Library, and to another in the *Hours of the Blessed Virgin Mary* (Add. MS 54782, folio 104r), acquired by the British Museum in 1851. The costumes of the saint and the artist come from the *Dance of Mirth* illustration (plate 96) in the *Roman de la Rose* of about 1490–1500, acquired by the British Museum in 1753.[25] The saint's costume is adapted from the woman with a black headdress in the right foreground, and the painter's comes from the lead musician in the left background.

Another work of this period done in the style of medieval illumination is *The Blue Closet* (plate 97). According to F. G. Stephens, probably paraphrasing Rossetti himself, this watercolor was "an exercise intended to symbolize the association of color with music. . . .The sharp accents of the scarlet and green seem to go with the sound of the bell; the softer crimson, purple and white accord with the throbbing notes of the lute and the clavichord, while the dulcet, flute-like voices of the girls appear to agree with those azure tiles on the wall and floor which gave this fascinating drawing its name of *The Blue Closet*."[26] Here is an example of a type of painting that was to influence the Aesthetic Movement of the 1890s: a subjectless work that depended on color harmonies—the substance of painting itself—for its meaning. It is not surprising that it was much admired and bought by the young William Morris, one of Rossetti's new friends of 1856.

FIVE

NEW FRIENDS

he year 1856 marked the beginning of what has sometimes been called the second Pre-Raphaelite movement. It had its roots in the friendship of Edward Coley Jones (later to become Burne-Jones) and William Morris as undergraduates at Exeter College, Oxford, in 1853. Both had intended to be ordained as ministers, but after a tour of the French cathedrals in 1855 they decided to dedicate their lives to art instead. Rossetti's watercolor *The First Anniversary of the Death of Beatrice* (plate 44), which they encountered in 1855, became their ideal in art. Burne-Jones expressed his admiration for Rossetti's *Maids of Elfen-mere* in the *Oxford and Cambridge Magazine* (which, funded by Morris, lasted only one year—1856); and one of its editors, Wilfred Heeley, persuaded Rossetti to contribute the poems *The Burden of Nineveh*, *The Staff and Scrip*, and a revised version of *The Blessed Damozel* to the magazine.

When Burne-Jones went to London over Christmas vacation, 1855–56, he attended one of Rossetti's classes at the Working Men's College—the first time in his life he had ever seen a painter. A few days later Vernon Lushington, a mutual friend, introduced him to Rossetti, and Burne-Jones was invited to call on Rossetti the next day. In a letter of March 6, 1856, to Allingham, Rossetti described his new acquaintance as "one of the nicest young fellows in—*Dreamland*."[1] Morris had briefly joined the Oxford architectural firm of G. E. Street to learn to be an architect, then moved to London in 1856 to take rooms with Burne-Jones

98. Detail of The Wedding of Saint George and the Princess Sabra, *1857*
See plate 107

at 17 Red Lion Square (the same rooms Rossetti and Deverell had lived in earlier); the two of them then became Rossetti's pupils.

In 1857 a new venture presented itself that was to engross the energies of all three men. Rossetti had met the Dublin architect Benjamin Woodward in 1854 through his friendship with Ruskin. In July 1857 Woodward invited Rossetti to do a mural for Oxford's new Natural Science Museum, which he had designed in "Veronese Gothic" style. The subject suggested was "Newton gathering pebbles on the shore of the ocean of Truth," which did not at all interest Rossetti. When he saw Woodward's newly completed Oxford Union Debating Hall (now the library) with its ten bays beneath the dome crying out for decoration, Rossetti declared *this* was the building he wanted to do murals for and offered to provide the artists to do them in return for only their expenses. The proposal was accepted, and the "Jovial Campaign" of the summer of 1857 began. It was a time of new companionship and disciples for Rossetti and a rare chance to do large-scale frescoes.

The campaign was a welcome diversion, for Rossetti's relationship with Siddal was in decline. They had quarreled, and Siddal had gone to Sheffield to stay with a cousin, William Ibbitt, a silversmith on Durham Street. She went with a friend to art school there, and although not formally registered, she was admitted to the figure class. (Siddal took the opportunity, missed by Rossetti, of attending the *Great Manchester Treasures Loan Exhibition* in May 1857, where paintings by artists from Giotto through Millais were on view.) Siddal's relationship with Rossetti was at a crossroads. If she wanted to become his wife, Victorian morality decreed that she could not first become his mistress. However, she had serious rivals for Rossetti's affection in Fanny Cornforth and Hunt's flirtatious fiancée, Annie Miller—rivals who might capitulate sexually and lure him away from her. Her motive for leaving to get an art education on her own might have been to become economically independent and to break away, if only temporarily, from a difficult relationship.

Siddal's leaving had less impact on Rossetti than it might have had because he was so absorbed in the exciting new mural project at Oxford. He was particularly interested in doing work on a grand scale at this time because his good friend William Bell Scott was doing a series of wall paintings at the Trevelyans' estate, Wallington Hall, in 1857. Rossetti had been influenced by seeing the frescoes of Paul Delaroche and Hippolyte-Jean Flandrin during his 1849 visit to Paris, as well as by the cartoons for the wall decoration of the Houses of Parliament; his imagination had also been

fired by Lasinio's engravings of the Campo Santo frescoes. Here was an opportunity to create a monumental program on a completely different scale from the small watercolors Rossetti had been doing. The space in each of the ten bays is nine feet high, with two six-foil windows in each bay. The subject was Malory's *Morte d'Arthur*, a choice no doubt influenced by Morris's and Burne-Jones's passion for the tales. For Rossetti, this was a logical transition from his illustrations to Tennyson's poems, three of which had themes from Malory.

Rossetti described the Oxford Union murals in a letter of July 1858 to Charles Eliot Norton: "The series commences with {John Hungerford} Pollen's picture, *King Arthur obtaining the Sword Excalibur from the Damsel of the Lake*, and ends with {Arthur} Hughes's *Arthur carried away to Avalon and the Sword thrown back into the Lake*. The other pictures painted are, first, by {William} Morris, *Sir Palomides' Jealousy of Sir Tristram*; second, by {Valentine} Prinsep, *Sir Pelleas leaving the Lady Ettarde*; and third, by {J. R. Spencer} Stanhope, *Sir Gawaine meeting Three Ladies at a Well*."[2] Burne-Jones's subject represented Merlin being imprisoned by the Damsel of the Lake, and "My own subject. . .is Sir Launcelot prevented by his sin from entering the chapel of the Sanc Grail. He has fallen asleep before the shrine full of angels, and, between him and it, rises in his dream the image of Queen Guinevere, the cause of all. She stands gazing at him with her arms extended in the branches of an apple-tree"[3] (plate 99).

A preliminary sketch shows a trial pose for Guinevere (plate 101). The sleeping knight was posed by Burne-Jones, and the features of the queen evolve in a series of sketches from resembling Siddal to resembling a dark-haired lady, Rossetti's new model—Jane Burden (plate 100). In a review of the Oxford murals Coventry Patmore explained the meaning of Guinevere's pose: "The Queen while she regards Lancelot has her arms among the branches of an apple-tree—apparently to remind us of man's first temptation."[4] Guinevere stands between Lancelot and an angel who distinctly resembles Siddal (plate 102). Rossetti's conception is bold pictorially as well as allegorically, and he used the disturbing interruption of the windows to dramatize the space between the three main windows.

Rossetti had gathered a group of artists to join him in the mural project. Brown, Hunt, and Scott had declined, but Rossetti enlisted Burne-Jones, Morris, Hughes, Pollen (the only one with any experience doing frescoes), Prinsep, and Stanhope. As Prinsep said, "Rossetti was the planet round which we revolved. . . ."[5] Most of the young men were inexperienced as painters, and there were a number of technical problems to be

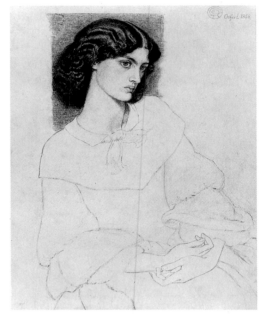

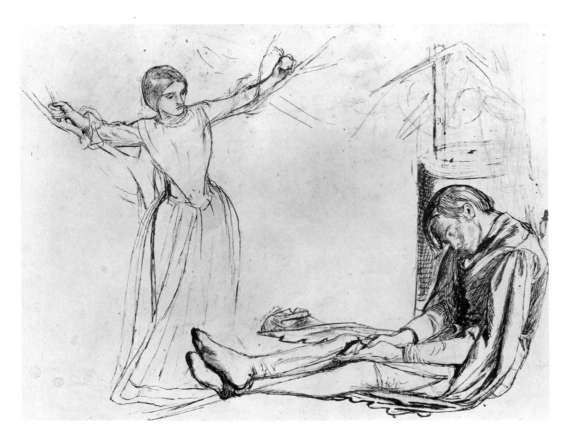

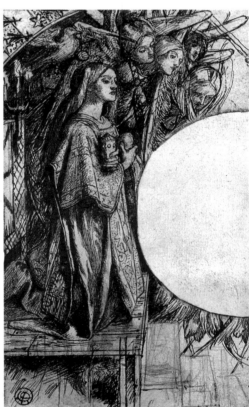

overcome. The windows piercing each of the bays were whitewashed over during the mural painting, but their location and the harsh light created major obstacles to designing and seeing the murals. The walls were still damp and inadequately plastered, or possibly only whitewashed, so that the outlines of the brick intruded. Rossetti's plan of using distemper with

103. Max Beerbohm (1872–1956)
The sole remark likely to have been
made by Benjamin Jowett about the mural
paintings at the Oxford Union, 1916
Watercolor and pencil on paper,
17¾ x 11¾ in.
Tate Gallery, London

sizing as the painting medium was a disaster, for the color, at first as glowing as a manuscript illumination, faded fast (subsequent attempts at restoration have been made, most recently in 1986). Finally, not enough time had been allowed for the project, and although Morris and Pollen finished early, the others could not complete their work in the six-week period allotted. Max Beerbohm's cartoon of Rossetti at work on his fresco—with Benjamin Jowett (a noted professor of Greek) inquiring, "And what were they going to do with the Grail when they found it, Mr. Rossetti?" (plate 103)—suggests the local skepticism that is likely to have greeted the project.

Still, when the color was fresh and unfaded, Rossetti's fresco elicited some ecstatic responses. Ruskin felt it was the finest work of color he had ever seen; Coventry Patmore praised

> *a style of colouring so brilliant as to make the walls look like the margin of a highly illuminated manuscript. The eye. . . is thus pleased with a voluptuous radiance of variegated tints. . .there is scarcely a square inch in all those square feet of colours which has not half a dozen tints in it. The colours, coming thus from points instead of from masses, are positively radiant. . . .The apparition of the* Damsel of the Sanc Grael. . .*is like "a stream of rich, distilled perfume" and affects the eye as much as one of Mendelssohn's most unwordable* Lieder ohne Wörter *impress the ear.*[6]

Patmore's description calls attention to the importance of color in Rossetti's art, both formally and symbolically. In studies for the mural, as in his watercolors of the 1850s, he combined techniques to achieve dense, luminous color, often using gouache, watercolor, and colored chalks together.

A work that Rossetti planned for another Oxford mural, but that exists only in later works on paper, is *How Sir Galahad, Sir Bors and Sir Percival Were Fed with the Sanc Grael; But Sir Percival's Sister Died by the Way* (plate 104). Here the intensity of the watercolor simulates Rossetti's original plan for the fresco, while the rhythmic procession of knights and angels and the rich patterns show a later stage in Rossetti's development, suggesting the dense designs of Morris wallpapers and textiles. The model for Galahad was a new acquaintance made during the Oxford campaign, Algernon Charles Swinburne, who was to become one of the members of the second Pre-Raphaelite group. He became a good friend of Rossetti, even sharing his house at 16 Cheyne Walk at one time. Swinburne was not a painter but a poet. A perpetual *enfant terrible*, he became famous with the publication of his poem *Atalanta in Calydon* in 1865. His inebriated

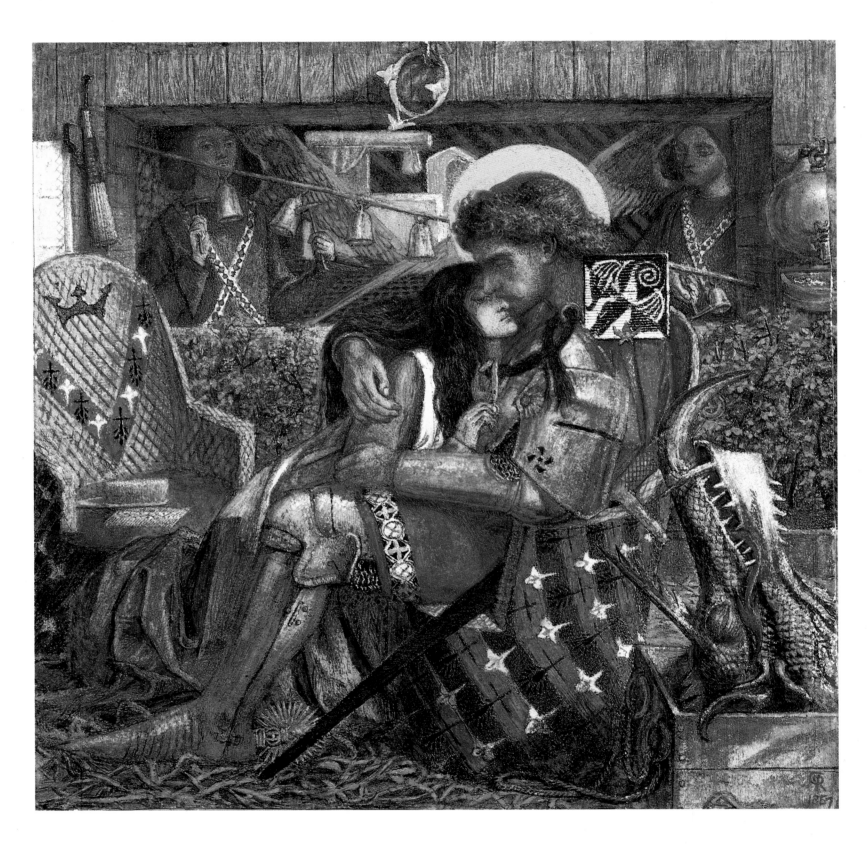

107. The Wedding of Saint George and
the Princess Sabra, *1857*
Watercolor on canvas, 13½ x 13½ in.
Tate Gallery, London

112

About six weeks after meeting Jane Burden, Rossetti was summoned to Derbyshire by Siddal, who was in poor health and needed his support. With Rossetti's responsibility to Siddal thus made clear, Jane began posing for Morris, and she was engaged to him by 1858. Rossetti's caricature (plate 110) contrasts Jane's queenly height with her fiancé's rather stocky figure and frizzled hair—Morris was dubbed "Topsy" because of his wild curly locks, a nickname possibly derived from *Uncle Tom's Cabin*. Jane was the model for Morris's rather brooding *Queen Guinevere* (plate 111), his only known completed work in oil. It caused him so much frustration that he is supposed to have scrawled on the back of a study for the work, "I cannot paint you, but I love you."[10] Morris also painted Burden as La Belle Iseult, another legendary adulteress.

Jane Burden and William Morris were married at Saint Michael's Church in Oxford on April 26, 1859. She later told her lover Wilfrid Scawen Blunt that she had never loved Morris, but the advantages to her of such a match were obvious, for Morris had an assured income and could support her in far better style than she had been accustomed to. Though a shy suitor, he was attractive as a young man and generous. She may have been more attracted to Rossetti, as many have speculated, but Siddal had prior claim on him.

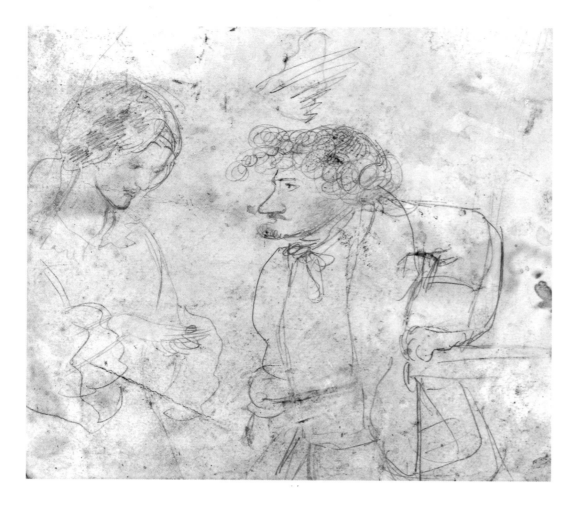

110. William Morris Presenting a Ring to
His Future Wife, 1857
Pen and ink on paper, 9⅝ x 13 in.
Birmingham City Museum and Art Gallery,
Birmingham, England

The decorative phase of Pre-Raphaelitism was stimulated by the Morrises' need for furnishings of good medieval design. Morris and Burne-Jones had ordered pieces for their lodgings at Red Lion Square that were described by Rossetti as "some intensely mediaeval furniture...tables and chairs like incubi and succubi."[11] Now the Morrises had to furnish all of Red House, built for them in 1860 by their architect and friend Philip Webb. Their problems of finding suitable furnishings and Rossetti's idea of having a workshop, like Giotto's, to furnish all sorts of goods besides art, resulted in the establishment of "The Firm" in January 1861. The members of the limited company were engineer Peter Paul Marshall, architect Philip Webb, mathematician Charles Faulkner, and artists Rossetti, Brown, and Burne-Jones; William Morris was manager and controller. Eventually they produced not only furniture but also wallpaper, textiles, book designs, embroidery, and, in keeping with the High Church revival of ritual and decoration, stained-glass windows and ecclesiastical furnishings.

The first product of the Firm was a cabinet designed by Webb and painted by Morris, which was shown in the Exposition Universelle of 1862 and is now at the Victoria and Albert Museum. Rossetti painted two of

Opposite
111. William Morris (1834–1896)
Queen Guinevere, 1858
Oil on canvas, 28⅛ x 20 in.
Tate Gallery, London

size, technique, style, and complexity of composition from the early to the finished version. The watercolor with its awkward figures in shallow space exemplifies Rossetti's medieval style. The attenuated figure of the angel may even show the influence of Burne-Jones's long, slim figures with small heads. In the oil, the figures have become more weighty and more obviously rendered from life. Comparing the figures of David in the left-hand panel reveals a dramatic progression from an awkward, tentative figure to a fully muscled, almost classical figure in contrapposto pose, taken from a life study (plate 117). The color is deeper, more Venetian in its richness. It is

117. Study of the Shepherd for "The Seed of David," n.d. Pencil on paper, 16½ x 7¼ in. National Museum of Wales, Cardiff

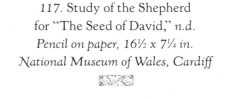

possible that the altarpiece was influenced by Paolo Veronese's *Adoration of the Magi* (1573), acquired by the National Gallery, London, in 1855. There are a number of similarities between the poses in the Veronese painting and the final version of Rossetti's central panel of *The Seed of David*—in particular, the detail of a king kissing the foot of the Christ child, which Rossetti so emphasized in his own composition, both in his written descriptions of his painting and in the poem accompanying it. The prototype for the unusual composition, with angels looking down from the

118. The Seed of David, 1858–64
Oil triptych, center: 90 x 60 in.;
sides: 73 x 24½ in.
Llandaff Cathedral, Cardiff, Wales

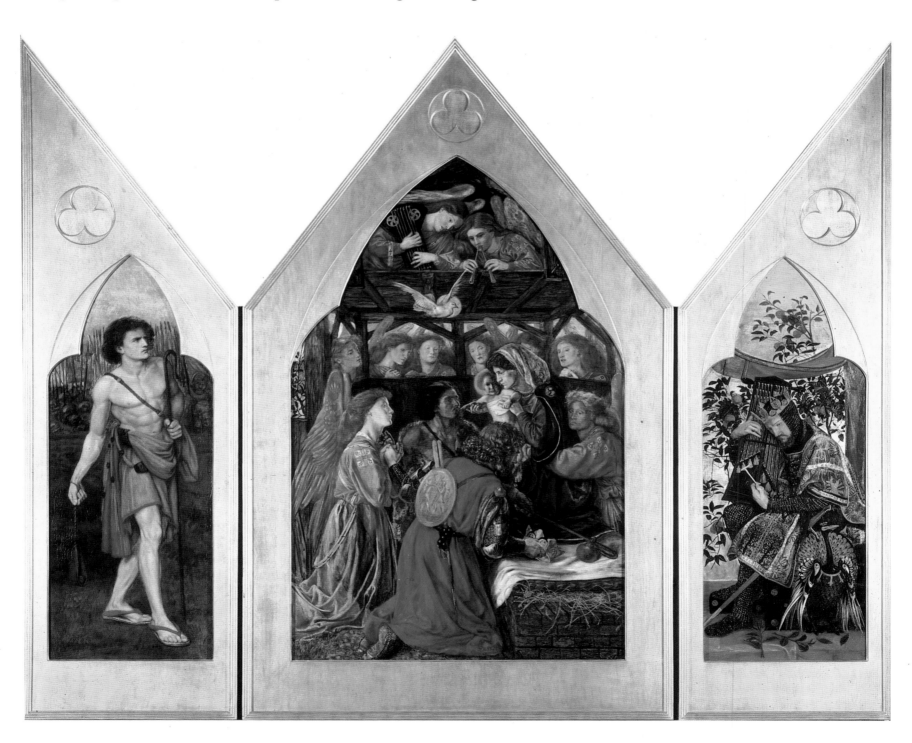

top story of a decaying house, may have been Tintoretto's *Annunciation* (1583–87, Scuola di San Rocco, Venice), described in detail by Ruskin in volume two of his *Modern Painters* and quoted frequently by Hunt in Pre-Raphaelite days; another source may have been Tintoretto's *Nativity* (plate 119), a description or reproduction of which could conceivably have been given to Rossetti by his new friend John Ruskin.[13]

ROSSETTI AND RUSKIN

ossetti's first contact with the art critic, writer, artist, and collector John Ruskin was through the collector Francis MacCracken, a Belfast ship owner and packing agent who sent Rossetti's *Ecce Ancilla Domini!* *(The Annunciation)* (plate 39) to Ruskin for an opinion. As Rossetti wrote to Woolner on April 16, 1853: "M'C. sent me a passage from a letter of Ruskin's about my Dantesque sketches exhibited this year at the Winter Gallery. . . . R. goes into raptures about the colour and grouping which he says are superior to anything in modern art—which I believe is almost as absurd as certain absurd objections which he makes to them. However, as he is only half informed about art, anything he says in favor of one's work is of course sure to prove invaluable. . . ."[1]

Later, when MacCracken sent Rossetti's watercolor *The First Anniversary of the Death of Beatrice* (plate 44) to Ruskin, the critic again reacted enthusiastically, describing it as "a thoroughly glorious work—the most perfect piece of Italy, in the accessory parts, I have ever seen in my life."[2] Shortly thereafter, in April 1854 (the same month that Ruskin's wife left him to marry Millais), he wrote to Rossetti, asking permission to call. To Brown, Rossetti wrote: "I of course stroked him down in my answer, and yesterday he came. His manner was more agreeable than I had always expected, but in person he is an absolute Guy—worse than Patmore. However he seems in a mood to make my fortune."[3] In May, Ruskin again wrote to Rossetti, asking "if you would sometimes allow me to have fellow-

120. W. Downey
Dante Gabriel Rossetti and
John Ruskin, n.d.
Cabinet photograph
Jeremy Maas

123

ship in your thoughts and sympathy with your purpose,"[4] and he had his bookseller send Rossetti copies of all his writings. The most celebrated art critic of the era, Ruskin had already published several volumes of *Modern Painters* and had defended the Pre-Raphaelite Brotherhood against attacks in 1851. Now, with Hunt in the Middle East and Millais getting ready to marry Ruskin's wife, Rossetti was the only major Pre-Raphaelite brother available to support the critic's belief in and identification with this avant-garde school.

Ruskin persuaded Rossetti to join him in teaching (without recompense) at the Working Men's College at 31 Red Lion Square—a progressive enterprise founded by Frederick Denison Maurice that offered its first evening classes on October 31, 1854. Starting January 22 of the next year, Rossetti conducted his own class on the figure. Both Ruskin and Rossetti believed in the democratic ideal of art for everybody, and both taught from nature alone, not from casts or engravings as was the common academic practice. Rossetti began by giving his students instruction in color rather than in light and shade—another departure from the norm. One of his students recorded his working method as follows:

> *After giving instruction, he would sometimes seat himself and show by example how to paint, throwing the pencil with apparent recklessness about the paper, making a number of lines.... He would then take up a brush, well fill it with violet carmine, and rub it on the margin of the paper until all the moisture had departed and only dry colour was left in the brush. This dry colour he would drag about the paper until he had produced a very rugged modelling. Over this he would, with a similar dry brush, rub various colours, until he had gained a rough general effect of colour....Then he would...wash all this together....Working over this, but with a more flowing brush, he would soon complete a work which possessed all that splendid colour which, I suppose that only he could attain.[5]*

Although William Rossetti said his brother stopped teaching about the end of 1858, his letters to Brown indicate that he was still teaching in 1861, and several accounts recall his teaching at the college as late as February 1862—a seven-year commitment to a volunteer activity. Ruskin later said, "It is to be remembered of Rossetti with loving honour, that he was the only one of our modern painters who taught disciples for love of them."[6]

Ruskin became an important and influential patron of Rossetti, writing in October 1854, "I really do covet your drawings as much as I covet

121. Study for the Figure of Rachel in
"Dante's Vision of Rachel and Leah," 1855
Pencil on paper, 13⅝ x 6⅜ in.
Birmingham City Museum and Art Gallery,
Birmingham, England

122. Dante's Vision of Rachel and Leah, 1855
Watercolor on paper, 14 x 12½ in.
Tate Gallery, London

Turner's; only it is useless self-indulgence to buy Turner's and useful self-indulgence to buy yours."[7] He offered Rossetti not only his own steady patronage, but also that of his friends, including Ellen Heaton, Charles Eliot Norton of Harvard University, and John P. Seddon (who gave the Llandaff Cathedral commission to Rossetti). He recommended William Rossetti as an art critic for the American art magazine the *Crayon*, and he admired and supported Elizabeth Siddal.

Ruskin commissioned several works from Rossetti, and he inevitably had trouble getting him to produce them on time, as did most of Rossetti's patrons. Ruskin teased Rossetti about this in a letter of 1855: "Dear Rossetti—In your growling letter you are Grief, and I am Patience on the monument"[8] (a reference to Viola's speech to Duke Orsino in act 2, scene 4 of *Twelfth Night*). Rossetti responded in kind, twitting Ruskin about his slowness in producing the next volume of *Modern Painters*, "who, I tell him, will be old masters before the work is ended."[9]

One work for Ruskin, commissioned in April 1855, was *Dante's Vision of Rachel and Leah* (plate 122), which illustrated canto 27 of *Purga-*

tory. The model for Rachel, on the left, was Siddal, representing the contemplative life in counterpart to Leah, representative of the active life (plate 121). Another important work commissioned by Ruskin was *The Passover of the Holy Family: Gathering the Bitter Herbs* (plate 123), a watercolor of 1855–56. As the poem Rossetti wrote for this picture makes clear, he used the image of Israel's first Passover to foreshadow the sacrifice of Christ: "Here meet together the prefiguring day and day prefigured." Given the painting's explicit symbolism, Ruskin's letter to Rossetti of about 1856 is amusing: "Patmore is very nice, but what the mischief does he mean by Symbolism? I call that Passover plain prosy Fact. No Symbolism at all."[10] (This difference in interpretation may relate to a difference in religious upbringing: Rossetti was of the High Anglican Church, whereas Ruskin came from an Evangelical, nonsacramental background.) The watercolor has another kind of resonance as well, for this is the work copied by Frederic Shields for the memorial window to Rossetti in All Saints Parish Church, Birchington-on-Sea, where Rossetti is buried.

123. The Passover of the Holy Family:
Gathering the Bitter Herbs, *1855–56*
Watercolor on paper, 16 x 17 in.
Tate Gallery, London

Rossetti did several other religious works for Ruskin, including the poignant *Saint John Comforting the Virgin at the Foot of the Cross* (plate 124). Ruskin also encouraged him to do a major drawing, *Mary Magdalene at the House of Simon the Pharisee* (plate 127), which can be read as a pendant to *Found* (plate 52). The woman in *Found* rejects salvation, whereas the Magdalene deserts her riotous life to go to Christ. Although the head of the Magdalene was reputedly modeled by Ruth Herbert (plates 125, 126), the body, the stance, and the hair are certainly reminiscent of Fanny Cornforth, the model for *Found*. The head of Christ was modeled by Burne-Jones. The drawing, crowded with a Pre-Raphaelite cast of thousands, represents some of Rossetti's most precise and exceptional draftsmanship. The contrast between the urgency of those outside the house and the stillness of Christ on the inside is particularly remarkable. The study of the fawn shows Rossetti still interested in the Pre-Raphaelite tradition of drawing from nature (plate 128).

Rossetti also painted a number of medieval subjects for Ruskin and

124. Saint John Comforting the Virgin at the Foot of the Cross, 1857–58 Pen and ink and india ink and sepia wash on paper, 6⁷⁄₁₆ x 6 in. Fitzwilliam Museum, Cambridge, England

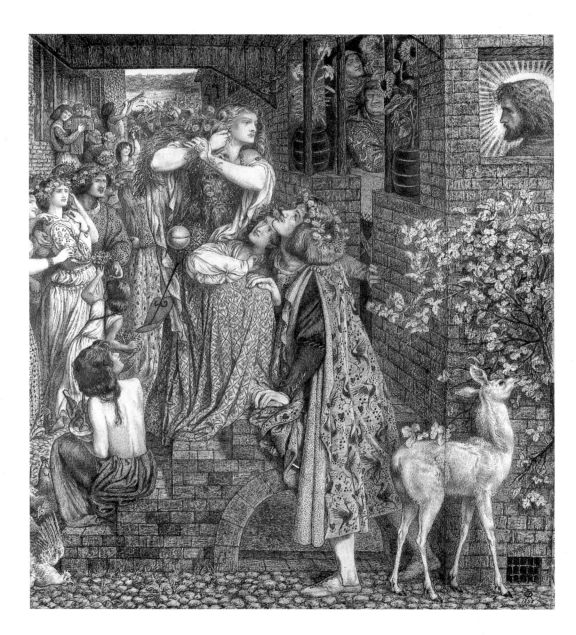

Above, top
125. Study of the Head of the Magdalene
for "Mary Magdalene at the House of
Simon the Pharisee," c. 1858
Pencil and ink on paper,
8¼ x 6½ in.
Ashmolean Museum, Oxford, England

Above, bottom
126. Head of a Woman Called
Ruth Herbert, 1876,
Chalk on buff paper, 15½ x 12⅜ in.
Yale Center for British Art, New Haven,
Connecticut; Paul Mellon Collection

Above
127. Mary Magdalene at the House of
Simon the Pharisee, 1858
Pen and india ink on paper,
21¼ x 18⅜ in.
Fitzwilliam Museum, Cambridge,
England

Right
128. Study of a Fawn for "Mary Magdalene
at the House of Simon the Pharisee," c. 1859
Pencil on paper, 4¼ x 3¼ in.
Birmingham City Museum and Art Gallery,
Birmingham, England

his friends. Other medieval-style works of this period include *A Christmas Carol* (plate 129); *Before the Battle* (plate 130); *Golden Water (Princess Parisadé)* (plate 132); and *My Lady Greensleeves* (plate 131), which takes its subject from a medieval ballad. Despite their quaint charm and brilliant, unusual colors, these seem to lack the freshness and conviction of Rossetti's earlier medieval works.

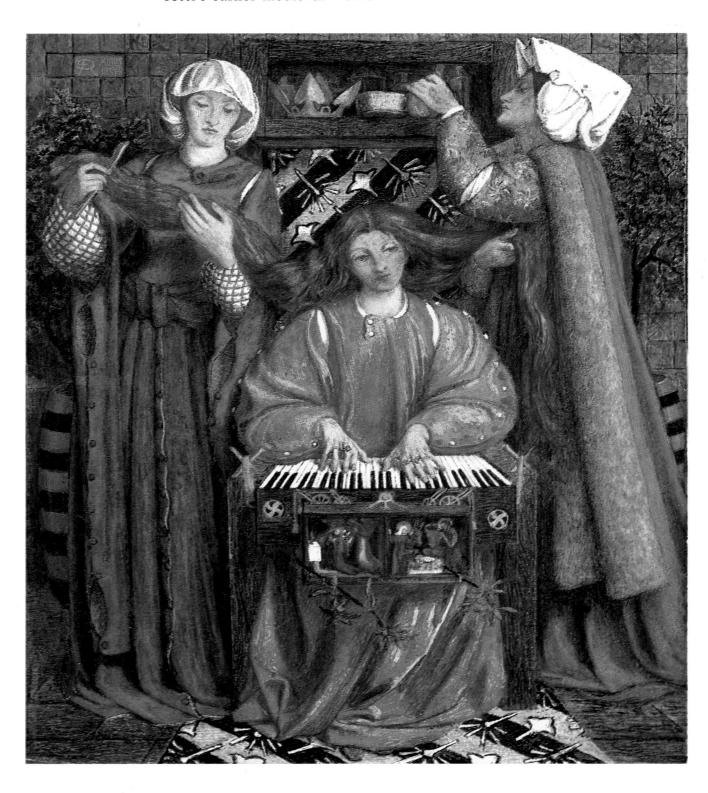

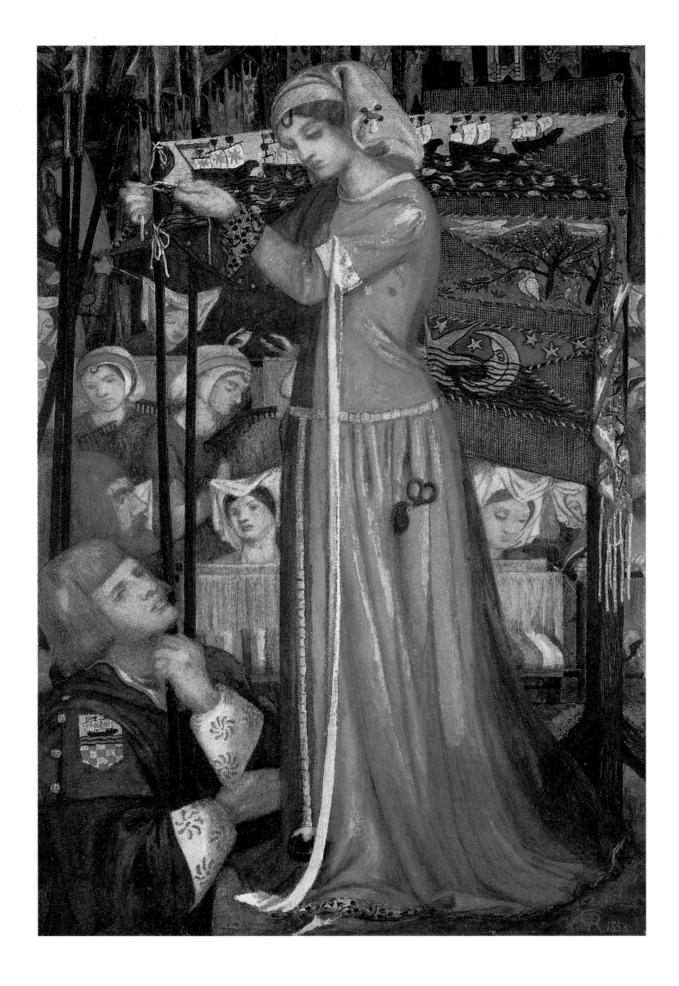

130

them to do ever since 1855.[12] A great admirer of Siddal, Ruskin described her in 1855 to his friend William Acland as having "more the look of a Florentine fifteenth-century lady than anything I ever saw out of a fresco. . . ."[13] He nicknamed Siddal "Ida," taking the title from the educated and talented heroine of Tennyson's poem *The Princess*. In March 1855 Ruskin saw Siddal's drawings for the first time and bought them all. "He declared that they were far better than mine," wrote Rossetti, "or almost than anyone's, and seemed wild with delight at getting them."[14] The next month Ruskin arranged to provide Siddal with a yearly allowance of 150 pounds in return for the right to first choice of all her works produced up to that sum. He wrote to Siddal in April 1855, "If you do not choose to be helped for his sake, consider also the plain *hard fact* is that I think you have genius; that I don't think there is much genius in the world; and I want to keep what there is, in it, heaven having, I suppose enough for all its purposes."[15] Ruskin did have one problem with geniuses (he classified Turner, Millais, George Frederic Watts, Rossetti, and Siddal as the five artistic geniuses he had known[16]): they wouldn't take advice—specifically, his advice. In 1857 he wrote to Rossetti: "I must see Ida; I want to tell her one or two things about her way of study. I can't bear to see her missing her mark only by a few inches, which she might as easily win as not."[17]

Although Siddal was gratified to have Ruskin as such an enthusiastic patron, and Rossetti was very proud and delighted about it, being taken up by Ruskin had its drawbacks. He was a compulsive mentor, constantly giving her tutelage that ran counter to her own ideas and to Rossetti's. Rossetti wanted to be the sun in every relationship, with everyone else revolving about him—and so did Ruskin.[18] It is not surprising that Siddal, torn between the two brilliant and domineering men, became so ill in 1857 that she had to relinquish Ruskin's yearly allowance—and his control.

Ruskin's support of Rossetti also entailed a good deal of high-handed criticism and advice. Ruskin wrote to the artist in 1855: "This drawing is in many respects likeable—but in many more *wrong*. . . . Flesh is not Buff . . . but neither is it pea-green, as you draw it."[19] Displeased by the *Saint Catherine* he had commissioned, he wrote to Rossetti in 1855: "You are a conceited monkey, thinking your pictures right when I tell you positively they are wrong. What do *you* know about the matter, I should like to know?"[20] He reproached Rossetti on a more personal level in 1860: "But what I *do* feel *generally* about you is that without intending it you are in little things habitually selfish—thinking only of what you like to do, or don't like to; not of what would be kind."[21] When Rossetti was painting one of

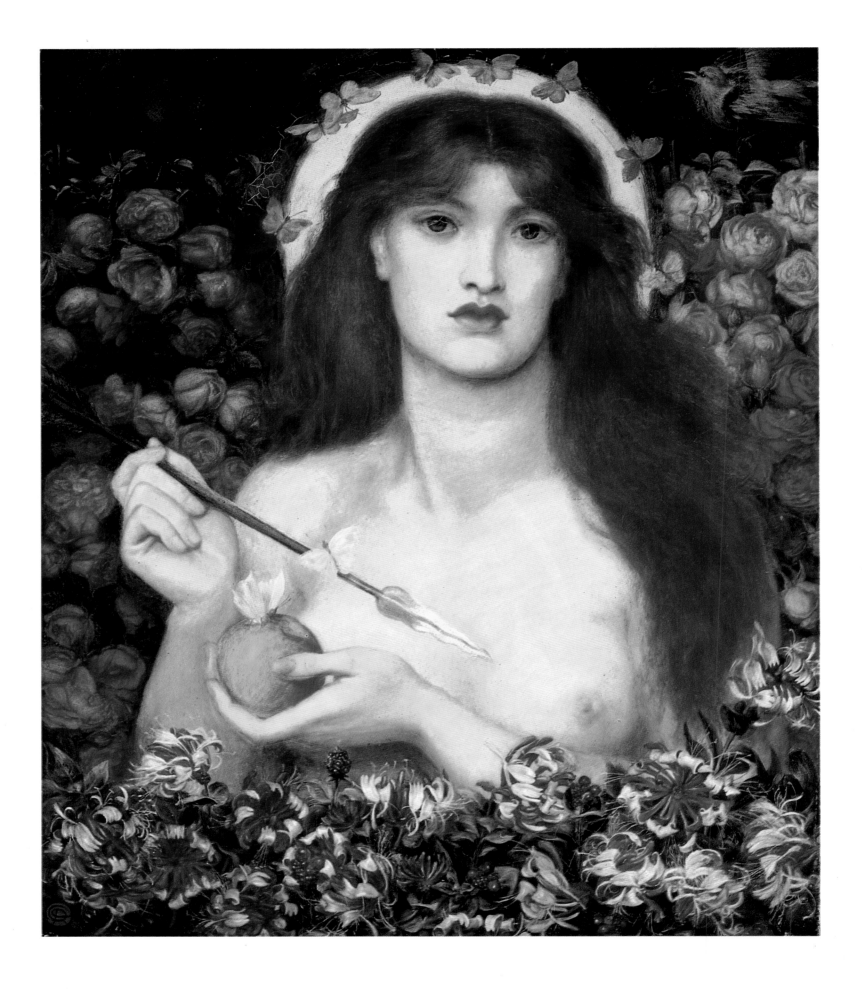

his few nudes, *Venus Verticordia* (plate 139)—from a gigantic model who was a cook at a house on Portland Place—Ruskin looked in and was upset by so much sensuality, later complaining to the artist about the "coarseness" of the flowers. One of Rossetti's patrons, knowing full well it wasn't the flowers that Ruskin considered coarse, later wrote to a friend: "What does that extraordinary Ruskin mean when he speaks of the 'coarseness' of the flowers? . . . I suppose he is reflecting upon their morals, but I never heard a word breathed against the perfect respectability of a honeysuckle. Of course roses have got themselves talked about from time to time, but really if one were to listen to scandal about flowers, gardening would become impossible."[22]

A variety of differences—both aesthetic and personal—terminated the close friendship between Rossetti and Ruskin about 1862, although Ruskin called on him as late as 1869.[23] He had given Rossetti much besides financial support: praise and encouragement in his art and poetry, the loan of works in his collection (especially illuminated manuscripts), and intelligent, if blunt, criticism. Ruskin may have influenced the use of Venetian painting and mythology as sources for Rossetti's later painting. His well-founded complaints about Rossetti's lack of fundamental skills may have driven him to life-drawing classes to prepare for painting *The Seed of David* and encouraged a more professional approach to his painting.

In return, the artist provided Ruskin with a link to Pre-Raphaelitism, the avant-garde art of the day. According to one modern commentator, Rossetti also offered Ruskin "an element of genuine human contact which Ruskin was rarely able to experience. Despite Ruskin's material generosity to Rossetti, I believe he received from the painter more than he gave."[24] In addition, Rossetti introduced Ruskin to Burne-Jones, who became his life-long friend, and to Burne-Jones's wife, Georgiana, who provided great emotional support to Ruskin.

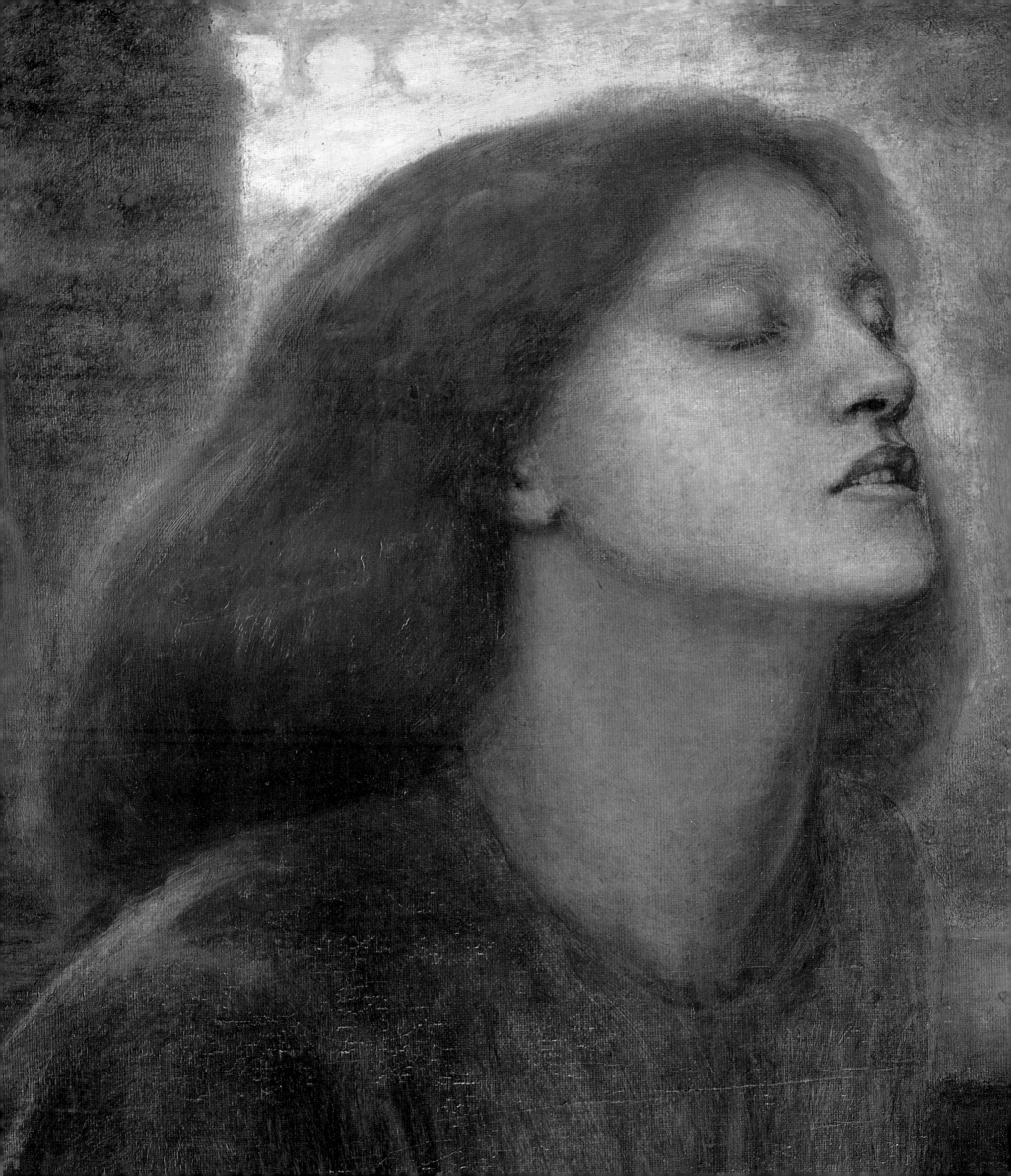

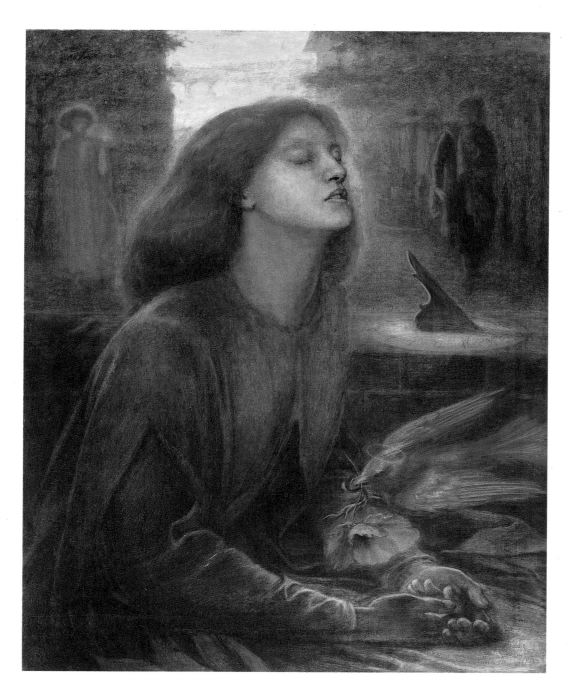

Rossetti started a painting in 1862 that symbolized his relationship to Siddal. This was *Beata Beatrix* (plate 147), which he worked on throughout the 1860s but did not complete until 1870. The subject came from Dante's *Vita nuova*, which describes Beatrice in a trance overlooking Florence when she is transported mystically from earth to heaven. The figure of Dante, on the right, gazes at Love, on the left. The sundial points to the hour of Beatrice's death. The dove, which drops a poppy into Beatrice's hands, is red—a messenger of both love and death—and the poppy, symbolic of sleep and death, may also refer to opium, which caused Siddal's death. This painting was a new type for Rossetti. Besides departing from the hard edges, bright color, and photographic detail of Pre-Raphaelite

painting, it also makes a symbolic statement rather than telling a narrative. Evoking a mood with the single figure of a beautiful woman rather than relating an event, the painting is to be contemplated, not read; and it marks the beginning of Rossetti's attempts to portray a moment, both temporal and eternal, when flesh and spirit are wed.

Rossetti was also at work illustrating his sister's *Goblin Market and Other Poems* (plate 148), published by Macmillan in 1862 and received with generally favorable notice for both the poems and the illustrations. One review in the *Times* did remark, "Miss Rossetti can point to work which could not easily be mended," and Rossetti did a caricature of his sister, hammer in hand, demolishing a number of items which "could not easily be mended" (plate 149). Rossetti also did the illustrations for her *Prince's Progress*, published in 1866, which tells the story of a prince who arrives too late to save a waiting princess from death. Two studies for the illustrations (plates 150, 151) show Rossetti's improved skill in rendering drapery and three-dimensional form; the study for the frontispiece also conveys quite sensitively the emotions the princess endured while waiting.

A letter to Allingham from Rossetti in January 1861 announced Siddal's pregnancy; on May 2 she was delivered of a stillborn baby girl, a great sorrow to both the Rossettis. Siddal recovered rapidly, but she relied more and more heavily on laudanum, an addictive opiate that had been prescribed for her previous illnesses. In the beginning of 1862 she was again pregnant.[7] On the evening of February 10 the Rossettis and Swinburne went out to an early supper at a new restaurant, the Sablonière, returning home by eight. Rossetti went out again, probably to teach. When he returned at eleven-thirty, he found his wife in bed, unconscious, and rushed out to find her doctor, Francis Hutchinson, who tried to resuscitate her. Rossetti, distraught, then went out in search of Brown, who returned with him to Chatham Place. Siddal had not recovered, and Rossetti went out yet again to get his friend Dr. John Marshall and two other doctors. Their efforts failed, and Elizabeth Siddal Rossetti died the next morning.

There was an inquest on February 12, and it returned the verdict of accidental death, although there have been suggestions that Siddal committed suicide. The verdict of accidental death is supported by the fact that laudanum did not contain a standardized percentage of opium, so she could have overdosed unintentionally. Inarguably against this is the fact that she had pinned to her nightgown a note (removed and destroyed by Brown) that read, "Take care of Harry" (her feeble-minded brother).

As a final tribute, the heartbroken Rossetti buried his poems in Sid-

Top
148. Illustration for Goblin Market, 1862
Wood engraving, 3⅜ x 4⅛ in. (image)
Museum of Fine Arts, Boston;
The John H. and Ernestine A. Payne Fund

Bottom
149. Christina Rossetti in a Tantrum, 1862
Pen and ink on paper, 8¾ x 7 in.
The National Trust, Wightwick Manor,
Wolverhampton, England

Opposite, left
150. Study for "The Prince's Progress," 1865
Pencil and pen with india ink
on paper, 6⅜ x 4⅜ in.
Birmingham City Museum and Art Gallery,
Birmingham, England

dal's casket. He told his brother that every night for two years after Siddal's death he saw her on the bed as she died.[8] (This was the beginning of the insomnia that haunted him and shortened his life.) He moved back to the family home for a few months to escape the memories at Chatham Place, then he leased Tudor House, at 16 Cheyne Walk, which he initially shared with his brother, Swinburne, and the novelist George Meredith; he would remain there for the last twenty years of his life.

VENETIAN PAINTINGS AND LILLIPUTIAN PATRONS

153. Death of a Wombat, 1869
Pen and ink on paper, 7 x 4½ in.
The British Museum, London

152. Detail of Veronica Veronese, 1872
See plate 182

In the 1860s the garden at 16 Cheyne Walk became a menagerie of the exotic animals Rossetti collected: peacocks, kangaroos, an armadillo, a Chinese horned owl, deer, and even a Brahmin bull (which had to go after it chased Rossetti around the garden). His favorite was the wombat, which had rather disconcerting habits. One sitter, for example, discovered that the wombat had eaten her new hat. "The only consolation Gabriel had to give his indignant visitor was: 'Oh, poor wombat! It is *so* indigestible!'"[1] When the wombat expired, possibly due to dietary irregularities, Rossetti mourned its passing in *Death of a Wombat* (plate 153).

In 1862 Rossetti hired his first assistant, Walter John Knewstub, who was succeeded in 1867 by Henry Treffry Dunn. It was the assistant's job to stretch and prime canvases, run studio errands, cut chalks, put in backgrounds, and sometimes reduce figures for replicas, but Rossetti did the main work on all his paintings. Each assistant lived at 16 Cheyne Walk, often serving as household supervisor as well as painting assistant.

In the spring of 1863 Fanny Cornforth became "housekeeper" at 16 Cheyne Walk, although she was somewhat lax in her housekeeping duties. She had been very upset by Rossetti's marriage in 1860 and had retaliated by marrying Timothy Hughes that August. That she had continued to model for Rossetti during his marriage is evident from *Fair Rosamund* (plates 154, 155), done in 1861. (Fair Rosamund was the mistress of Henry II and bitterly hated by his wife, Queen Eleanor.) Cornforth was also the model for *Woman Combing Her Hair* (plate 156). Another model that Ros-

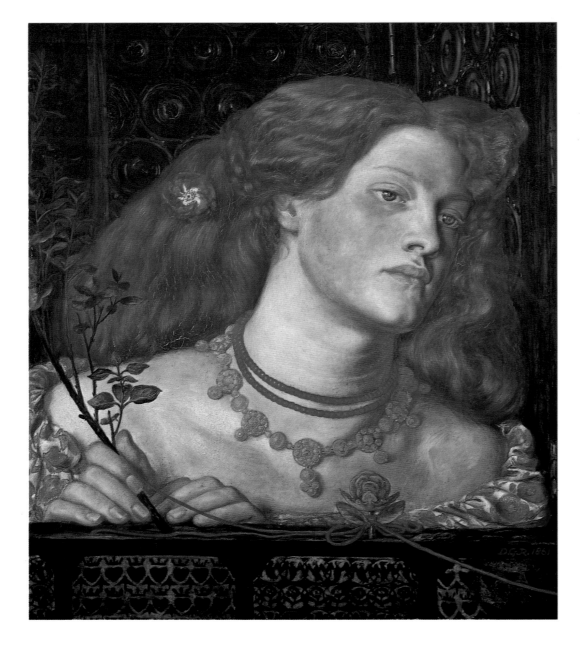

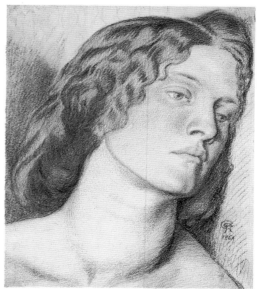

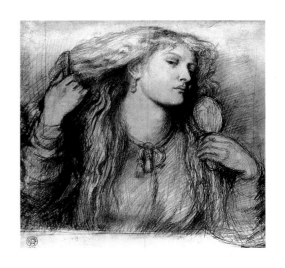

setti was using at this time was Hunt's ex-fiancée, Annie Miller, who sat for *Helen of Troy* (plate 158).

In 1859 Rossetti had moved away from the inspiration of medieval manuscripts and early Renaissance masters to that of High Renaissance painting, particularly the work of the Venetian masters. He began emphasizing color over line, the three-dimensionality of a single figure rather than the linear patterning of a crowd composition, and secular instead of religious subject matter. Abandoning a style he had exhausted, he began a series of mature, expansive, coloristic works.

There were a number of reasons for this new direction in Rossetti's style. He may have been influenced by Ruskin's praise of the Venetian style

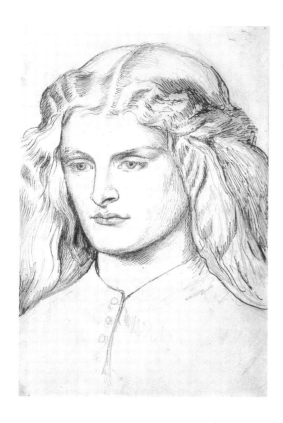

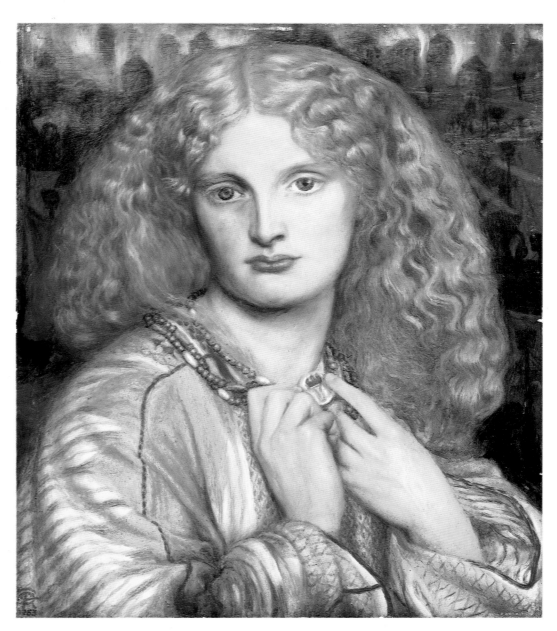

in *Modern Painters* (1843–60) and *The Stones of Venice* (1851–53) and by his proclamation in 1858 that "the Venetians alone, by a toil almost super-human. . .were able finally to paint the highest visible work of God with unexaggerated structure, undegraded colour and unaffected gesture."[2] Rossetti may also have seen the numerous articles on Venetian painters that appeared in the *Art Journal* and other periodicals during the 1850s. Titian's *Portrait of a Poet (Probably Ariosto)* (now attributed to Palma Vec-chio) and *La Schiavone* were in the National Gallery for him to study, and he could have seen works by Titian and Tintoretto at Hampton Court; he also owned a number of photographs of works by Titian. While in Paris for his honeymoon in 1860, he recorded his delight at Veronese's *Marriage*

Feast at Cana, "the greatest picture in the world beyond a doubt."[3] In 1859 and 1862 Rossetti also had the benefit of Burne-Jones's sketches and descriptions of Venetian works made during that artist's trips to Italy.

Rossetti's change in style was accompanied by a significant change in technique. During the 1850s he had worked mainly in watercolors, producing only one oil painting in that decade, *Saint Catherine*, before 1859; from then on, his major works were in oil. Rossetti pointed out in a letter to the *Athenaeum* of October 25, 1865, that his first works had been in oil and that he "never abandoned such practice, or considered myself otherwise than as an oil-painter."[4] In a number of his oil paintings after 1859 he switched from the white underpainting preferred by the Pre-Raphaelites to the red ground preferred by Titian. By the late 1860s Rossetti had developed clearly defined painting methods and achieved far greater technical control of his materials. His friend Frederic Shields reported: "In his own practice every step was determined, so that when once a design was fairly on the canvas it went on steadily, unhurriedly, and, in the main, unalterably upon the well-appointed course toward its set goal of perfect beauty. . . . He was wont to say that the difficulties of design and painting, imperiously demanding stern application and unbending resolution to surmount them, had restrained him from his natural inclination to lie on his back and write poetry all day; and had been a powerful motor for good in his life and character."[5]

Rossetti's new style surprised some of his old friends. Hunt wrote about *Bocca Baciata* (plate 159), exhibited at the Hogarth Club in 1860: "Gabriel sent two excellent examples of his last oil work. He had now completely changed his philosophy, which he showed in his art, leaving Stoicism for Epicureanism. . . . He executed heads of women of voluptuous nature with such richness of ornamental trapping and decoration that they were a surprise, coming from the hand which had hitherto indulged itself in austerities."[6]

Bocca Baciata, for which Fanny Cornforth was the model, initiated Rossetti's Venetian style (that he portrayed Cornforth with remarkable accuracy can be seen by comparing the painting with a photograph of her, plate 51). On the back of the painting is an inscription from Boccaccio that, translated into English, reads, "The mouth that has been kissed {*bocca baciata*} loses not its freshness; still it renews itself as does the moon." Behind the woman's head is a background of marigolds, initiating Rossetti's practice of featuring flowers, appropriate either in hue or symbolism, in his work. The parapet on which the woman rests her hands

159. Bocca Baciata (Lips That Have
Been Kissed), 1859
Oil on panel, 12⅝ x 10⅝ in.
Museum of Fine Arts, Boston;
Gift of James Lawrence

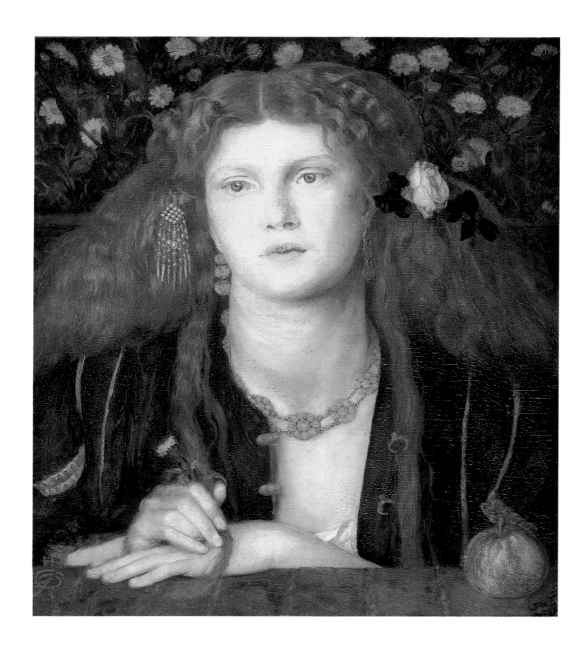

may come from Titian; the apple placed there suggests both the Temptation and the Fall. Appropriately, given the shift from Dante to Boccaccio, a mood of sensual opulence, not spirituality, prevails. Hunt criticized the painting in a letter to Thomas Combe: "It impresses me as very remarkable in power of execution—but still more remarkable for gross sensuality of a revolting kind, peculiar to foreign prints, that would scarcely pass our English Custom house from France. . . ."[7]

A subject well suited to Rossetti's interest in the Renaissance was *Lucrezia Borgia,* a watercolor first painted in 1860–61, repainted in 1868, and replicated in 1871 (plate 160). It represents Lucrezia Borgia washing her hands after poisoning her husband, while in the background her father, Pope Alexander VI, walks the victim around to settle the poison in his sys-

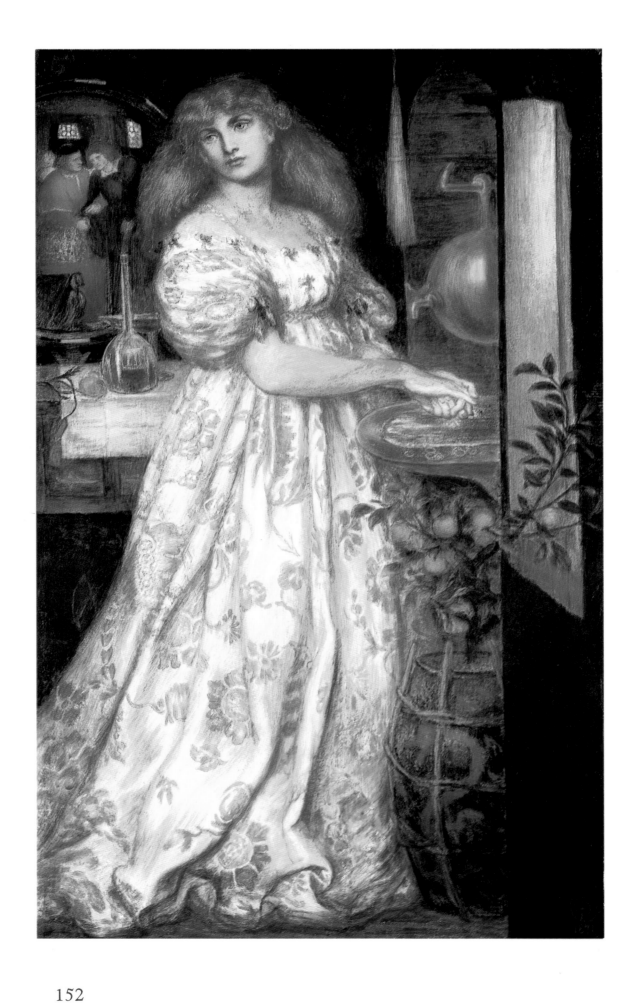

tem. The subject may have been suggested by Gaetano Donizetti's popular opera *Lucrezia Borgia*, first produced in 1833, which Rossetti had seen in 1848.[8] The round urn and towel on the right come from Dürer's *Birth of the Virgin*, which had been quoted by Rossetti in earlier works. The round mirror in the painting is Rossetti's own. This is far from being a Renaissance painting; it is a work of nineteenth-century romanticism and historicism dramatizing a somewhat improbable view of the earlier era.

During Rossetti's Venetian period, which lasted nearly a decade, he produced a gallery of women, usually half-lengths or busts, including *My Lady Greensleeves* (plate 161), modeled by Mrs. Knewstub, wife of his assistant; *Fazio's Mistress* (plate 243), modeled by Fanny Cornforth; and *Woman in Yellow* (plate 162), modeled by Annie Miller. The subject of *Fazio's Mistress* comes from Fazio degli Uberti's fourteenth-century love poem *Portrait of His Lady*, which Rossetti had translated. Symbolism abounds in this work: the comb marking the lady as a siren, the peacock representing vanity, and each flower communicating a specific message.[9] The pose and ambience of the painting may relate to Titian's *Young Woman at Her Toilet*, which Rossetti could have seen at the Louvre during his visits in 1849 and 1860.

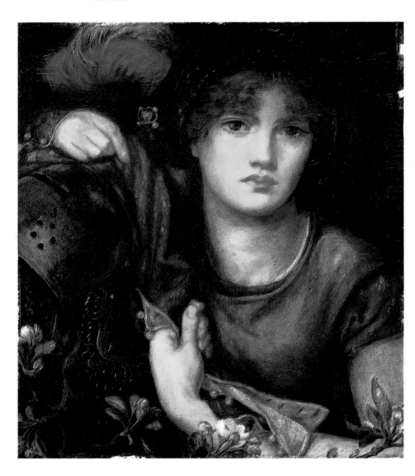

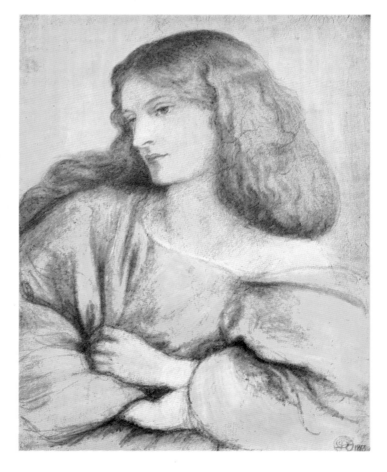

Another painting of a woman has a different pose and a very different meaning: *Joan of Arc*, originally done in oil in 1863 and replicated in watercolor twice in 1864 (plate 163) and once in oil in 1882. According to William Rossetti, the model was a German woman, a Mrs. Beyer (plate 164). The representation of the militant saint, wearing armor and holding a sword, is very unlike the soft, alluring beauties Rossetti preferred in this era. It proved to be one of his most popular images, a popularity possibly reflecting the contemporaneous agitation for women's suffrage and property rights. A thoroughly unmilitary atmosphere permeates *Morning Music* (plate 165). Here the color harmonies of gold and red underscore the opulence of the scene, creating a mood of languid contemplation.

Color is the main attribute of *The Blue Bower* (plate 166), in which Cornforth appears against a background of Oriental patterned tiles and passion flowers; the cornflowers in the foreground may be a pun on her name. The overall tonalities of blue and green contrast with the red orange of the model's hair, jewelry, and the dulcimer tassel to create a vivid play

Left
163. Joan of Arc, 1864
Watercolor on paper, 20¼ x 21¾ in.
Tate Gallery, London

Right
164. Mrs. Beyer, c. 1862
Pen and ink, sepia and brush on paper,
6⅜ x 4⁷⁄₁₆ in.
Fitzwilliam Museum, Cambridge, England

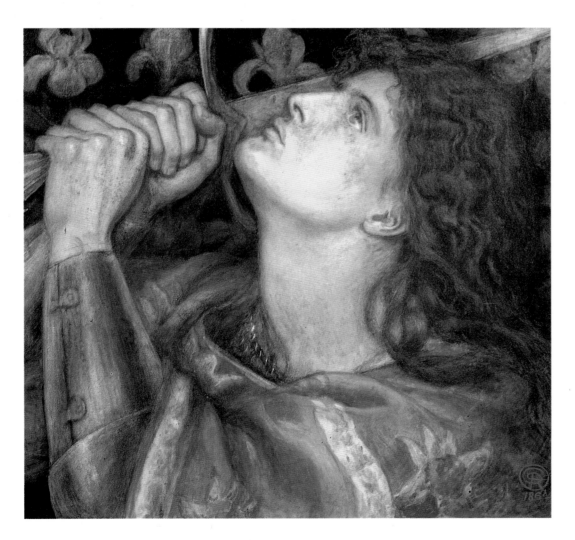

of sensual, almost barbaric color. The painting may relate to Rossetti's poem of 1860, *The Song of the Bower:*

> *What were my prize, could I enter thy bower...*
> *Large lovely arms and a neck like a tower,*
> *Bosom then heaving that now lies forlorn.*
> *Kindled with love-breath, (the sun's kiss is colder!)*
> *Thy sweetness all near me, so distant today;*
> *My hand round thy neck and thy hand on my shoulder,*
> *My mouth to thy mouth as the world melts away.*

Contrasting with this symphony of color is a drawing from the same year, *Study for "Washing Hands"* (plate 167); the finished painting shows

a man and woman at the end of a love affair. The linear purity and grace of the figure, modeled by Ellen Smith (plate 168), show Rossetti to have had as much command over line as he did over color. The same pose is echoed in an oil of 1865, *Il Ramoscello* (plate 169). The dark background with the monogram and date on the left and title lettered on the right resembles the backgrounds in various half-length portraits by Hans Holbein, one of which Rossetti saw at Hampton Court in 1861.[10] The sinuous curves of the lace, the brooch, and the interlaced dress decoration anticipate the Art Nouveau styles of the 1880s and '90s.

Inscribed on the frame of *The Beloved (The Bride)* (plate 170) are the

following verses: "My Beloved is mine and I am his, Let him kiss me with the kisses of his mouth for thy look is better than wine. She shall be brought unto the King in raiment of needlework: the virgins that be of her fellows shall bear her company, and shall be brought unto thee" (Song of Solomon 2:16, Psalms 45:14). The subject, though ostensibly biblical, offered Rossetti an excuse to portray Oriental opulence. The model for the bride was Marie Ford, a professional model; the woman on the right was Keomi, the Gypsy mistress of Frederick Sandys.[11] As a foil to the pale beauty of the bride, Rossetti did studies of a black girl (plate 172), replaced by a black boy (plate 171) in the finished painting. The idea for this juxtaposition may

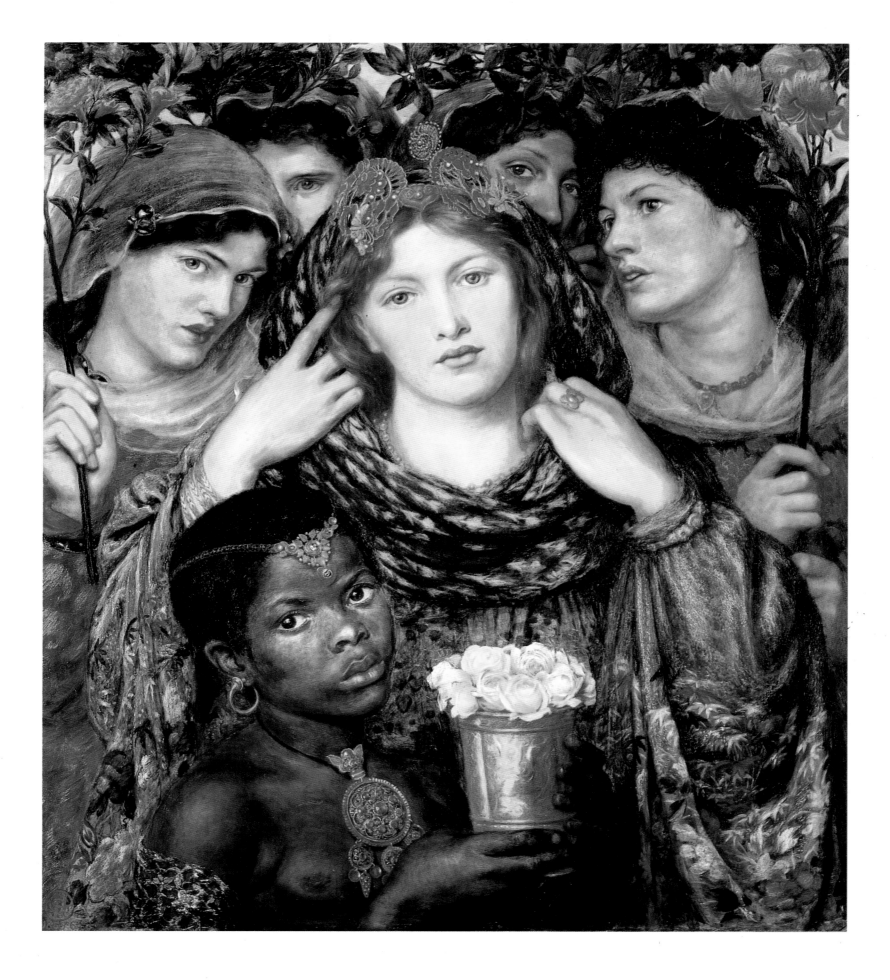

have come from seeing Edouard Manet's *Olympia* during Rossetti's visit with that artist in 1864.[12] Rossetti had gone to Paris in November 1864 to see the large retrospective in memory of Eugène Delacroix, who had died the previous year. Rossetti enjoyed and admired Delacroix's paintings, as he did those of Courbet, Millet, and Ingres. It was on this visit that Henri Fantin-Latour introduced Rossetti to Manet. Rossetti became acquainted with several other artists in the 1860s, particularly Frederick Sandys, who lived at 16 Cheyne Walk for almost a year and a half, and James Abbott McNeill Whistler. It was Rossetti who introduced Whistler to the joys of collecting blue-and-white china (plate 174), and there are a number of stories about their rivalry in acquiring it.[13]

174. *Rossetti's blue-and-white china collection*
The National Trust, Wightwick Manor,
Wolverhampton, England

In 1865 Rossetti and Charles Augustus Howell became good friends. Howell was Ruskin's secretary from 1865 to 1870 and worked as Rossetti's art agent during the 1870s; by 1873 he had sold sixty-eight paintings and drawings for him, taking a ten percent commission. Howell was also a friend of Whistler, who said of him, "criminally speaking, the Portugee was an artist."[14] Howell, who was born in Oporto, was involved in a number of questionable enterprises, but Rossetti appreciated his sales ability and his tall tales, describing him in a limerick:

> *There's a Portuguese person named Howell*
> *Who lays on his lies with a trowel.*

When he gives-over lying
It will be when he's dying
For living is lying with Howell. [15]

Rossetti was less amused, however, when Howell charged him 500 pounds for unspecified items in 1876, and their relationship ended soon after.

A new model entered Rossetti's work in 1865, appearing later in his study of Andromeda for *Aspecta Medusa*, a projected painting that was never brought to completion. This was Alexa (or Alice) Wilding, a dressmaker Rossetti saw on the street one evening, probably in July 1865. He paid her a weekly fee to sit for him exclusively, and her features show up

175. Frederick Sandys (1829–1904)
Portrait of Charles Augustus Howell, *1882*
Colored chalks on pale blue paper,
35⅞ x 21⅝ in.
Ashmolean Museum, Oxford, England

in a number of Rossetti's paintings, including *Monna Vanna*, *Sibylla Palmifera*, *La Ghirlandata*, *La Bella Mano* (plate 229), and *Lady Lilith* (plate 220). The Andromeda study is an early example of Rossetti's use of red chalk to make large drawings—a technique he developed in the late 1860s and 1870s.

Monna Vanna (plate 177) is the most Titianesque of Rossetti's "Venetian" paintings. The appellation *Monna Vanna* is taken from Dante's *Vita nuova*, *Monna* being a contraction of *Madonna*, or "my lady." The opulent sleeve prominently displayed on the right (plate 176) may have as its prototype Titian's *Portrait of a Poet (Probably Ariosto)*, acquired by the

176, 177. Monna Vanna, 1866
Oil on canvas, 35 x 34 in.
Tate Gallery, London

National Gallery in 1860. Writing about the painting, Stephens said: "*Monna Vanna* or *The Lady with the Fan*...has something that is evanescent and fickle in her expression, a self-centered character revealed by every feature, lovely as they are....A heart-shaped jewel of clear white crystal is suspended on her breast, a hard, cold, colourless gem that is significant of her soul and its influences."[16] He may have read more into this particular work than is actually there.

Sibylla Palmifera (plate 178), or "Soul's Beauty," is accompanied by

162

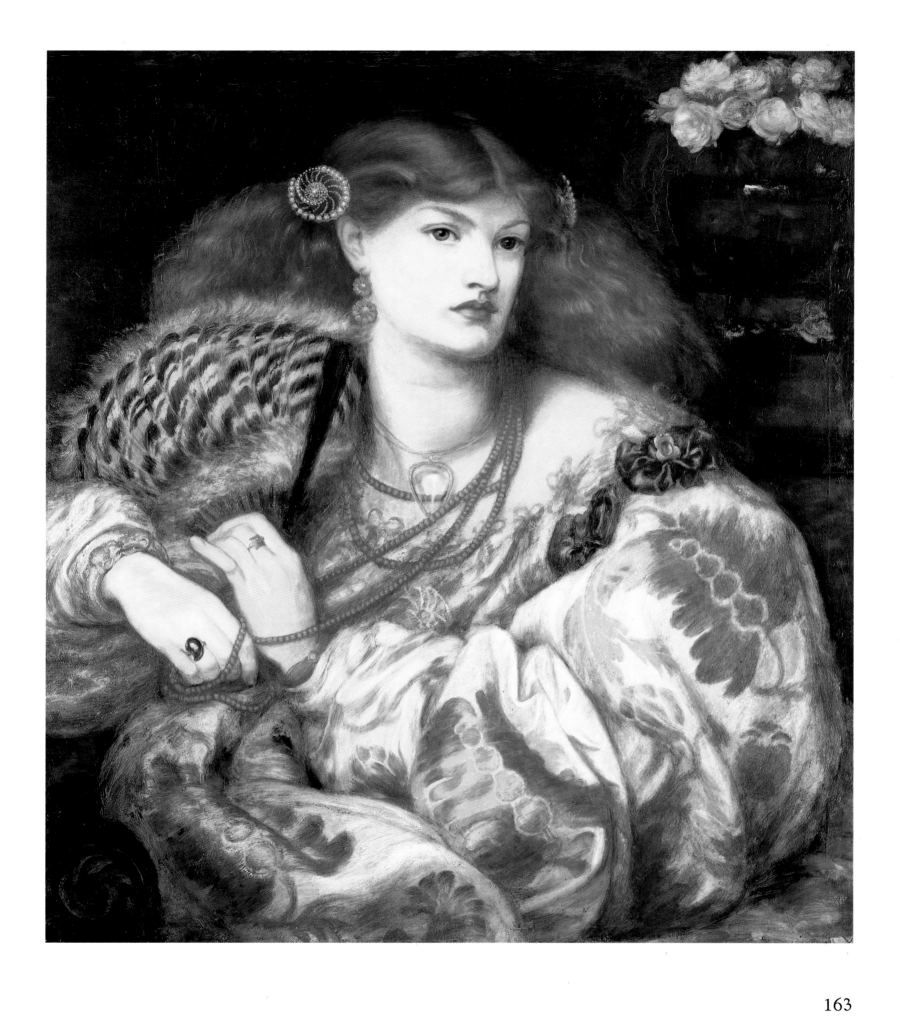

163

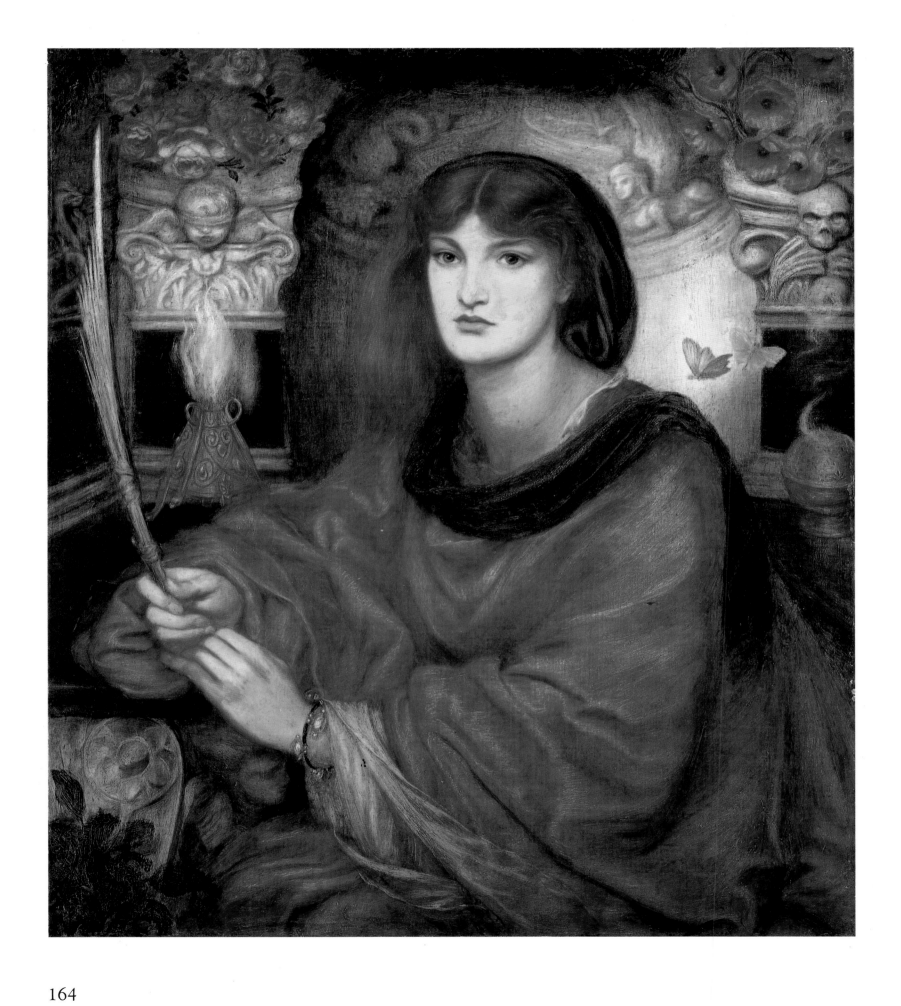

164

Sonnet 77 from Rossetti's *House of Life*, which identifies the painting's subject:

> This is that Lady Beauty, in whose praise
> Thy voice and hand shake still,—long known to thee
> By flying hair and fluttering hem,—the beat
> Following her daily of thy heart and feet,
> How passionately and irretrievably,
> In what fond flight, how many ways and days!

The palm in the woman's right hand may refer to the traditional symbol of victory, in this case symbolizing the triumph of beauty or the soul over death; the butterflies at right are traditional symbols of the soul. The work was commissioned by George Rae, one of Rossetti's most important collectors in the 1860s.

It has been suggested that the subjects and handling of Rossetti's late paintings were influenced by his patrons' desires; and the artist has been characterized as "a prisoner, albeit a willing prisoner, of his own business arrangements."[17] Even his brother acknowledged: "The gentlemen who commissioned or purchased his pictures {of beautiful women with floral adjuncts} are chiefly responsible for this result; as he, on the contrary, would in several instances have preferred to carry out as paintings some of his more important designs, including numerous figures of both sexes."[18] Shields reported that Rossetti was critical of his patrons' taste: "He held that the 'Lilliputian leanings' of English picture-buyers are prejudicial to the development of the grandest quality of design."[19] However, Rossetti did propose subjects to his patrons, and their commissions often enabled him to realize his own ideas and fantasies.

Because he did not exhibit at the Royal Academy or London galleries, Rossetti was dependent on a small group of picture buyers, mostly from the rising merchant class in provincial industrial centers. Most significant among them were Francis MacCracken, a Belfast shipping agent; Thomas E. Plint, a stockbroker from Leeds; James Leathart, a Newcastle lead merchant; J. H. Trist, a wine merchant from Brighton; William Graham, a member of Parliament from Glasgow; W. A. Turner, a Manchester manufacturer; George Rae, a Birkenhead banker; and Frederick Richard Leyland, a ship owner from Liverpool (and the owner of twenty-six of his drawings and twelve of his oils). The Londoners among his patrons tended to be professional men, such as James Anderson Rose, a solicitor; Clarence E. Fry, a photographer; F. S. Ellis, a publisher; and George P. Boyce, an

artist. Rossetti also had several important women patrons: the Dowager Marchioness of Bath, Ellen Heaton of Leeds, Barbara Leigh Smith Bodichon, and Lady Ashburton. Several of his patrons, such as Leyland and Graham, became Rossetti's good friends, and Graham and the William Cowper-Temples provided refuge and care for him during his various illnesses.

Though shrewd in his dealings with patrons and often responsive to their requests, Rossetti was far from fawning over them. Although Francis MacCracken, for example, was an important patron, Rossetti's attitude toward him was usually mocking. He wrote a biting parody in 1853 of Tennyson's poem *The Kraken* on the subject of MacCracken (here obviously pronounced with a long *a* to rhyme with *Kraken*).

179. Frederick Richard Leyland, 1879
Crayon on paper, 18 x 15⅛ in.
Delaware Art Museum, Wilmington;
Samuel and Mary R. Bancroft
Memorial Collection

> *Getting his pictures, like his supper, cheap,*
> *Far, far away in Belfast by the sea,*
> *His watchful one-eyed uninvaded sleep*
> *MacCraken sleepeth. While the P.R.B.*
> *Must keep the shady side, he walks a swell*
> *Through spungings of perennial growth and height:*
> *And far away in Belfast out of sight*
> *By many an open do and secret sell,*
> *Fresh daubers he makes shift to scarify,*
> *And fleece with pliant shears the slumbering "green"*
> *There he has lied, though aged, and will lie,*
> *Fattening on ill-got pictures in his sleep,*
> *Till some Preraphael prove for him too deep,*
> *Then, once by Hunt and Ruskin to be seen,*
> *Insolvent he will turn, and in the Queen's Bench die.*[20]

That Rossetti did not deal with MacCracken very kindly visually either is evident from his cartoons of the patron receiving Deverell's *Banishment of Hamlet*, which that artist had substituted for the *Twelfth Night* painting requested by MacCracken (plates 180, 181).

It was Rossetti's practice to set prices for each work in terms of its size, medium, number of figures, and subject matter. As his reputation grew, his prices increased. In dealing with collectors, he usually required payment of an advance when the work was commissioned, another sum when it was well along, and the final amount on completion. This system was complicated by Rossetti's habit of borrowing from his patrons against the completed work; for major patrons such as Leyland he was usually

Top
180. Untitled (Cartoon of MacCracken),
May 31, 1853, letter to Walter Deverell
The Huntington Library,
San Marino, California

Bottom
181. Untitled (Cartoon of MacCracken),
c. 1853 letter to Walter Deverell
The Huntington Library,
San Marino, California

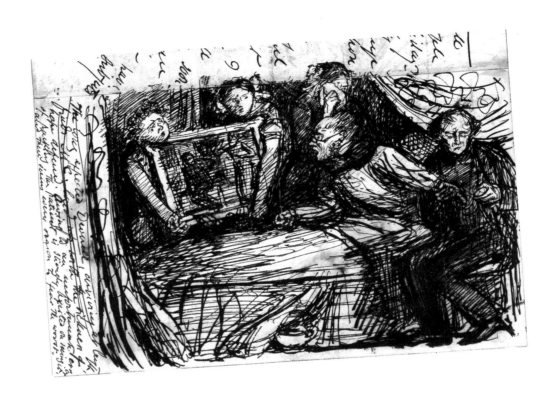

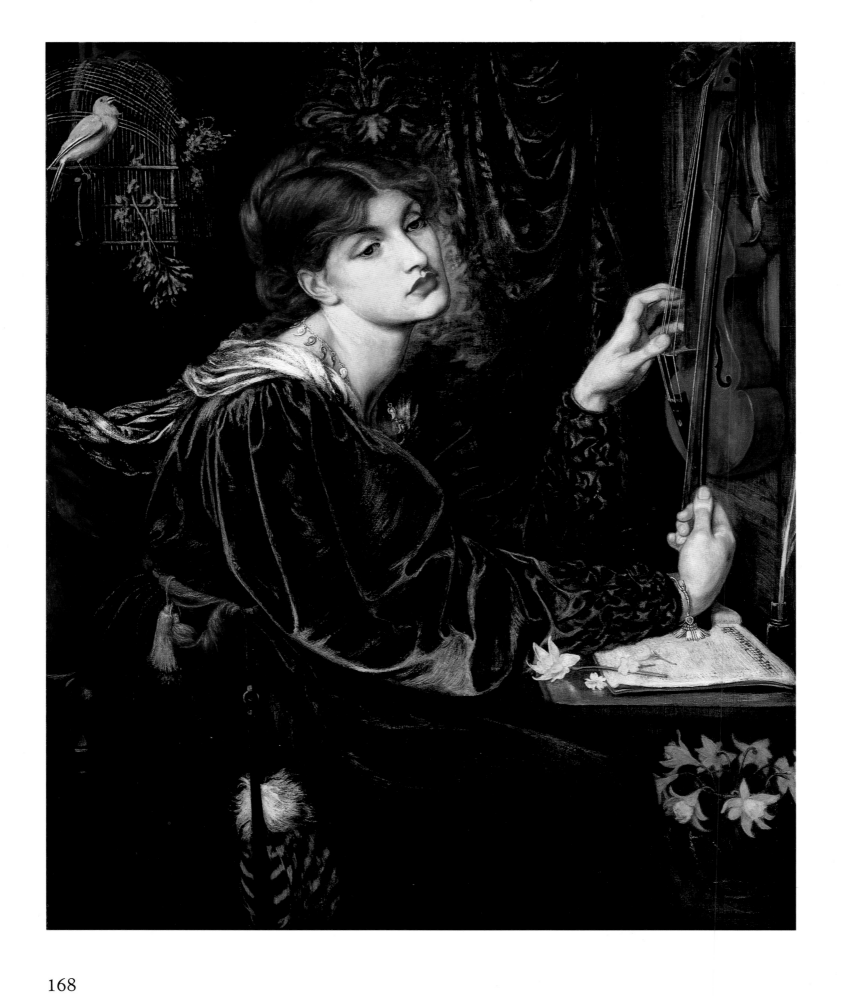

168

working on a number of paintings, in all stages from conception to nearly finished canvases. Rossetti was adamant about keeping control of exhibition and reproduction rights. Because he believed so strongly that most engravings or woodcuts did not do justice to his works, he refused to sell rights to reproduce them, even though that could have earned him several thousand pounds.

Rossetti sold works to dealers as well as private patrons, although usually with reluctance. He nicknamed Leonard Rowe Valpy "the Vampire," wrote rather rude limericks about both the Agnews and Ernest Gambart, and portrayed Gambart as Judas in his cartoon for the stained-glass *Sermon on the Mount* (plate 113).

Rossetti described his patrons' taste to Shields in a letter of January 12, 1871: "They are special men who buy special things and almost never effect a divergence from their limited loves."[21] Leyland, for example, liked single-figure compositions with musical instruments in them, such as *Veronica Veronese* (plate 182), which shows Alexa Wilding plucking the strings of a violin as she seeks inspiration by listening to a caged bird—an image personifying art's reliance on nature. Some collectors, such as J. H. Trist, collected works by a large group of Pre-Raphaelite artists, including Brown, Burne-Jones, and Hughes. Two collectors, Leyland and Graham (the two who owned the greatest number of Rossetti's paintings), displayed his work alongside that of Renaissance painters. Graham favored a juxtaposition with Botticelli, whose work he felt Rossetti's resembled.[22] Leyland's collection, while not as extensive as Graham's, included paintings by Botticelli, Fra Filippo Lippi, Crivelli, Tintoretto, Giorgione, Velázquez, Rubens, Francia, Rembrandt, and Memling, as well as Whistler's famous Peacock Room and paintings by Millais, Brown, William Windus, James Smetham, Sandys, and Burne-Jones.

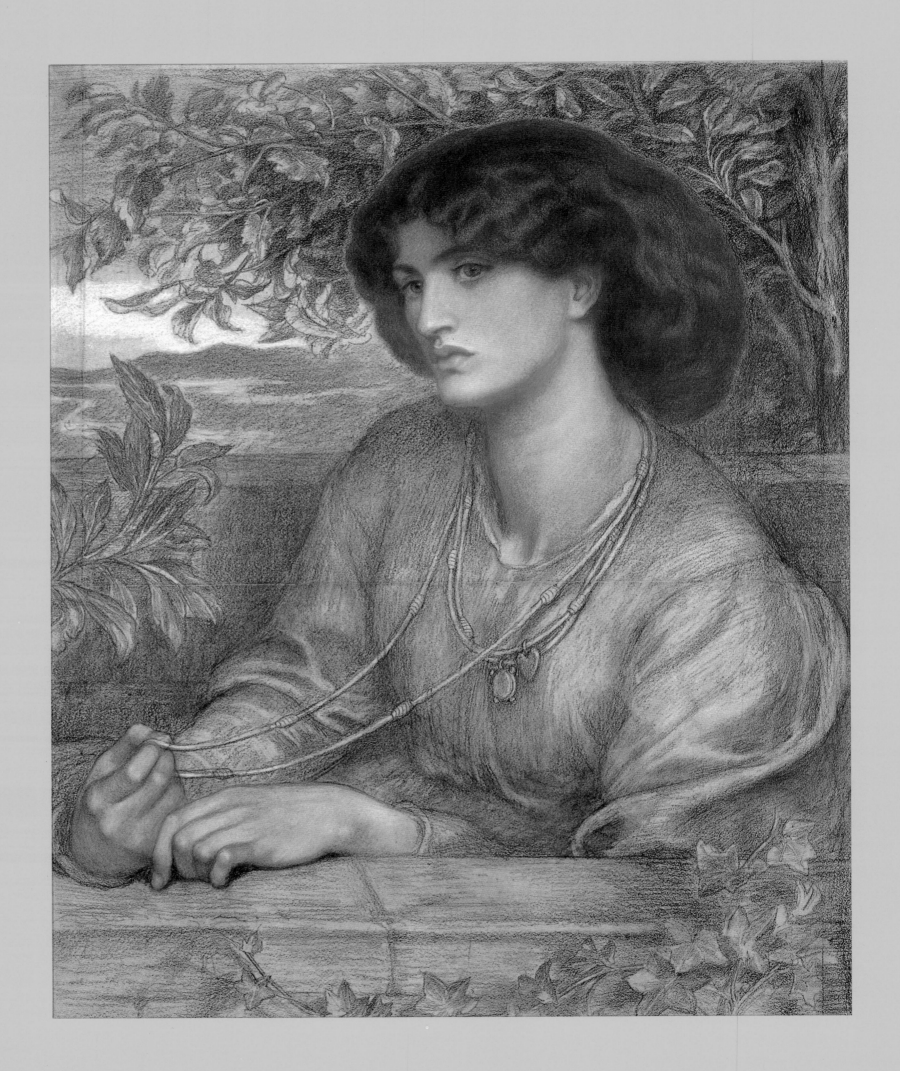

JANE MORRIS

183. Aurea Catena (Portrait of
Mrs. Morris), c. 1868
*Graphite and colored chalks on
blue wove paper faded to greenish gray,
30⅜ x 24⅝ in.
The Harvard University Art Museums
(Fogg Art Museum),
Cambridge, Massachusetts;
Bequest of Grenville L. Winthrop*

ane Burden had first entered Rossetti's life in 1857 as the Oxford "stunner" who modeled for Queen Guinevere and several drawings. After Rossetti married Siddal and Burden married William Morris, the two young couples, along with Ned and Georgiana Burne-Jones, saw each other often. The Morrises modeled for the heads of Mary and David the King in Rossetti's *Seed of David* altarpiece (plate 118), completed in 1864, but it was not until 1865, three years after Siddal's death, that Jane Morris started sitting regularly for Rossetti. It has been suggested that Rossetti had fallen in love with Burden but married Siddal out of a sense of responsibility.[1] However, there is no documentary evidence to this effect, and given Rossetti's imperious, impetuous character, it seems probable that if he had really been deeply in love with Burden (whom he had, after all, just met) in 1857, he would not have gone off to Siddal.

In 1865 William Morris was forced to sell Red House and move to London with his family, as his yearly income of about 900 pounds had fallen to 450 pounds. Jane was ill, suffering the first of many illnesses that would plague her, and Morris had to develop the Firm into a business that could help support the family. He and Jane had two daughters: Jane Alice (called Jenny), born in January 1861, and Mary (called May), born on March 25, 1862. Jane had started embroidering designs for the Firm in 1861, and her needlework (which May eventually continued) was to make an important contribution to the Firm's reputation and income.

The year Jane Morris moved into town Rossetti had her pose for a series of photographs in his garden at 16 Cheyne Walk (plate 185). Several of these were used as *aides mémoires* for Rossetti paintings, including *Reverie* of 1868 (plate 184), *The Roseleaf*, and *La Pia de' Tolomei* (plate 188).[2] Rossetti's first large oil portrait of Jane Morris (plate 186) was envisioned as early as 1866[3] but not finished until 1868. The Latin inscription at the top of the canvas translates: "Famous for her poet husband, and famous for her face, may my picture add to her fame." A pink carnation lies on an open book, and there are white roses nearby. In the "language of flowers," a white rose means "I am worthy of you," and a pink carnation stands for

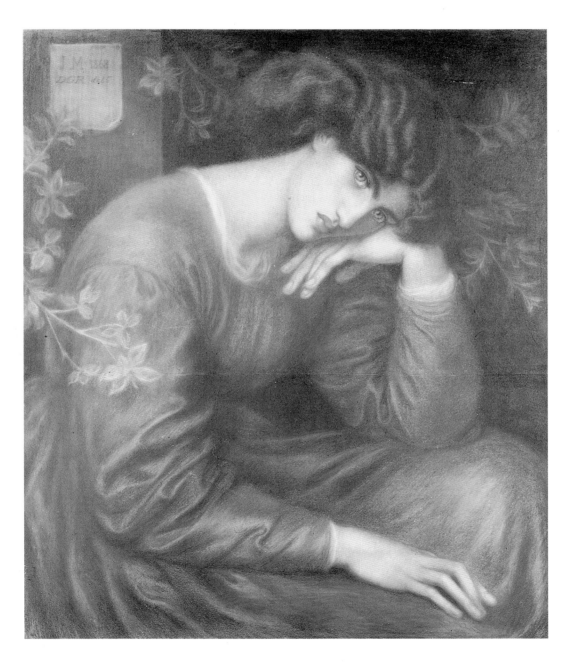

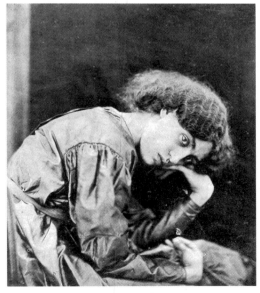

Left
184. Reverie, 1868
Colored chalks on paper, 33 x 28 in.
Ashmolean Museum, Oxford, England

Right
185. Jane Morris, 1865
Photograph
Victoria and Albert Museum, London

woman's love, or as Leigh Hunt wrote in his *Love Letters Made of Flowers*,

One's sighs and passionate declarations
In odorous rhetoric of carnations.[4]

Mariana (plate 187)—a similar painting, with Morris in the same blue silk dress—was started in 1868, though not finished until 1870. The subject comes from Shakespeare's *Measure for Measure*, act 4, scene 1, where a page sings, "Take, O take those lips away, That so sweetly were foresworn" (the entire verse is inscribed on the frame).

Left
186. Mrs. William Morris, 1868
Oil on canvas, 43½ x 35½ in.
Society of Antiquaries of London

Right
187. Mariana, 1870
Oil on canvas, 43 x 35 in.
Aberdeen Art Gallery and Museums,
Aberdeen, Scotland

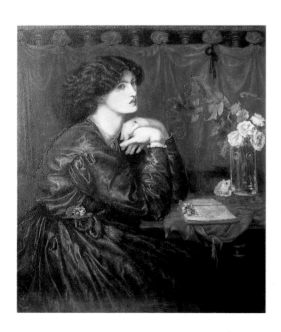

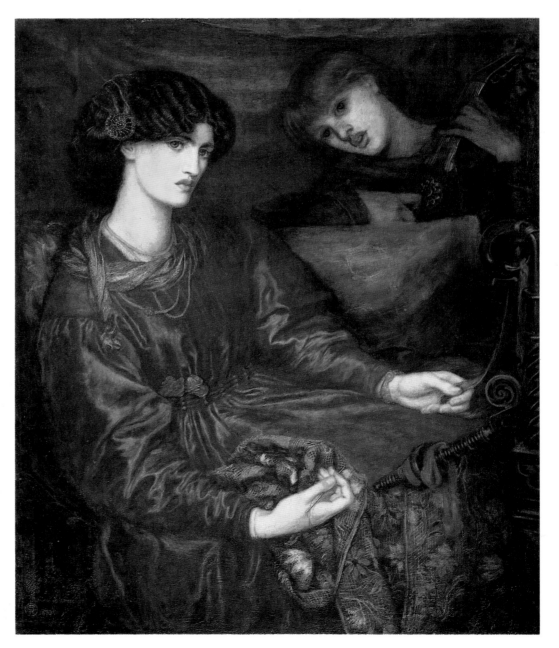

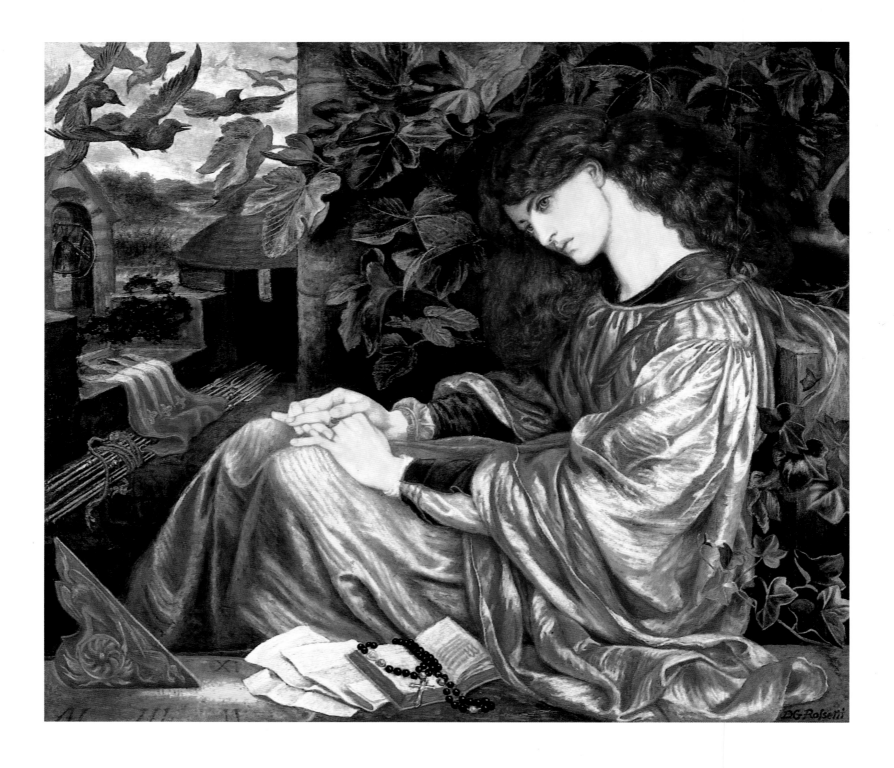

At the end of April 1868 Rossetti gave a party for the Morrises to celebrate Jane's sitting for *La Pia de' Tolomei*. He was to work on this painting for thirteen years—almost the same length of time as his close friendship with Jane Morris was to endure. *La Pia de' Tolomei* was one of the first in his series of symbolic portraits of Morris in situations or personae that expressed Rossetti's perceptions of her circumstances, her character, and his feelings for her. Pia de' Tolomei, the daughter of a Sienese family, married

Above and opposite, right
188, 191. La Pia de' Tolomei, 1868–81
Oil on canvas, 41½ x 47½ in.
Spencer Museum of Art, University of
Kansas, Lawrence

174

a Guelf lord who took her to Pietra in the Maremma marshes; there she died in 1295, either from exposure to the poisonous air or from a more expeditious poison. She appears in canto 5 of Dante's *Purgatory*, among the victims of sudden deaths. Morris is represented in a pose similar to several in the 1865 photographs; she had copied the shimmering peach robe from a portrait Rossetti owned of Smeralda Bandinelli, attributed to Botticelli.[5] La Pia is fingering her wedding ring; on the right are sprays of ivy, sometimes interpreted as symbolizing life in death. The fig branches in the background came from a sketch supplied by Shields (plate 190);[6] Charles Fairfax Murray sent landscape drawings of the Maremma and towers of the Castello della Pietra to Rossetti from Italy in 1880.

A biographer said of William Morris: "In one of his tempers, he was capable of almost anything. His 'tempestuous and exacting company' in the phrase of one of his most intimate friends, had something of the quality of an overwhelming natural force."[7] Such a man would not have been easy to live with, and Rossetti's portrayal of La Pia may have expressed his belief

that Jane was a martyr to William's demands. William Morris's feelings can be surmised, in part, from his *Earthly Paradise* (1868), which contained the lines:

> *Ah, has it come to pass, and hast thou lost*
> *A life in Love, and must thou still be tossed*
> *One moment in the sun 'twixt night and night?*

Years later, he was to say to a friend, "Sometimes Rossetti was an angel, and sometimes he was a damned scoundrel."[8]

In 1867 Rossetti had begun suffering from eye trouble, which was particularly distressing since his father had been nearly blind when he died. He consulted a number of doctors, but found no organic cause of the problem. After the 1868 party for the Morrises, his eyesight deteriorated still further, and he had to give up painting entirely. He wrote to his solicitor, James Anderson Rose, on October 19, 1868: "I am suffering from the most alarming of all ailments—a sudden and persistent deterioration of eyesight. . . . In connection with this it is most necessary that I should see you and consult you respecting arrangements which the future may call for imperatively."[9] William Bell Scott, who knew Rossetti well, commented in a letter to Alice Boyd, on November 9, 1868: "Gabriel has not tried painting, nor seen any doctor, nor seen the sweet Lucretia Borgia {Scott's name for Jane Morris}. I have now come to the conclusion . . .—that the greatest disturbance in his health and temper. . . is caused by an uncontrollable desire for the possession of the said L.B."[10] By the end of 1868 Rossetti's eyesight had returned, and he was painting Jane Morris again.

Because of Jane's own health problems, Morris took her abroad in the summer of 1869 to the spa at Ems, Germany. Rossetti corresponded frequently with her, often sending amusing sketches to enliven his letters (plates 192–94). The following February he put levity aside to write: "No one else seems alive at all to me now, and places that are empty of you are empty of all life. . . .You are the noblest and dearest thing that the world has had to show me, and if no lesser loss than the loss of you could have brought me so much bitterness, I would still rather have had this to endure than have missed the fullness of wonder and worship which nothing else could have made known to me."[11] In Jane Morris he had found an inspiration that was both spiritual and sensual. As William Rossetti put it, "It seemed a face created to fire his imagination, and to quicken his powers—a face of arcane and inexpressible meaning. To realize its features was difficult; to transcend its suggestion, impossible."[12]

By 1870 the love affair between Rossetti and Jane Morris was obvious to all. One of their contemporaries later reminisced: "My most representative recollection of him is of his sitting beside Mrs. Morris, who looked as if she had stepped out of any one of his pictures, both wrapped in a motionless silence as of a world where souls have no need of words."[13] Possibly to make the affair less public, Jane Morris visited Rossetti in April

Resolution;
or, The Infant Hercules.

The German
Lesson

The M's at Ems

and May at Scalands, at a cottage in East Sussex loaned him by Barbara Leigh Smith Bodichon, a leading feminist who had been a good friend of Rossetti and Siddal. To give a semblance of respectability to the visit, William Morris took Jane there and brought her back. The same desire for respectability was no doubt the reason Rossetti and William Morris took a joint lease on Kelmscott Manor, in Oxfordshire, in the summer of 1871. Morris had progressive ideas about marriage and refused to see marriage as a narrow property contract; he also knew that he had failed to make his wife happy. None of the three, however, desired a scandal.

Rossetti wrote enthusiastically about Kelmscott Manor to his mother on July 17, 1871: "This house and its surroundings are the loveliest 'haunt of ancient peace' that can well be imagined—the house purely Elizabethan in character"[14] (plate 195). The original gray-stone manor house, by Richard Turner, had been finished about 1571, with the northeast wing added in 1670. Its medieval quality greatly appealed to William Morris, who hated the ugliness of nineteenth-century buildings. Rossetti's description of it as a "haunt of ancient peace" comes from Tennyson's poem *The Palace of Art*, an apt source since Kelmscott Manor was to become a palace of art for Rossetti. William Morris took Jane to Kelmscott in early July 1871, then left for Iceland on the sixth to do research on his Nordic saga; Rossetti moved to Kelmscott six days later while Philip Webb enlarged his Cheyne Walk studio. Rossetti wrote rather snidely to Webb, "Let us hope Top {Morris} is up to his navel in ice by this time and likes it."[15]

Opposite, bottom left
198. Head of a Girl (May Morris?), 1874
*Black and red chalks on green
paper, 36 x 24 in.
Birmingham City Museum and Art Gallery,
Birmingham, England*

Opposite, bottom right
199. Mary Magdalene, 1877
*Oil on canvas, 30 x 25½ in.
Delaware Art Museum, Wilmington;
Samuel and Mary R. Bancroft
Memorial Collection*

195. The East Front, Kelmscott Manor

Left
196. Jenny Morris, 1871
Colored chalks on pale blue gray paper,
17¼ x 15½ in.
Society of Antiquaries of London

Right
197. May Morris, 1871
Colored chalks on pale blue gray paper,
17¼ x 15½ in.
Society of Antiquaries of London

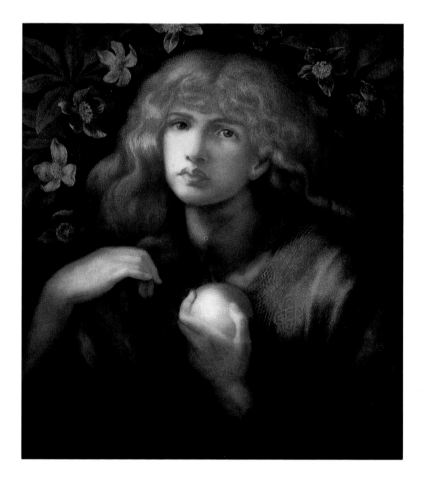

Rossetti and the Morris daughters were very fond of each other. That year he did portraits of Jenny (plate 196) and May (plate 197) that capture their features with great delicacy and sensitivity. He delineated May's features again in 1874 (plate 198), and she was probably the model for a head of Mary Magdalene (plate 199) done in 1877. Rossetti's readi-

ness to share the sisters' games and enthusiasms is evident from his letter of December 22, 1875:

> *Dear Jenny and May,*
>
> *A mind (of no common order) has conceived for your benefit the idea of isolating from a well-known series of the British Drama, all Fiends, Spectres, Vampires and other persons of any interest. A second mind (of the executive class) will carry out this conception presently in the metropolis itself; and the result will not be long before it reaches you in the form of a Christmas Box. Lest the Box, by virtue of its contents, should too much resemble a coffin, a sufficient proportion of the comic drama will be admitted to keep your hair only partially on end.*
>
> *Yours affectionately,*
> *The Third Gravedigger*
>
> *P.S. Ha! fiend, I know thee now.*[16]

Rossetti had his studio in the Tapestry Room at Kelmscott Manor, which was hung with a series of four seventeenth-century Flemish tapestries depicting the life of Samson (plate 200). This milieu was occasionally distracting, as he indicated to Scott in 1871: "I am writing in my delightful sitting-room or studio, the walls of which are hung with tapestries.... The subject of the tapestries is the history of Samson, which is carried through

200. The Tapestry Room, Kelmscott Manor

with that uncompromising uncomfortableness peculiar to this class of art manufacture. Indeed, I have come to the conclusion that a tapestried room should always be much dimmer than this one. These things constantly obtruded on one in a bright light become a persecution."[17]

Jane and her daughters returned to London at the end of the summer, while Rossetti remained at Kelmscott Manor until later that autumn. During his stay he had written a number of sonnets for his *House of Life*, and painted or drew a number of works, mostly of Jane; his second stay at Kelmscott, from 1872 to 1874, would also be a time of great productivity.

In 1869, after Rossetti's unnerving loss of eyesight, he had begun to consider publishing his poetry as an alternative source of income and of fame. The woman he loved was married to a successful poet, and even though he could mock William Morris as a petty tradesman (plate 201) or predict "Topsy's" fall from grace in socialism (plate 202), he could not ignore Morris's achievements as a poet. Unfortunately, the sole copy of many of the poems Rossetti wanted to publish lay in Highgate Cemetery with Elizabeth Siddal, where the grieving poet had put them at the time of her burial in 1862. The only solution was to exhume the coffin and the poems. A letter from Rossetti to the invaluable Charles Augustus Howell, dated August 16, 1869,[18] gave permission for the exhumation, which took place October 5. The book was well enough preserved to be used as a guide for the first collection of Rossetti's poems, which was published by F. S. Ellis in April 1870.

The book contained fifty sonnets entitled "Towards a Work to Be Called 'The House of Life,'"—which had almost all been inspired by Jane Morris—as well as poems that had originated as early as the 1840s. The first edition of one thousand copies sold out promptly, in part because Rossetti had used his network of friends to review the work favorably: Swinburne in the *Fortnightly Review* (May 1870), William Morris (ironically enough) in the *Academy* (May 14, 1870); John Skelton in *Fraser's Magazine* (May 1870); Joseph Knight in the *Globe* (April 20, 1870) and the *Sunday Times* (May 1, 1870); Westland Marston in the *Athenaeum* (April 30, 1870); William James Stillman in *Putnam's New Monthly Magazine* (1870, volume 6, pages 95–101); W. D. Howells in *Atlantic Monthly* (July 1870); and Sidney Colvin in the *Pall Mall Gazette* (April 21, 1870). Rossetti received letters of congratulation from Robert Browning, George Eliot, George Meredith, Sir Henry Taylor, and Tennyson, among others. All this praise left him totally unprepared for the belated thunderbolt of criticism from Robert Buchanan in the *Contemporary Review* of October 1871.

Possibly because William Rossetti had criticized Buchanan in 1866 in the course of defending Swinburne's *Poems and Ballads*, or possibly because Buchanan believed that Rossetti had plagiarized his poem *Artist and Model* for *Jenny*, he attacked Rossetti with a vengeance in a review entitled "The Fleshly School of Poetry," signed with the pseudonym Thomas Maitland. "Mr. Rossetti is affected, naturally affected," he wrote, "but it must have taken him a great deal of trouble to become what we see him—such an excess of affectation is not in nature." He continued, "Whether he is writing of the holy Damozel, or of the Virgin herself, or of Lilith, or of Dante, or of Jenny, the streetwalker, he is fleshly all over, from the roots of his hair to the tip of his toes. . . . Never spiritual, never tender; always self-conscious and aesthetic." He finished up by describing Rossetti's poetry as "a stupendous preponderance of sensuality and sickly animalism."[19] (These accusations of "sensuality" and "animalism" were particularly charged in Victorian times, branding Rossetti as immoral, uncivilized, and sexually irresponsible.)

Not surprisingly, Rossetti's first impulse was to challenge the reviewer to a duel. Instead, he replied in a letter to the *Athenaeum* of December 16, 1871, explaining that "Maitland" had distorted his material by quoting it out of context and defending his poetry from the charge of "animalism": "For here all the passionate and just delights of the body are declared—somewhat figuratively, it is true, but unmistakably—to be as naught if not ennobled by the concurrence of the soul at all times." None-

theless, other journals not primed by Rossetti's chosen reviewers—the *Saturday Review,* the *Quarterly,* and *Blackwood's Magazine,* among others—supported "Maitland's" criticism in whole or in part, and in May 1872 Buchanan published an expanded version of "The Fleshly School of Poetry" in pamphlet form. Rossetti had avoided adverse criticism for years by selling most of his work privately and by seldom publishing his poems. He was unusually sensitive to any criticism at all, and these attacks convinced him that he was the victim of a conspiracy—as his father had believed about his own work, many years before. He was also terrified that his liaison with Jane Morris had somehow been discovered and that her name would be sullied. The result was Rossetti's nervous breakdown and his attempt, in June 1872, to commit suicide by taking laudanum, as his wife had done. He recovered slowly and was finally able to go to Kelmscott Manor on September 24, 1872, attended by George Hake, son of his friend Dr. Thomas Gordon Hake.

Rossetti's sojourn at Kelmscott in 1872–74 removed him from the public eye and allowed him to recuperate partially from the attack, although he suffered recurring bouts of persecution mania, often brought on by excessive use of chloral taken with whiskey in an effort to cure his insomnia.

He had the support of a number of friends, and his artistic skills continued unabated, as his two brilliant portraits of Thomas Gordon Hake and George Hake make clear.[20] Rossetti consulted the solicitor Theodore Watts-Dunton about a legal matter at this time, and a friendship ensued that sustained the artist until the end of his life. Jane Morris and her daughters periodically stayed with Rossetti at Kelmscott, and whenever they would return to London he was able to get models such as Alexa Wilding to come down to Kelmscott to pose. In July 1873 William Morris went back to Iceland, and Jane spent over two months with Rossetti at Kelmscott. His mother and sister also visited in July 1873, especially enjoying the gardens in full bloom.

On April 16, 1874, Morris wrote to Rossetti that he would no longer be able to pay for his share of Kelmscott Manor. This amounted to an eviction notice, since even if Rossetti had taken over the lease, Jane could no longer have visited him with propriety. Soon after receiving William's letter, Rossetti picked a violent quarrel with some local fishermen, which started rumors about his mental state. His health began to suffer, and in July he left Kelmscott Manor for his Cheyne Walk establishment, never to return. That autumn, William Morris took sole control of the Firm, which became Morris and Company. He eventually compensated Rossetti and some of the other original stockholders for their shares by a payment of 1,000 pounds—which Rossetti settled on Jane Morris.

During his few years at Kelmscott, Rossetti enjoyed a great resurgence of creative powers, both in art and literature. He worked on a number of major oil paintings, including *La Ghirlandata* (plate 206), which was modeled by Alexa Wilding; the angel heads were posed by May Morris in the summer of 1873. He used a landscape he had painted in 1850 at Knole Park as the background for an oil painting and a pastel (plates 9, 210) entitled *The Bower Meadow*. Maria Spartali Stillman was the model for the woman at left, Alexa Wilding for the one at right. This is an unusual painting in Rossetti's oeuvre as it takes place out of doors and has a number of figures. The theme may be music and dance, with the contrasting hues of green and reddish-pink underscoring the complementary modes.

Jane Morris was the model and inspiration for a series of drawings, pastels, and an oil painting on the subject of Pandora (plate 211), which he had begun in 1869. A striking aspect of all the representations is the emphasis on the box containing Hope, inscribed "ULTIMA MANET SPES" (Hope remains at last) in one version, which could describe Jane Morris as the bearer of hope for Rossetti, both as a man and as an artist. J. Lem-

205. Theodore Watts-Dunton, *1874*
Crayon on paper, 20 x 15 in.
National Portrait Gallery, London

206. La Ghirlandata, *1873*
Oil on canvas, 45½ x 34½ in.
Guildhall Art Gallery, London

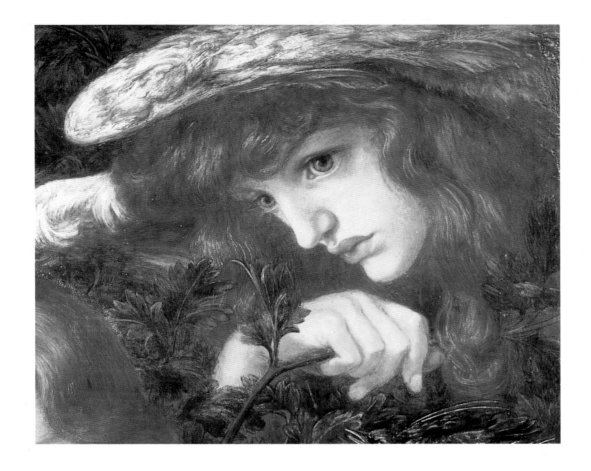

207–9. *Details of* La Ghirlandata, *1873*
See plate 206

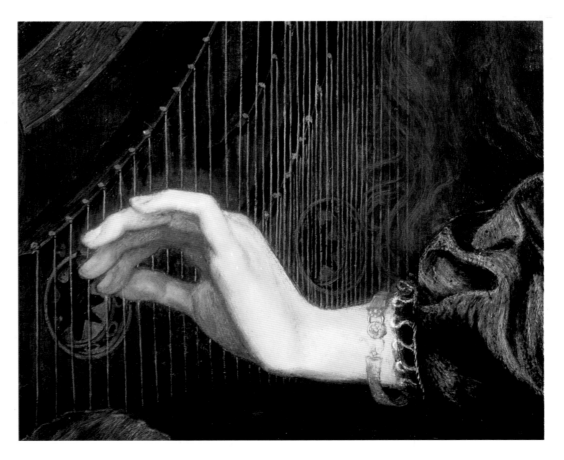

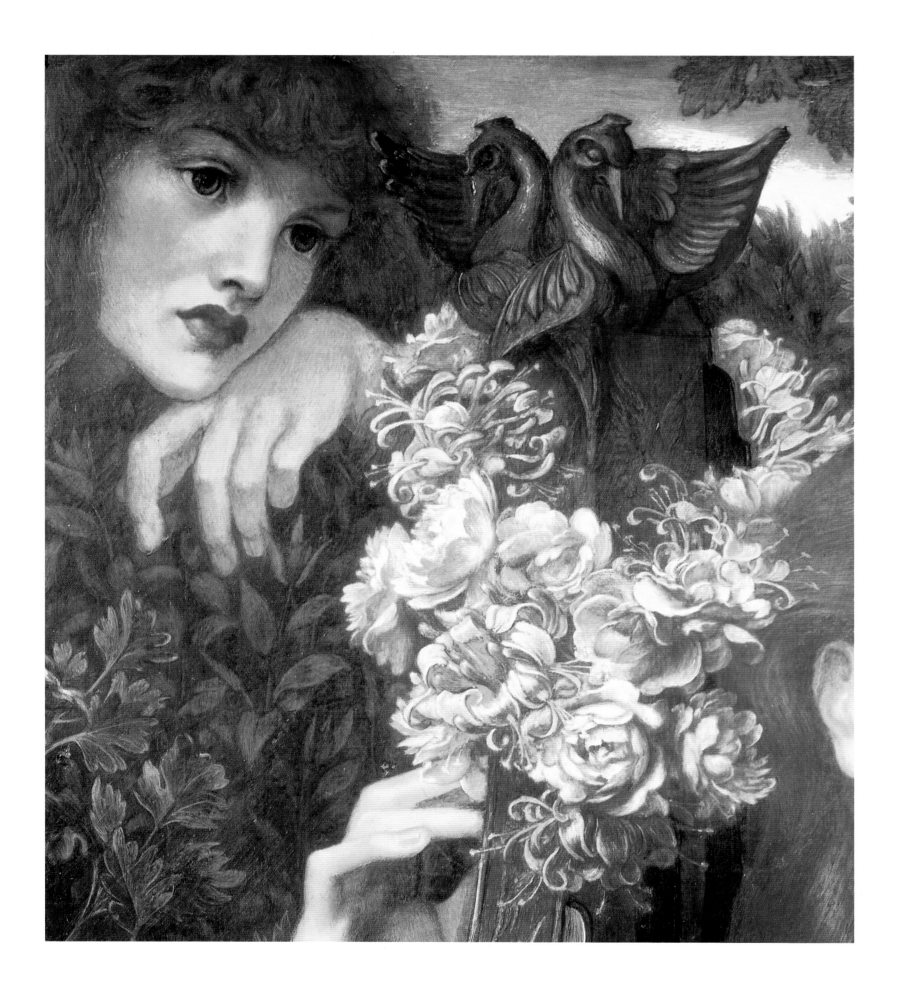

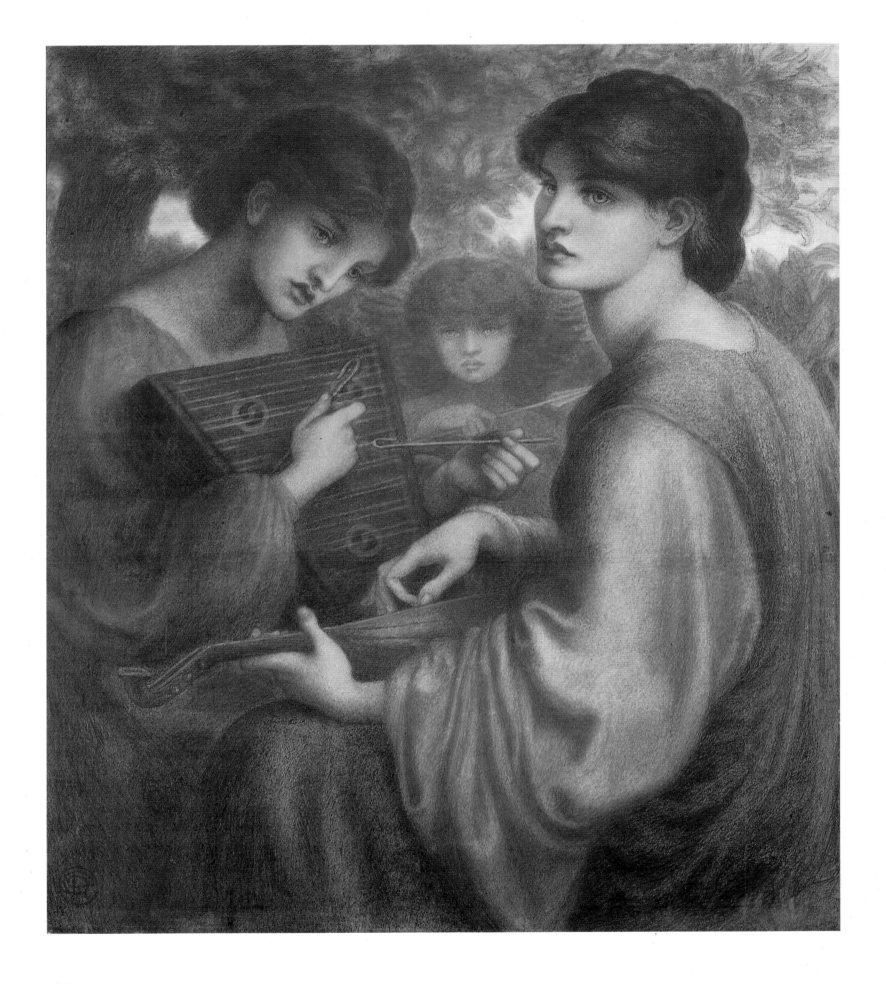

188

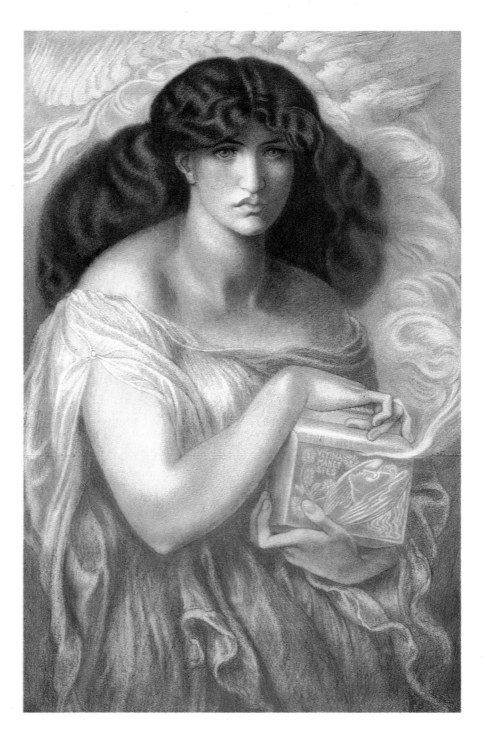

Opposite
210. The Bower Meadow, c. 1872
Pastel on paper, 31 x 26⅛ in.
Fitzwilliam Museum, Cambridge, England

211. Pandora, 1879
Colored crayon on paper, 38 x 24½ in.
The Harvard University Art Museums
(Fogg Art Museum),
Cambridge, Massachusetts

prière's classical dictionary, which Rossetti used for his mythological pictures, suggests another reason for Rossetti's equation of Morris with Pandora: "The woman was called Pandora which intimates that she had received every necessary gift,"[21] surely a delicate and heartfelt compliment to his beloved.

Between 1871 and 1877 Rossetti worked on eight different paintings on the theme of Proserpine (plate 212), for which Morris provided both the meaning and the model. He described his vision of the goddess in a

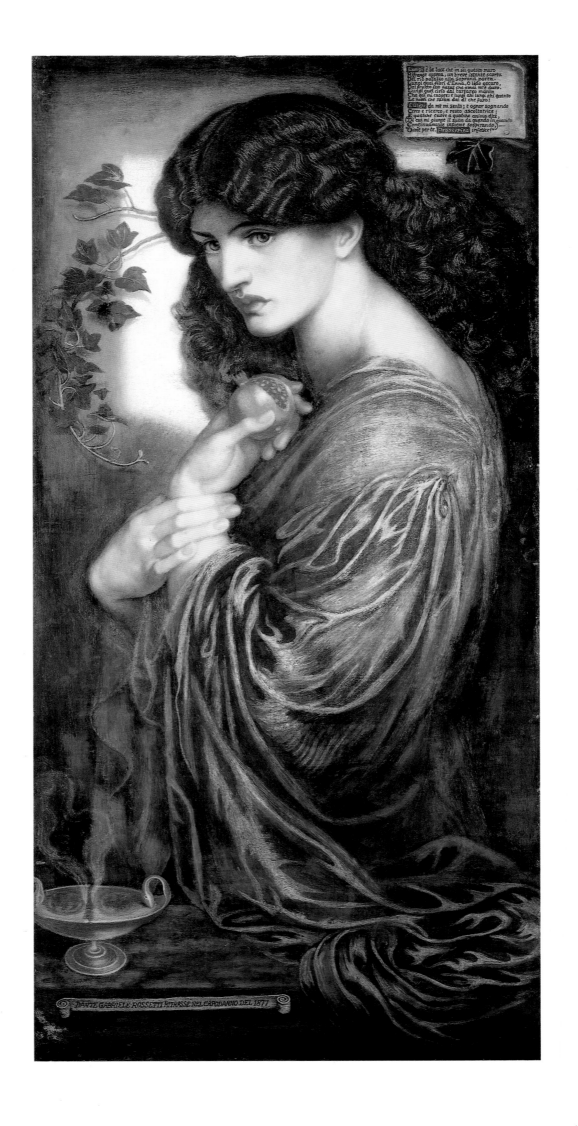

letter to Frederick Leyland, on October 4, 1873: "The conception of the figure is connected with the legend by which Proserpine (having fatally partaken of a pomegranate in Hades & so excluded herself from permanent return to earth which would otherwise have been granted her) was permitted to spend one half the year in the upper light. . . . Proserpine looks yearningly towards the momentary light which strikes into her shadowy palace; and the clinging ivy which strays over the wall (in the picture) further suggests the feeling of Memory. . . ."[22]

In many ways, this image of Proserpine—who had been abducted by Pluto to be queen of Hades—summed up Rossetti's view of Jane Morris as a goddess bound to a husband from whom she was only occasionally released to joy and light. The incense burner on the left denotes a goddess; the pomegranate is a symbol of her captivity and her marriage, and it may also refer to the Christian adaptation of the pomegranate to symbolize life after death. The dark robe contrasts with the pale face of the goddess and with the lighter accents of the gold incense burner and red-orange pomegranate. The draperies fall in a curvilinear pattern that echoes the arc of the ivy spray and the rippling dark hair of Proserpine.

Although he wrote his own poem for the painting (on the tablet at upper right), Rossetti may also have been inspired by Swinburne's *Hymn to Proserpina* and *Garden of Proserpina*, both published in 1866; and by a poem on Proserpine by Aubrey De Vere (which Rossetti referred to in a letter of March 6, 1856, to Allingham[23]), with the haunting refrain:

> *Must I languish here forever*
> *In this empire of Despair?*[24]

From October 1875 to June 1876 Rossetti stayed at Aldwick Lodge, near the seaside resort of Bognor Regis, Sussex. It was there that Jane Morris visited him, alone, from early November through March, returning to London only to spend Christmas with her family. While at Aldwick Lodge, Rossetti worked on *Astarte Syriaca* (plate 213) with Morris as model, one of the most impressive and evocative works of his career. The head is taken from a pastel of Jane Morris (plate 215) done in 1875; the head of the attendant at left was modeled by May Morris (plate 214). The gesture of the main figure derives from the Medici Venus, the most respected and copied emblem of female beauty in Victorian times. The proportions are almost Mannerist, with a small head on a massive and elongated body. The girdle of roses and pomegranates symbolizes passion and resurrected life. The green of the robe was Rossetti's favorite color and according to Cesare

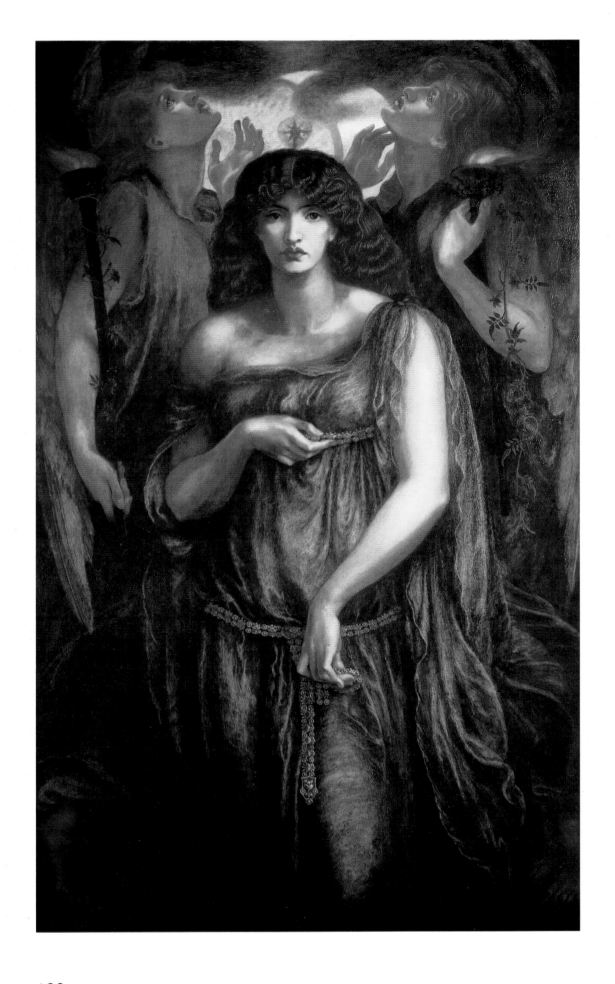

213. Astarte Syriaca, 1877
Oil on canvas, 72 x 42 in.
Manchester City Art Galleries,
Manchester, England

Left
214. Study of an Attendant Spirit for
"Astarte Syriaca," 1875
*Colored chalks heightened with white
on pale green paper, 19½ x 14 in.
Ashmolean Museum, Oxford, England*
❧

Right
215. Study for the Head of "Astarte
Syriaca," 1875
*Pastel on pale green paper,
21½ x 17¾ in.
Victoria and Albert Museum, London*
❧

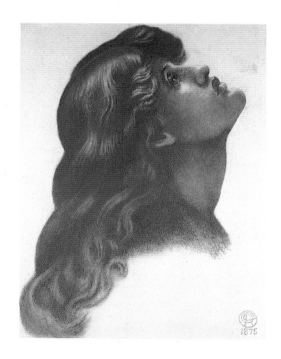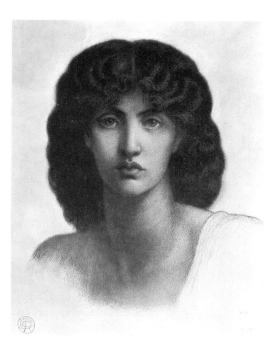

Ripa's *Iconologia*, a book frequently consulted by artists, it represents art and the hope of honor that spurs the artist on.[25] In Filippo Pistrucci's *Iconologia*, written by the artist friend of the Rossettis, Life, Art, and Eternity are all female figures shown wearing classical green gowns.[26] The luminosity of *Astarte Syriaca* resulted from Rossetti's glazing technique; he wrote to Watts-Dunton on February 12, 1877, "I have been glazing it and it is much enriched."[27] In this technique, which characterizes his late work, Rossetti was probably following Titian, who had used successive glazes to create rich, glowing color.

Rossetti wrote the following sonnet for the painting, the last six lines of which are inscribed on the frame he designed for it:

*Mystery: lo! betwixt the sun and moon
Astarte of the Syrians: Venus Queen
Ere Aphrodite was. In silver sheen
Her twofold girdle clasps the infinite boon
Of bliss whereof the heaven and earth commune.
And from her neck's inclining flower-stem lean
Love-freighted lips and absolute eyes that wean
The pulse of hearts to the spheres' dominant tune.*

*Torch-bearing, her sweet ministers compel
All thrones of light beyond the sky and sea
The witness of Beauty's face to be:*

That face, of Love's all-penetrative spell
Amulet, talisman, and oracle,—
Betwixt the sun and moon a mystery.

It is interesting to compare the opening of this poem with the opening of two others he had written in 1849 about religious paintings seen on his Continental tour. *For a Virgin and Child: by Hans Memmelinck* begins:

Mystery: God, man's life born into men
Of woman.

For a Marriage of St. Catherine, by the Same begins:

Mystery: Catherine, the bride of Christ.
She kneels, and on her hand the holy Child
Setteth the ring.

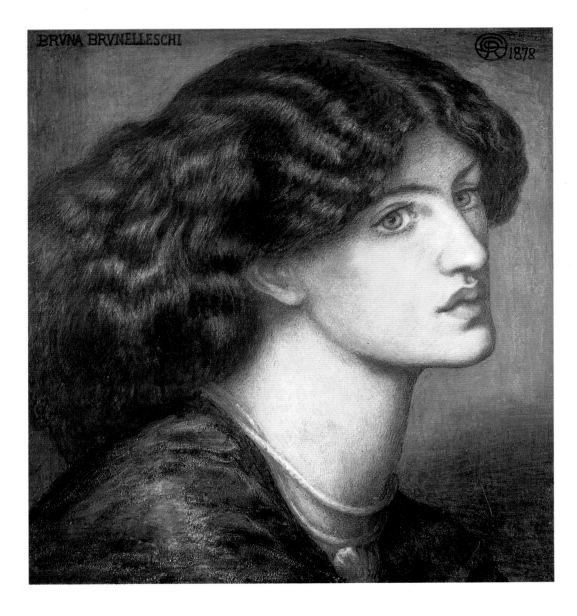

216. Bruna Brunelleschi, 1878
Watercolor on paper, 13¼ x 12 in.
Fitzwilliam Museum, Cambridge, England

194

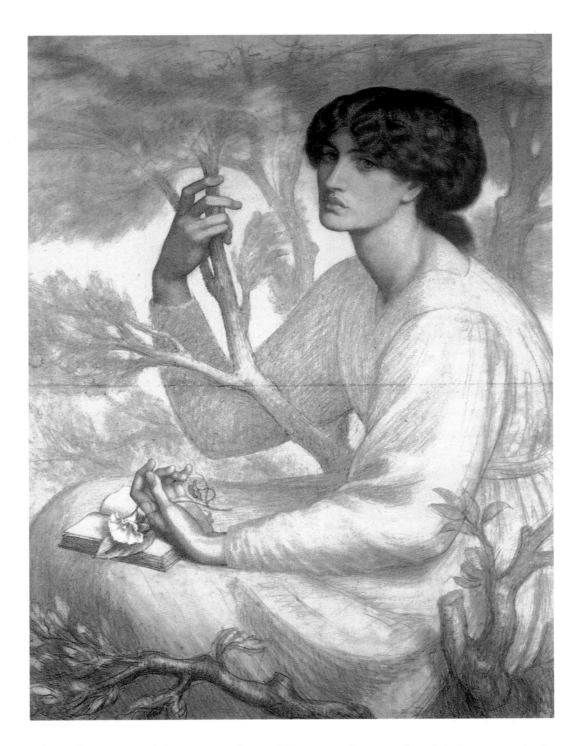

The religious model was supplanted by a secular one, but both are symbols of love, whether divine or human.

Jane Morris continued to pose for Rossetti through 1881, the year before his death. He captured her image in such exquisite portraits as *Bruna Brunelleschi* (plate 216) and *The Day Dream* (plate 218)—the latter commissioned by Constantine Ionides from an earlier drawing in which she embodies the creative power of nature as symbolized by the return of Spring (or the release of Proserpine to earth). A late image of Morris can be seen

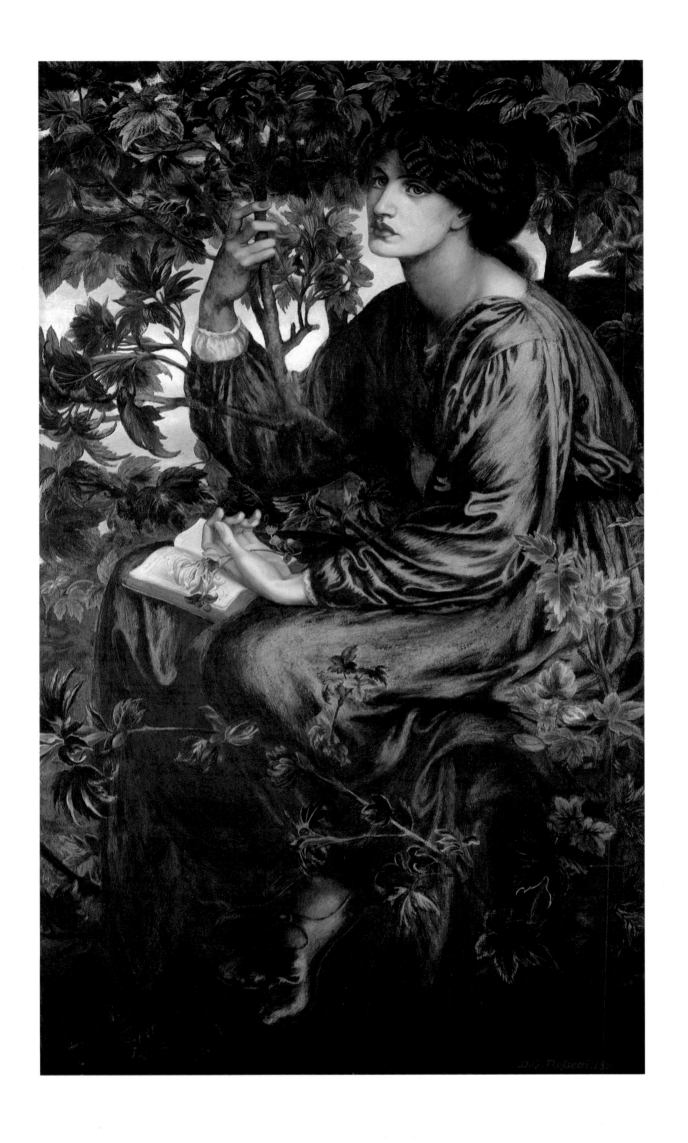

in *La Donna della Finestra* (plate 10), for which studies were begun as early as 1870. Here the Venetian half-length prototype is evident, and the detail of the bottle-glass window in the right background may come from Dürer's *Saint Jerome* engraving or possibly from a Retzsch illustration to *Faust*. Rossetti wrote to Theodore Watts-Dunton in May 1879: "Today I have got on the background of the *Lady of Window,* and really the picture is quite transfigured and ought to sell. It looks as if I were not dead yet."[28] The over-robe is the same as the one in *La Pia de' Tolomei* (plate 188), and the brilliant roses in the background betoken love. The subject, taken from Dante's *Vita nuova,* refers to the woman in the window or "The Lady of Pity," who pitied Dante in his grief at the death of Beatrice. The reference here is no doubt to a modern Dante (Rossetti) mourning his Beatrice (Siddal) and finding a new love in the pitying lady (Morris).

While Morris was with Rossetti at Aldwick Lodge, she discovered the extent of his addiction to chloral. Soon after that, the discovery that Jenny Morris, her older daughter, had epilepsy brought Jane and her husband closer together. The next year, 1877, Rossetti had a second breakdown. He recovered, but it had become evident that he and Jane Morris could have no future together. Their friendship continued, as did their correspondence, but it became more affectionate than passionate. Rossetti wrote in May 1878 expressing his "deep regard for you;—a feeling far deeper (though I know you have never believed me) than I have entertained towards any other living creature at anytime of my life. Would that circumstances had given me the power to prove this: for proved it *wd.* have been."[29]

In 1892 Wilfrid Scawen Blunt asked Jane Morris whether she had been very much in love with Rossetti. "She said, 'Yes, at first, but it did not last long. It was very warm while it lasted. When I found that he was ruining himself with Chloral and that I could do nothing to prevent it I left off going to him—on account of the children. . . . If you had known him,' she said, 'you would have loved him and he would have loved you—all were devoted to him who knew him. He was unlike all other men—.'"[30]

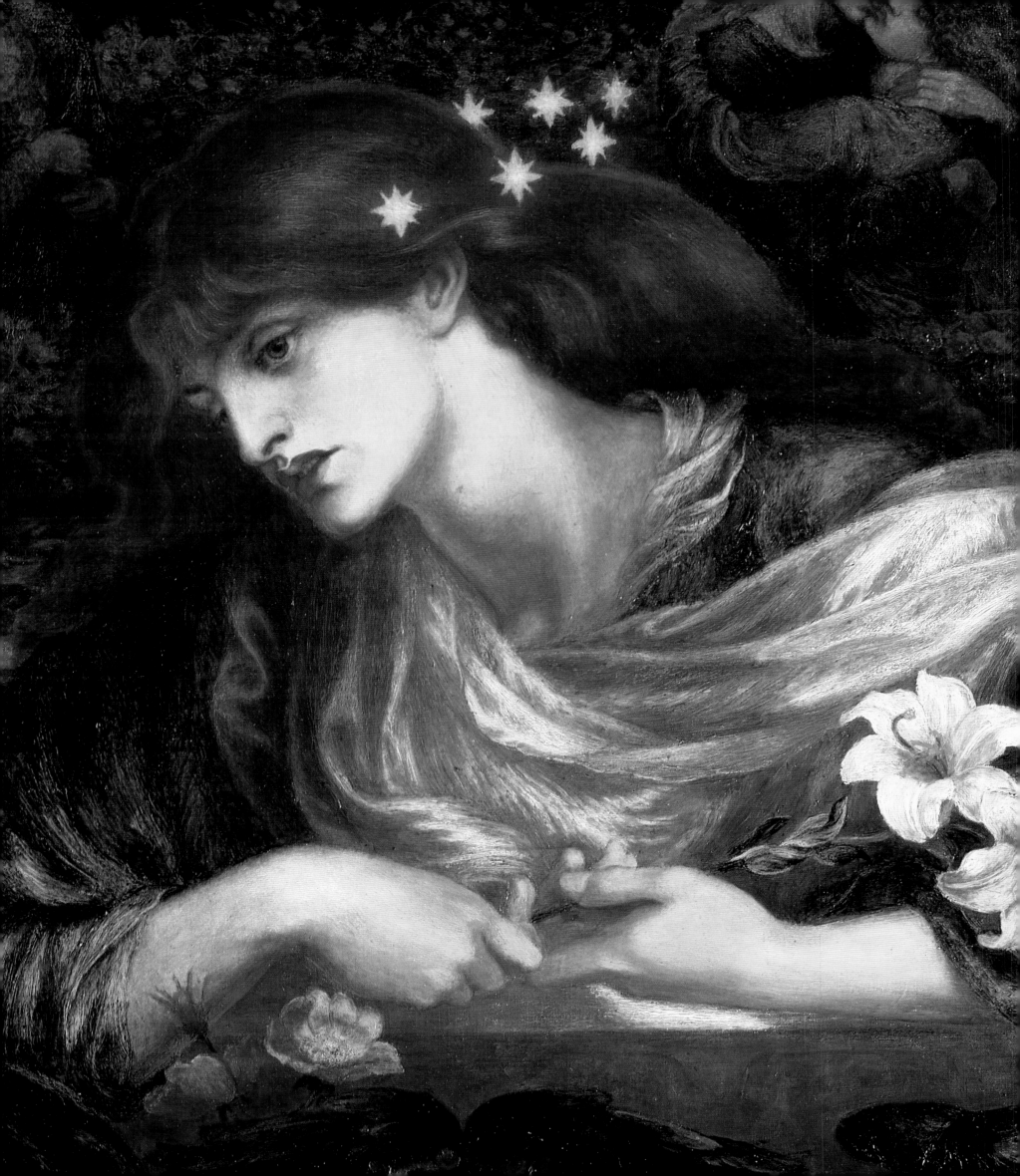

THE LATE WORK

In the late 1860s Rossetti started moving away from the heads of his Venetian period to a preponderance of three-quarter figures. Many of these are single figures, but some include groups and attendants, as in *Dante's Dream at the Time of the Death of Beatrice* (plate 224), *La Bella Mano* (plate 229), *The Blessed Damozel* (plate 231), and *Astarte Syriaca* (plate 213). Rossetti demonstrated complete control over the oil medium, producing colors that are deeper and richer than before, often brought to perfection by glazes. His iconography became denser, no longer dependent on a single source such as a ballad, myth, or literary reference, but synthesizing multiple sources with the artist's personal experience. His recognition of the artist's role as more actively intellectual is expressed in his comment in the early 1880s, "Conception, my boy, FUNDAMENTAL BRAINWORK that is what makes the difference in all art."[1]

Rossetti prided himself on having mastered all the mechanics of his craft: "Now I paint by a set of unwritten but clearly defined rules, which I could teach any man as systematically as you can teach with arithmetic."[2] He laid out his palette in the following sequence: Purple Madder, Ivory Black, Indian Lake, Yellow Madder, French Ultramarine, Burnt Sienna and Light Red, Yellow Ochre, Light Red, Orange Vermillion and Strontium Yellow, Indian Lake and Pale Yellow Madder (to make a warm glaze—the last five colors mentioned are Rossetti's "flesh palette"), Vermillion, Madder Carmine, Indian Red, Deep Yellow Madder, Cologne Earth,

219. Detail of The Blessed Damozel, *1875–78*
See plate 231

199

Burnt Umber, Ultramarine Ash, and Davy's Foundation White.[3] For the ground of the face, Rossetti used Foundation White thinned with benzine and one fifth linseed oil.[4]

The subjects of Rossetti's late oil paintings have been characterized as femmes fatales, but most are larger-than-life goddesses who communicate some allusive meaning related to the artist's own experience and understanding of life. In these late works the woman is no longer an object for viewing but, unequivocally, a subject. These women have been seen as projections of the artist's anima and as sacred icons of a new religion that worships beauty, uniting sacred and profane love.[5] As Rossetti wrote in *Heart's Hope* (sonnet 5 from *The House of Life*):

Thy soul I know not from thy body, nor

Thee from myself, neither our love from God.[6]

An eternal quality infuses many of his late images of women: the Blessed Damozel, Proserpine, Pandora, Astarte Syriaca, and Mnemosyne are all goddesses and hence immortal; he also portrayed "Soul's Beauty" and "Body's Beauty," which are abstract ideas and thus equally immune to the passage of time.

These female images have elicited negative, even fearful responses, such as this recent critique of *Astarte Syriaca*: "Coarse in drawing and execution, lurid in colour, an overscaled and exaggerated vision of Jane Morris, the painting is nevertheless a powerfully haunting image of woman, tall, dominant, impassive and quite merciless."[7] How, one wonders, does the commentator know she is merciless? There is nothing to indicate this in the painting itself nor does Rossetti's accompanying sonnet make any mention of it. It seems her main crime is to take a dominant stance, and the execution is seen as "coarse" in the same way that Ruskin described the flowers in *Venus Verticordia* (plate 139) as coarse.

Some of the reactions of the 1870s and '80s are understandable as a projection of fears regarding the social and sexual assertion of women. In the 1870s there was agitation that eventually culminated in the Women's Property Act of 1883, which gave wives the right to retain personal earnings from employment separate from their husbands'—until then married women had had no rights to their own property. Women's suffrage was also a major issue, and publications on birth control by Annie Besant and Josephine Butler also appeared in the 1870s—another controversial move toward women's emancipation. Under these circumstances, it is not surprising that images of dominant women might cause a frisson of fear or dislike, a reaction that had nothing to do with their aesthetic merit.

200

On November 18, 1869, Ponsonby Lyons jestingly wrote to Rossetti in answer to his questions about Lilith, "Lilith, about whom you ask for information, was evidently the first strong-minded woman and the original advocate of women's rights."[8] Rossetti had begun *Lady Lilith* (plate 220) in 1864 and finished it 1868, with Fanny Cornforth as model. The oil painting originally looked more like the watercolor replica in the Metropolitan

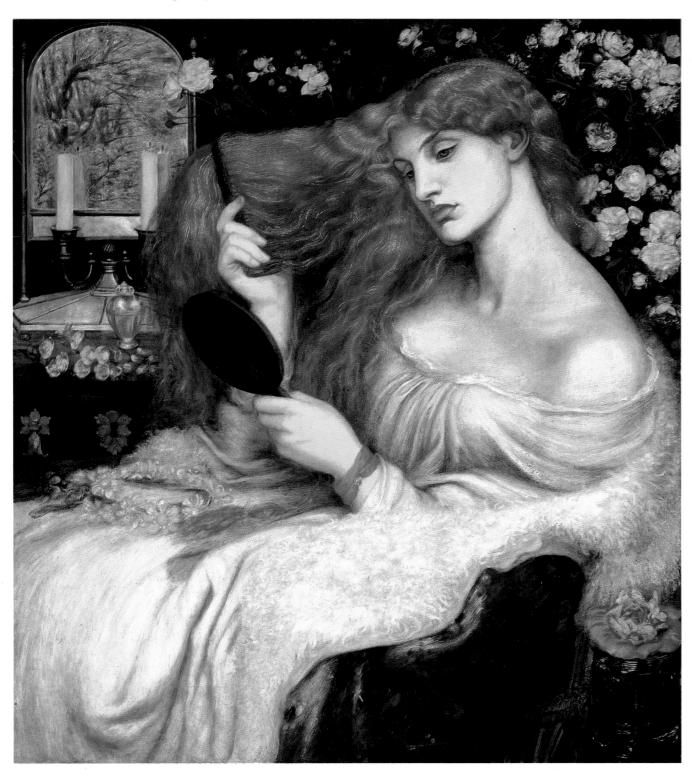

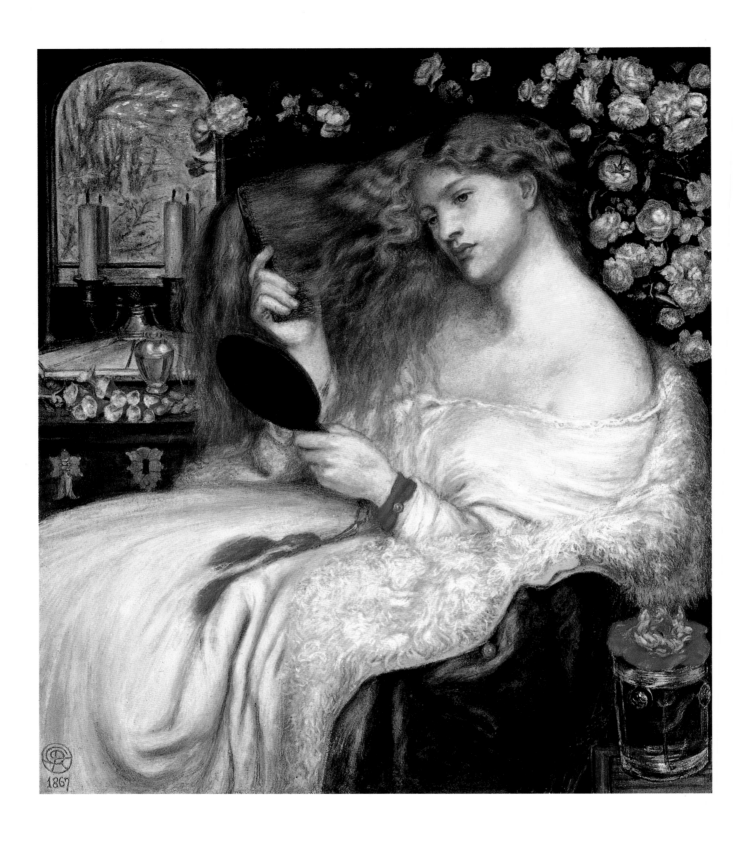

Museum of Art (plate 221) than it does today, because in 1872–73 Rossetti repainted it with the head of Alexa Wilding at the request of its buyer, Frederick Leyland. An even better idea of the original can be found in *Woman with a Fan* (plate 222), which shows Cornforth in a pose very similar to that in *Lady Lilith*.

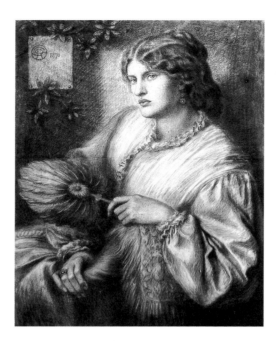

222. Woman with a Fan, *1870*
Crayons on paper, 37¾ x 28 in.
Birmingham City Museum and Art Gallery,
Birmingham, England

Rossetti used Lilith to represent the "Body's Beauty," in contrast to the "Soul's Beauty" of *Sibylla Palmifera* (plate 178). According to rabbinic legend, Lilith was Adam's first wife—a seductress and demon woman who gave birth only to devils and who wanted equal rights in everything. Her sensuality is accentuated by the outstretched golden hair, which is referred to in lines from Goethe's *Faust* on the back of the watercolor:

> *Beware of her hair, for she excels*
> *All women in the magic of her locks*
> *And when she twines them round a young man's neck*
> *She will not ever set him free again.*

In Rossetti's own sonnet inscribed on the frame, the rose, foxglove, and poppy are given as Lilith's floral attributes. The roses in the background (taken from Ruskin's garden) seem an inappropriately innocent white, but their pallor alludes to the legend that all the roses in Eden were white until they blushed red at the beauty of Eve, who was created after Lilith.[9] Perhaps the best characterization of the painting is Swinburne's: "The sleepy splendour of the picture is a fit raiment for the idea incarnate of faultless fleshly beauty and peril of pleasure unavoidable."[10]

Rossetti's largest painting, *Dante's Dream at the Time of the Death of Beatrice* (plate 224), is an oil approximately seven feet by ten and a half feet. It is an 1871 version of a watercolor done in 1856 (plate 223), commissioned by Ellen Heaton. The contrast between the two works is revealing, not only in terms of the changes in size and medium but also in the change from

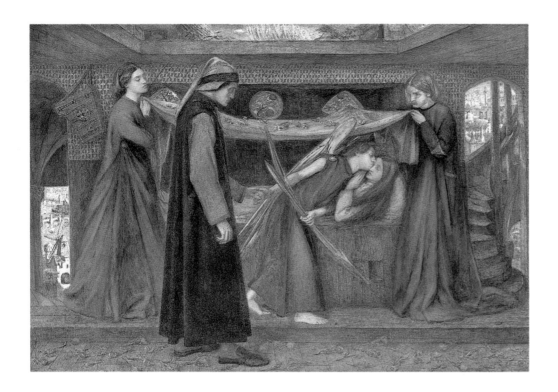

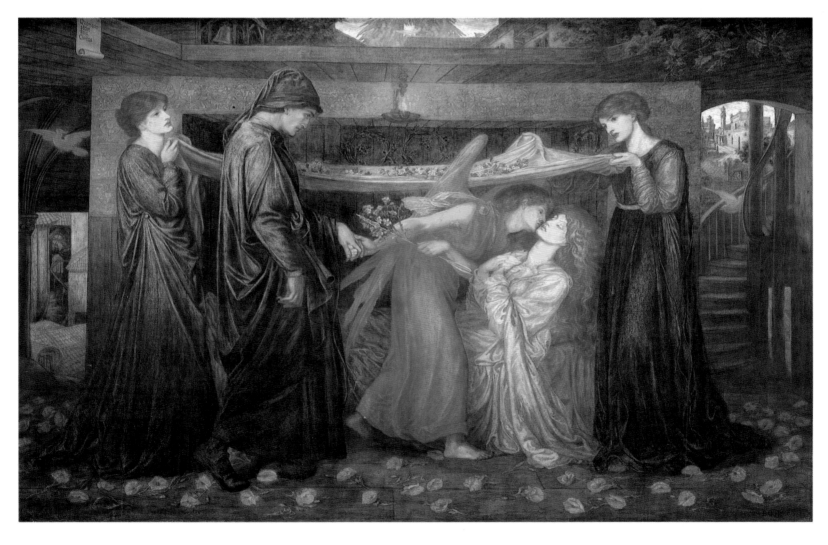

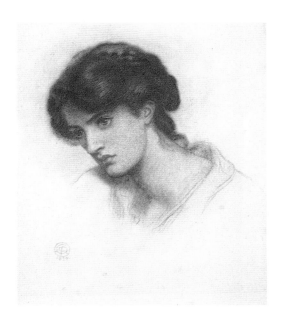
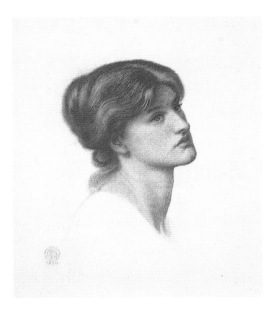
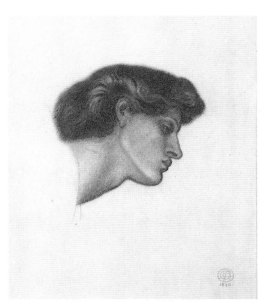

the stiff quaintness of the earlier medieval style to the fully rounded, thoroughly confident Renaissance style of the later work. The model for the later Beatrice was Jane Morris, portrayed as a blonde. The head of the right-hand attendant was modeled by Maria Spartali Stillman (plate 226) and the one on the left (plate 227) by Alexa Wilding. The head of the figure of Love kissing Beatrice was taken from the young Johnston Forbes-Robertson (plate 228).

Another painting of Rossetti's with elaborate setting and complex groups of figures is *La Bella Mano* (plate 229). The title refers not only to Rossetti's poem on the frame of the painting but also to a series of Petrarchian sonnets of that name by Giusto de' Conti.[11] The iris and the lemon tree in the foreground are symbols of the Virgin, while the rose is a symbol

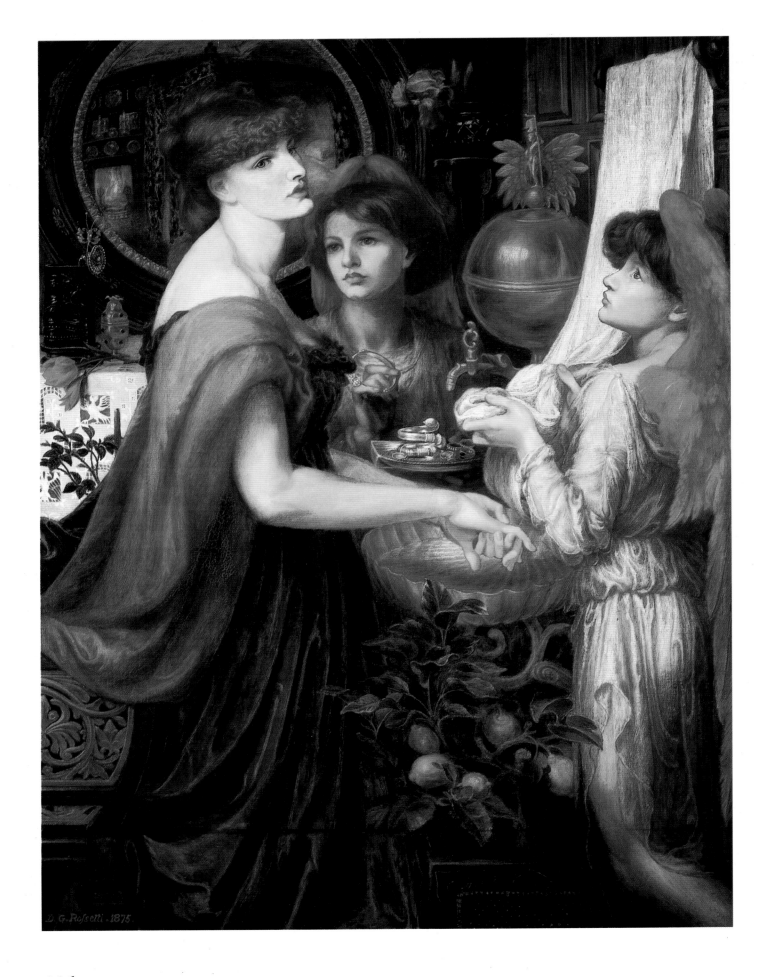

206

of the Virgin and of Venus,[12] both referred to in Rossetti's poem. The scallop-shaped basin is also a symbol of Venus, who rode to shore from her sea birth on a scallop shell. The hand washing here denotes purity rather than the end of an affair, which it had signified in Rossetti's earlier *Lucrezia Borgia* (plate 160) and *Washing Hands* (plate 167).

The only work that Rossetti painted *from* one of his own poems was *The Blessed Damozel* (plate 231), which was expressly commissioned in 1871 by William Graham, an important Rossetti patron. In contrast to many of Rossetti's spiritualized representations of earthly women, this is a heavenly damsel yearning after her lover on earth. The damsel leans on the bar of heaven, as described in Rossetti's poem:

> And still she bowed herself and stooped
> Out of the circling charm;
> Until her bosom must have made
> The bar she leaned on warm.

She was a very corporeal heavenly lady indeed. The model for the damsel was Alexa Wilding, and Rossetti's housemaid, Mary, was the model for the

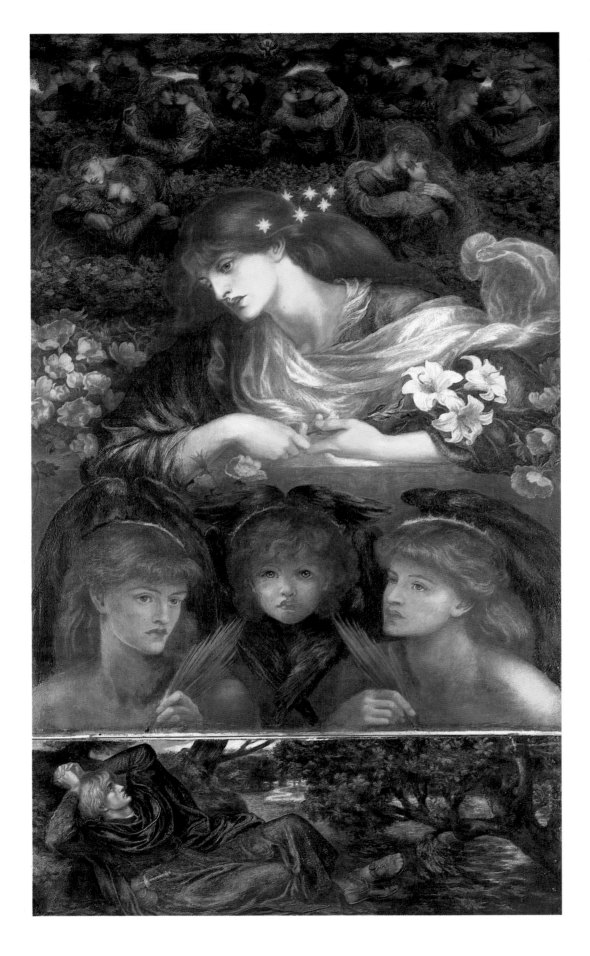

angels.[13] Some of the work for the picture was done during the summer of 1876, when Rossetti visited Romsey, the William Cowper-Temple's estate at Broadlands, in Sussex, to escape a summer heat wave. The predella, added at Graham's request and executed in early 1878, shows the reclining figure of the lover looking heavenward.

One of the most lyric features of the painting is the background of embracing lovers, seen more clearly in a preparatory drawing (plate 233). The female lovers resemble Jane Morris, a resemblance confirmed by the fact that she was the first owner of this drawing. The rhythmic composition and the joyful tenderness of the lovers recall the paintings of Botticelli—specifically, the *Mystic Nativity* (plate 234) of 1500, which shows pairs of humans and angels embracing in the foreground and a circular dance of angels in the heavens. Rossetti saw this painting at the *Leeds Exhibition* in 1868: "I spent a couple of hours in the Exhibition at Leeds, where there are a good many things worth seeing—a most glorious Sandro Botticelli (Nativity)."[14]

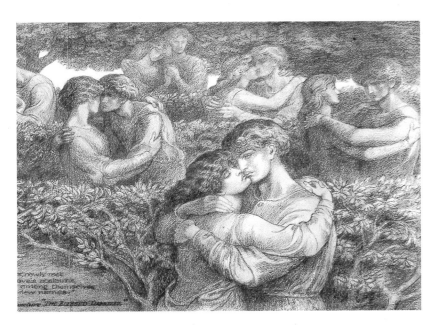

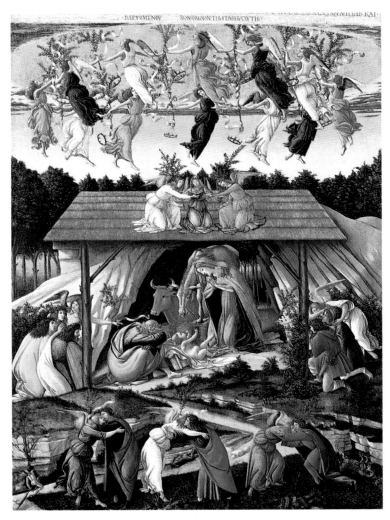

A subject that Rossetti took from Boccaccio was that of Fiammetta. He did a head in oil in 1866 and a major painting, *A Vision of Fiammetta* (plate 236), in 1878; Maria Spartali Stillman was the model for the latter. He probably first encountered this subject when he translated three sonnets by Boccaccio in his *Early Italian Poets*, published in 1861. The three-quarter figure of Fiammetta is based on a description in the sonnet *Of His Last Sight of Fiammetta*:

> *Round her red garland and her golden hair*
> *I saw a fire about Fiammetta's head.*

Fiammetta was Boccaccio's name for Maria d'Aquino, whom he supposedly met on the day before Easter, 1336, in the Church of San Lorenzo, Naples. She died young, and the first of Boccaccio's sonnets about her is entitled *To Dante in Paradise, after Fiammetta's Death*. Rossetti's own poem, *Fiammetta*, conveys the sense of swirling motion in the painting:

> *All stirs with change. Her garments beat the air:*
> *The angel circling round her aureole*
> *Shimmers in flight against the tree's gray bole:*
> *While she, with reassuring eyes most fair,*
> *A presage and a promise stands; as 't were*
> *On Death's dark storm the rainbow of the Soul.*

In this painting, as in many other of Rossetti's works, love and death are linked. Fiammetta is shown among apple blossoms, possibly as a reminder of the time of year Boccaccio first saw her. Rossetti had a terrible time getting the proper kind of blossom, as he could find no apple trees in bloom near him. He wrote to his friend Shields on April 1, 1878, asking him to send him branches of apple blossoms, and then thanked him a few days later for the apple-blossom studies he had sent (plate 235).[15] As in *Astarte Syriaca* and *Mnemosyne*, the proportions are somewhat Mannerist, with the head small in relation to the body.

The last major original painting that Rossetti worked on before his death is *Mnemosyne* (plate 237). It was started in 1876 as a version of *Astarte Syriaca* (plate 213), with Jane Morris modeling for it in Bognor Regis; next it was transformed into a figure of Hero bearing a lamp for Leander; and finally it became *Mnemosyne*, or *The Lamp of Memory*.[16] In Greek mythology Mnemosyne was a Titaness, the goddess of memory and mother of the Muses. The figure is very similar in pose and costume to the one in *Astarte Syriaca*, but Mnemosyne holds a lamp in her right hand and

Opposite
236. A Vision of Fiammetta, 1878
Oil on canvas, 57½ x 35 in.
Private collection

235. *Frederic Shields (1833–1911)*
Study for "A Vision of Fiammetta," 1878
Watercolor and pencil on paper, 9 x 7½ in.
Delaware Art Museum, Wilmington;
Samuel and Mary R. Bancroft
Memorial Collection

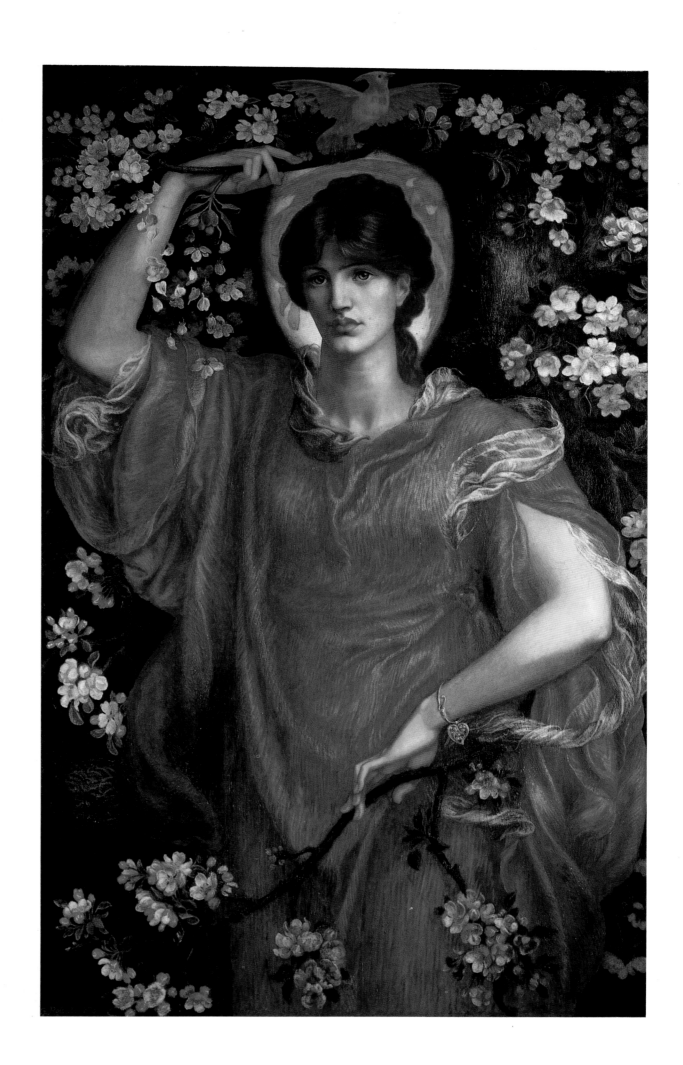

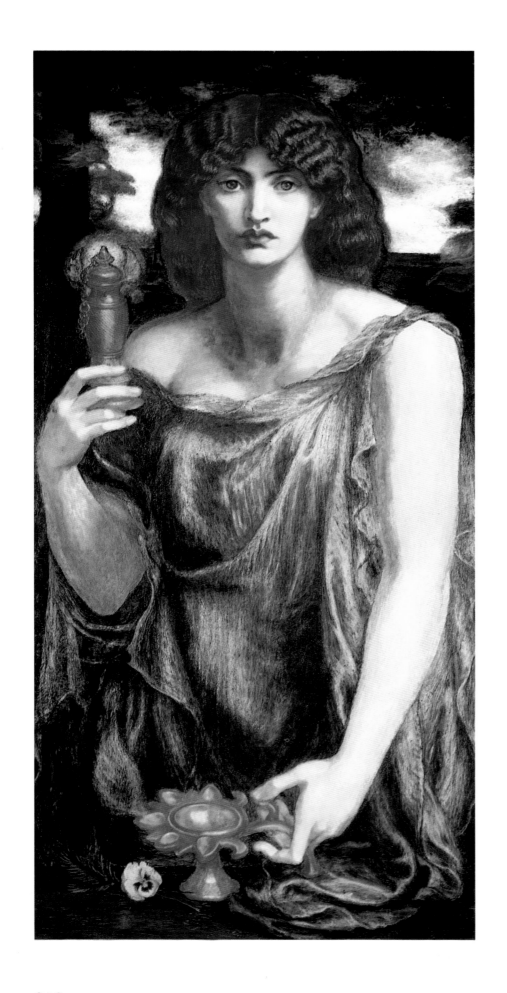

237, 238. Mnemosynė, 1881
Oil on canvas, 47½ x 23 in.
Delaware Art Museum, Wilmington;
Samuel and Mary R. Bancroft
Memorial Collection

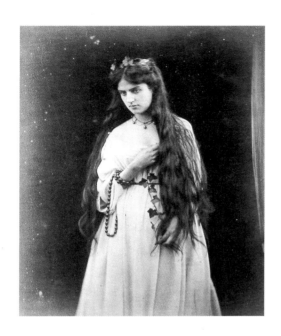

a winged chalice in her left, next to a pansy, symbol of remembrance, and a branch of yew, denoting sorrow. The pansy also had other, more personal meanings. It was the flower that Jane Morris chose for her writing paper (designed by Rossetti), and he also showed her with pansies in a study for *Water Willow* of 1871.[17] In addition, the diary of Wilfrid Scawen Blunt (who was Morris's lover from about 1889 to 1894) reveals that Jane would leave a pansy in his room when she wanted to make love.[18] The token undoubtedly had the same meaning for Rossetti.

The idea for *Mnemosyne* may have come from a photograph made by Julia Margaret Cameron in 1868, portraying Maria Spartali Stillman as Mnemosyne (plate 239). There are obvious similarities between Rossetti's painting and the photograph, which Stillman, a long-time model of Rossetti's, may have given him; Cameron, who presented Rossetti with a number of her photographs, could also have been the donor.

When Rossetti was finishing *Mnemosyne* in 1881, he was a seriously ill man. He had already had several brushes with death, and he may have surmised that he had not long to live. One of the inspirations of his life, from Pre-Raphaelite days on, had been the poetry of John Keats.[19] In book 3 of Keats's *Hyperion*, Mnemosyne encounters Apollo, who represents the persona of the poet (a figure with whom Rossetti would have identified). Apollo addresses the goddess (lines 111–20):

> *Mute thou remainest—mute! yet I can read*
> *A wondrous lesson in thy silent face:*
> *Knowledge enormous makes a God of me*
> *. . .*
> *Creations and destroyings, all at once*
> *Pour into the wide hollows of my brain,*
> *And deify me, as if some blithe wine*
> *Or bright elixir peerless I had drunk,*
> *And so become immortal.*

Thus, it is the encounter with Mnemosyne that makes the artist immortal. By painting the woman he loved as Mnemosyne, Rossetti not only deified his love but also made a bid for immortality through his art. While commemorating his passion for Jane Morris he used his art, in the words of Harold Bloom, as "the only revenge against time that endures."[20]

The use of a goddess from Greek mythology is consistent with Rossetti's classicism in his late works. Starting in 1861 he employed a number of classical references in his works, such as Cassandra, Helen of Troy,

Venus Verticordia, Pandora, Proserpine, and Astarte Syriaca. Rossetti's interest was in using myth to express meaning, not in reiterating the canon of classical form. He used myth as he had medieval legend, to clothe projections of his imagination.

A classical influence can be seen in the drawing Rossetti made to decorate his poem *The Sonnet* (plate 240), which has a winged figure of the soul instituting a "memorial to one dead deathless hour."[21] The fourteen-stringed harp represents the sonnet itself, as does the coin. *The Sonnet*, like *Mnemosyne*, is a bid for immortality. The poem, sans decoration, prefaces Rossetti's 102-sonnet sequence *The House of Life*, his literary last will and testament, published in 1881. Rossetti made the drawing for his mother on her birthday, April 27, 1880, in a volume of Main's *Treasury of English*

240. The Sonnet, *April 27, 1880*
Photograph of pen-and-ink drawing
Delaware Art Museum, Wilmington;
Samuel and Mary R. Bancroft
Memorial Collection

Sonnets. The winged female figure in classical robe may relate to the personification of Good Fame, plate 112 in Pistrucci's *Iconologia*, which shows a winged female figure floating in a similar position above the other personifications of "Fame in Various Modes." Both the literary and pictorial versions of Rossetti's *Sonnet* are representations in classical forms and language of his yearning for fame and immortality.

Rossetti became more reclusive due to his intensive labor in painting and to his recurring illnesses, including addiction to chloral. However, he still had a wide circle of friends who visited him frequently, including Frederic Shields, who painted regularly in Rossetti's studio, Theodore Watts-Dunton, Dr. Thomas Gordon Hake, the writer William Sharp, the sculptor

241. *Rossetti's bungalow in Birchington*
Photograph, Burchington-Pulton's
series 525
Delaware Art Museum, Wilmington;
Bancroft Archives

242. *Frederic Shields (1833–1911)*
The Dead Rossetti, 1882
Chalk on paper, 9⁹⁄₁₆ x 7⅞ in.
Delaware Art Museum, Wilmington;
Samuel and Mary R. Bancroft
Memorial Collection

and print dealer S.J.B. Haydon, the painters J. Noel Paton and Sidney Colvin, the blind poet Philip Bourke Marston, and old friends such as Scott, Stephens, Brown, and Burne-Jones.

In July 1879 a new friend and admirer entered Rossetti's life: Thomas Hall Caine, a builder's clerk in Liverpool with literary ambitions. Caine lectured on Rossetti's poetry in 1879, praising it generously, and sent the printed lecture to Rossetti, who responded immediately in a letter of July 29, 1879. This started an epistolary friendship between the two men in which they discussed literary issues and art. It seems that Caine became to Rossetti the son he never had, and Rossetti gave the younger man advice and access to his connections. They finally met on August 30, 1880, and the following year Rossetti suggested that Caine live at Cheyne Walk, as the young man wanted to make a career in the London literary world. Caine was influential in selling Rossetti's large painting *Dante's Dream at the Time of the Death of Beatrice* to the Walker Art Gallery in Liverpool that year, a major accomplishment. The year 1881 also saw the publication of a new edition of Rossetti's *Poems* and a new volume, *Ballads and Sonnets,* which included *The House of Life.*

By late 1881 Rossetti was very ill, and in November he called for a priest to give him absolution. His ideas about religion had always been somewhat inchoate, though Caine regarded him as "a monk of the Middle Ages." William Rossetti may have been more accurate when he commented, "If we could imagine 'a monk of the middle ages' whose mind was in a mist as to religious doctrine, who conformed to no religious rites, practiced no monastic austerity and in profession and act led an anti-monastic life, we might obtain some parallel to Dante Rossetti."[22]

In December 1881 Rossetti suffered a seizure that resulted in partial paralysis. He still painted whenever he could, even after going to Westcliff Bungalow at Birchington-on-Sea to recuperate on February 4, 1882. Caine visited him there, and Rossetti's mother, Christina, and William went down to help nurse him. Rossetti died on Easter Sunday, April 9, 1882. He was buried on April 14 at the Anglican All Saints Parish Church at Birchington-on-Sea, where two stained-glass windows by Frederic Shields were given in his memory by Rossetti's mother. The cross over Rossetti's grave—with a figure of Saint Luke, the painter, at the base—was designed by his oldest friend, Ford Madox Brown.

Summing Up

ny attempt to sum up Rossetti's career as an artist yields a number of paradoxes. He was intensely secular and profoundly spiritual, in many ways a mystic in his imagination, and yet he became the leader of what was dubbed the "Fleshly School" of poetry and painting. He lived in several worlds: the nineteenth-century England of materialism and progress, the medieval world of Dante, and the Renaissance Italy of Titian, Veronese, and Tintoretto. The greatest paradox he had to resolve was how to express abstract ideals by concrete means, capturing (as he put it) "the apparent image of unapparent realities."[1] Most often he used images of women to embody devotional, literary, and mythological abstractions. In his earlier work it is the encounter of lovers—Dante and Beatrice, Paolo and Francesca, Lancelot and Guinevere, Tristram and Yseult—that provides the significant moment. In much of his later work the figure of the woman alone carries the burden of meaning and pictorial interest.

Rossetti's media, styles, and compositions changed significantly during the course of his career. His brilliant use of color has overshadowed the other strong points of his work, such as his use of formal devices to create a Rossettian world, his mastery of a number of styles and sources, and his formulation of new types of heroines and female beauty. In 1916 no less an admirer of significant form than Roger Fry approvingly described Rossetti's *Chapel before the Lists* as follows: "The long parallelogram of the opening on the tent crossed by the pyramid of the two lovers is perfectly planned.

243. Fazio's Mistress, 1863
Oil on canvas, 17 x 15 in.
Tate Gallery, London

217

No less surprising is the 'science' with which he plays the directions of his straight lines."[2]

Rossetti wanted his expression to be uniquely his own, original in concept and in execution. He was, of course, influenced by the values of his period, but he was singularly independent in his choice of subject matter, type of feminine beauty, and mode of expression. Joan Rees has made the following comment about Rossetti's poetry, but it also applies to his painting: "In the psychological area which he cultivated, introspection of a small but intimate and sensitive region of the psyche, Rossetti was an explorer ahead of his time. The imagery which he evolved to express his findings and the way he handled it were also out of period."[3] Rossetti was most criticized for his best work, which defied the conventions of his society; and his paintings that most conform to Victorian notions of prettiness, decorum, and the proper role of women are his least successful. Fortunately, these are a small minority in his oeuvre.

His originality in creating new artistic types and new modes of presentation made Rossetti the most influential and imitated of the original Pre-Raphaelite Brotherhood. William Holman Hunt was much respected for his unswerving alliance to his view of Pre-Raphaelite painting and for his painstaking re-creation of a Middle Eastern milieu, but he was not widely imitated. John Everett Millais was greatly admired for his bravura painting technique, and he achieved presidency of the Royal Academy and a baronetcy; but he too lacked a following in his own and subsequent generations.

Both Hunt and Millais were annoyed in later life by the extravagant claims made for Rossetti by his admirers, including Ruskin. Millais commented: "Because in my early days I saw a good deal of Rossetti . . . they assume that my Pre-Raphaelite impulses in pursuit of light and truth were due to him. All nonsense! My pictures would have been exactly the same if I had never seen or heard of Rossetti."[4] Rossetti wrote on November 7, 1868, to Ernest Chesneau, a French art critic who was writing a book on English art, *Les Nations rivales dans l'art*: "With regard to the qualification of 'Chief of the Pre-Raphaelite School' which you attribute to me . . . I must assure you, with all possible instancy, that I am not in the least entitled to it Thus, when I find a painter so absolutely original as Holman Hunt described as being my 'disciple,' it is impossible for me not to feel humiliated in the presence of the truth, or to refrain from assuring you of the contrary with the utmost energy."[5]

Early in his career Rossetti was most influential through his illustra-

tions, both for Allingham's *Day and Night Songs* in 1854 and for Moxon's *Tennyson* in 1856–57. In a survey of English illustration of the period, Gleeson White remarks, "There can be no doubt that it is Rossetti who has most influenced subsequent draughtsmen."[6] Even though Rossetti did only a few book illustrations and was never fully satisfied with any of them, these works were seen and imitated by a number of artists. It was his *Maids of Elfen-mere* that introduced his work to Morris and Burne-Jones at Oxford and led to the inception of the "second Pre-Raphaelite movement." Rossetti was undoubtedly the guiding spirit of this movement, although for most of the artists who worked on the Oxford Union frescoes in 1857 the influence of his vocabulary and medieval subject matter was only temporary.

For Burne-Jones, however, Rossetti's inspiration lasted a lifetime. This can be seen both in his general style and subjects and in specific works. *Going to the Battle* (plate 244), for example, has a general subject related to Rossetti's "Froissartian" representations and a style related to Ros-

244. Edward Burne-Jones (1833–1898)
Going to the Battle, 1858
Pen and ink and gray wash on vellum,
8⅞ x 7¹¹⁄₁₆ in.
Tate Gallery, London

219

setti's angular figures and detailed, cramped compositions. The subject of Burne-Jones's *Sidonia von Bork* (plate 245) is taken from the book *Sidonia von Bork, die Klosterhexe* by Wilhelm Meinhold, a great Rossetti favorite, and its composition closely resembles Rossetti's *Lucrezia Borgia* (plate 160). Burne-Jones's watercolor *The Blessed Damozel* (Fogg Museum of Art) of 1860 obviously took its inspiration from Rossetti's poem on the subject.

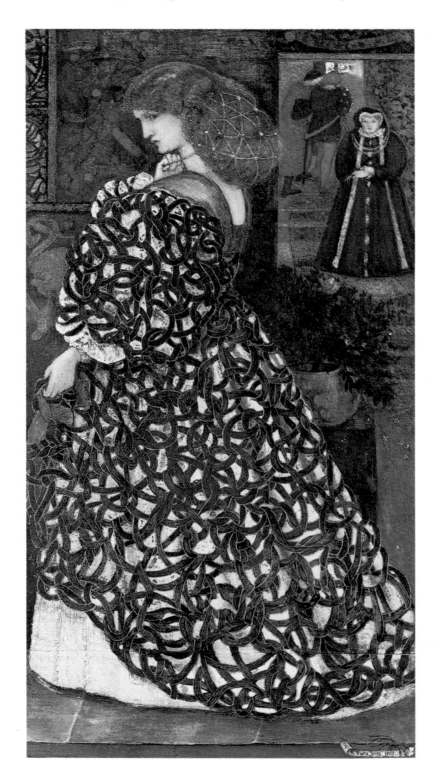

245. Edward Burne-Jones (1833–1898)
Sidonia von Bork, *1860*
Watercolor with gouache on paper,
13 x 6¾ in.
Tate Gallery, London

A very close parallel can also be seen between Rossetti's *Gate of Memory* of 1857 (plate 246) and Burne-Jones's *Danaë* or *The Tower of Brass* (plate 247) of 1887–88. Here Burne-Jones reversed the Rossetti composition, but in all essentials the two are almost identical. Even *The Last Sleep of Arthur at Avalon* (Museo de Arte, Ponce, Puerto Rico), a late work by Burne-Jones, is closely related to Rossetti's drawing and illustration *King Arthur*

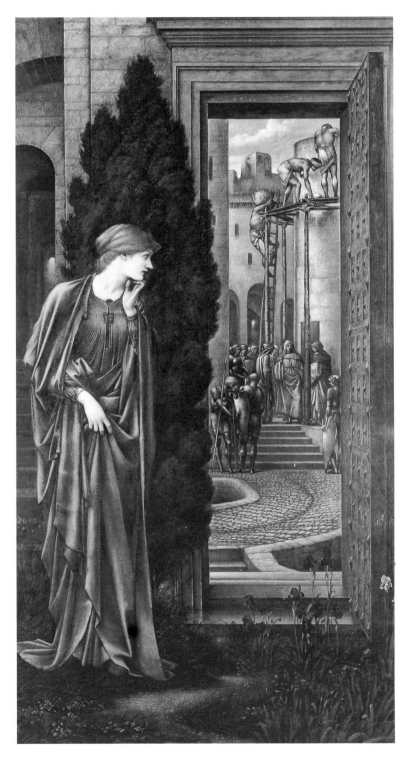

and the *Weeping Queens* (plate 83) of 1856–57, with its bevy of female figures surrounding the recumbent king. Burne-Jones acknowledged his tie to Rossetti when he said after Rossetti's death, "The worst of it is I've no longer Rossetti at my back—he has left me more to do than I've the strength for the carrying on of his work all by myself."[7] Rossetti also fundamentally influenced William Morris, not only by inspiring him to become a poet and artist but also by encouraging his interest in the decorative arts and his foundation of the Firm, which carried Pre-Raphaelite furnishings into the mainstream of English life.

Despite the fact that Rossetti did not exhibit widely, he had considerable influence on other contemporaries as well. This is clearly seen in James Archer's *Mort d'Arthur* (plate 248), which in composition, theme, and jewellike colors echoes Rossetti's palette in general and his *King Arthur*

248. James Archer (1823–1904)
La Mort d'Arthur, 1860
Oil on millboard, 17 x 20 in.
Manchester City Art Galleries,
Manchester, England

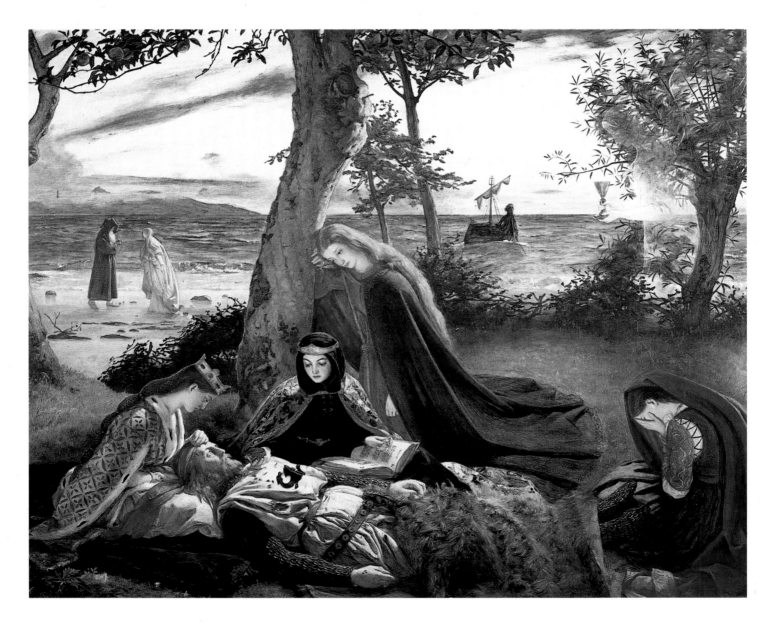

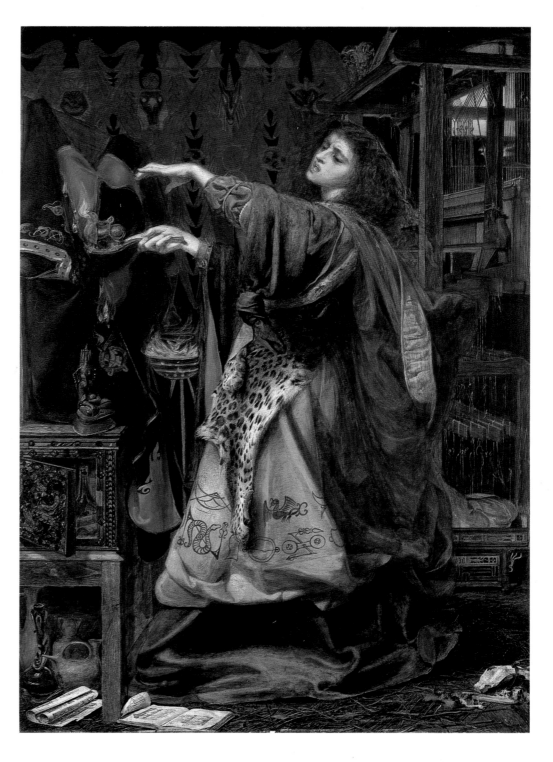

and the Weeping Queens in particular. Another contemporary Rossetti influenced so deeply that he had to write him a warning about plagiarism was Frederick Sandys. In his letter of June 1869 Rossetti cited specific borrowings in Sandys's *Lucretia, Helen,* and *Magdalene*.[8] Sandys's *Morgan-le-Fay* (plate 249) obviously owes much to Rossetti in terms of its Arthurian subject matter, detailed composition, and vivid coloring. Another artist Rossetti influenced decisively was his friend Frederic Shields, who progressed

from illustration to oil painting under Rossetti's tutelage. A younger disciple was Simeon Solomon, whose *Dante's First Meeting with Beatrice* (plate 250) shows Rossetti's influence both in its subject matter and in the detailed, angular drawing style. Rossetti's presence is also strongly expressed in Henry Holiday's *Dante and Beatrice* (plate 251), which takes its subject matter and possibly the figure of Dante from Rossetti, though not its style. Rossetti's influence is also apparent in the subject matter, composition, and coloring of works by Maria Spartali Stillman. She was one of his favorite models, and he encouraged her to paint. Although she studied with Brown, her art was much closer to Rossetti's in spirit and substance. This can be seen in such works as *Beatrice* (plate 252) and *The Pilgrim Folk* (plate 253), which follow Rossetti's lead both in theme and in style. In addition, his paintings served as inspiration for photographs by Julia Margaret Cameron and others.[9]

Rossetti's influence extended into the twentieth century with the works of such artists as John William Waterhouse, Byam Shaw, John Melhuish Strudwick, Sidney Meteyard, and many others who used Rossetti's poems as well as paintings as sources for their art.[10] In America his influence can be seen in the art of Buchanan Read, William James Stillman (who married Maria Spartali), and Joaquin Miller, as well as in the stained-glass designs of John La Farge and the decorative art of Louis Comfort Tiffany. The curvilinear outlines he favored were close to those that would later characterize Art Nouveau. Beginning with his Venetian period, and especially after 1868, the narrative content and moralizing so dear to his Victorian contemporaries disappeared from Rossetti's paintings. He

Left
250. Simeon Solomon (1840–1905)
Dante's First Meeting with Beatrice
(Meeting of Dante and Beatrice), 1859–63
Pen and ink on paper, 7⅝ x 9 in.
Tate Gallery, London

Right
251. Henry Holiday (1839–1927)
Dante and Beatrice, 1883
Oil on canvas, 55 x 78½ in.
Walker Art Gallery, Liverpool, England

emphasized female beauty instead, intensified by sumptuous colors and elaborate textures. Developing his own personal style as an expression of aesthetic freedom, he helped pave the way for the doctrine of art for art's sake, which would prove so important to the Aesthetic Movement and others. His creation of a personal iconography anticipated the Symbolist movement, with its emphasis on esoteric meaning and hermetic reference. In this area particularly, Rossetti's work is a forerunner of twentieth-century symbolic content, in which the key to meaning is not universally understood but depends on arbitrarily assigned references, often related to the experiences of its creator alone.

Rossetti's paintings and drawings were known in Europe through Frederick Hollyer's photographs and through Olivier Georges Destrée's book *Les Préraphaelites*, published in Paris in 1897. His paintings inspired Paul Verlaine's poem *Monna Rosa d'après un tableau de Rossetti*[11] and Claude Debussy's "La Demoiselle élue" (1893), a musical composition based on Rossetti's poem *The Blessed Damozel*. One of the most surprising aspects of Rossetti's influence can be seen in the work of Edvard Munch.

254. Edvard Munch (1863–1944)
The Kiss, 1897
Hand-colored woodcut, 17⅜ x 14⅝ in.
The Harvard University Art Museums
(Fogg Art Museum),
Cambridge, Massachusetts;
Purchase through the generosity of
Philip Straus, Class of 1937, and
Lynn Straus

226

255. *Detail of* Paolo and Francesca
da Rimini, *1855*
See plate 71

This influence has been cited in a number of examples, but the most convincing evidence can be seen in Munch's various versions of *The Kiss* (plate 254), which takes Rossetti's *Paolo and Francesca da Rimini* (plate 255) as a source.[12]

Ruskin summed up Rossetti's importance as an artist a year after his death: "I believe his name should be placed first on the list of men, within my own range of knowledge, who have raised and changed the spirit of modern Art: raised in absolute attainment; changed in direction of temper. . . . And he was, as I believe it is now generally admitted, the chief intellectual force in the establishment of the modern romantic school in England."[13] By developing his own means of expression and using his own deep sources of feeling and desire, Rossetti created an art that spoke to his own times and still resonates today.

NOTES

INTRODUCTION
(pages 17–29)

1. Oswald Doughty and John Robert Wahl, *Letters of Dante Gabriel Rossetti*, vol. 1 (Oxford: Clarendon Press, 1965), 37, 39, 48.

2. W. Holman Hunt, *Pre-Raphaelitism and the Pre-Raphaelite Brotherhood*, vol. 1 (New York: Macmillan, 1905), 128.

3. William Michael Rossetti, ed., *Pre-Raphaelite Diaries and Letters* (London: Hurst and Blackett, 1900), 231.

4. Ibid., 292.

5. See William E. Fredeman, "A Rossetti Gallery," *Victorian Poetry* 20 (Autumn–Winter 1982): 161–68.

6. Hunt, *Pre-Raphaelitism*, vol. 1, 204.

7. Francis L. Fennell, Jr., *The Rossetti-Leyland Letters* (Athens, Ohio: Ohio University Press, 1978), xi; and C. R. Cline, ed., *The Owl and the Rossettis* (University Park: Pennsylvania State University Press, 1978), preface.

8. During Rossetti's lifetime, his work was included in the following exhibitions: the *Free Exhibition*, opening March 24, 1849; the National Institution exhibition at the Portland Gallery, opening April 13, 1850; a winter 1850 exhibition organized by Thomas Seddon to raise money for the North London School of Design; the *Winter Exhibition*, 121 Pall Mall, December 1852–January 8, 1853; *The Pre-Raphaelite Exhibition*, 4 Russell Place, Fitzroy Square, in July 1857; two or three exhibitions at the Hogarth Club, 1858–61; the *Liverpool Exhibition* of 1858; the Liverpool Academy, September 14, 1861 (finished studies for *The Seed of David*); the *Royal Scottish Academy Exhibition*, 1862; the *International Exhibition*, 1862 ("designs in furniture and utensils by William Morris, Madox Brown and Rossetti"); the Liverpool Academy, 1864; the Arundel Club, February 1866; *Benefit Exhibition for Henry J. Hodding*, Manchester, 1871; the *Glasgow Exhibition*, April 1876; the *Manchester Exhibition*, 1878; the German Gymnasium, April 26–May 5, 1879; and the Liverpool Academy, August 1881.

9. Virginia Surtees, *The Paintings and Drawings of Dante Gabriel Rossetti (1828–1882): A Catalogue Raisonné*, vol. 1 (Oxford: Clarendon Press, 1971), nos. 40, 44, 45, 50, 53, 54, 57, 58, 62 R. I., 64B, 81, 81 R. I., 87, 90, 97, 98, 100, 105, 105B, 109, 110, 114, 116, 124, 124 R. I., 128, 132, 162, 164, 182, 224, 233.

10. Cline, *Owl*, no. 159.

11. Doughty and Wahl, *Letters*, vol. 4, 1634–35.

12. Ibid., 1470.

13. Ibid., vol. 3, 969.

14. Fennell, *Rossetti-Leyland Letters*, 22.

15. Surtees, *Catalogue*, nos. 91 and 91 R. I.

16. Hunt, *Pre-Raphaelitism*, vol. 1, 237.

17. Rosalie Glynn Grylls, *Portrait of Rossetti* (London: MacDonald, 1964), 37.

18. William Michael Rossetti, ed., *Dante Gabriel Rossetti: His Family Letters with a Memoir*, vol. 1 (London: Ellis and Elvey, 1895), 418.

19. Surtees, *Catalogue*, no. 260.

20. Ibid., no. 226.

21. W. M. Rossetti, "Notes on Rossetti and His Works," *Art Journal* 46 (1884): 208.

22. Doughty and Wahl, *Letters*, vol. 4, 1520.

23. Fennell, *Rossetti-Leyland Letters*, xxxi–ii.

24. William Davies, "The State of English Painting," *Quarterly Review* 134 (April 1873): 298.

25. William Tirebuck, *Dante Gabriel Rossetti, His Work and Influence* (London: Elliot Stock, 1882), 26.

26. Edouard Rod, "Les Préraphaelites anglais," in *Etudes sur le dix-neuvième siècle* (Paris: Perrin, 1888); in W. M. Rossetti, *Family Letters*, vol. 1, 429.

27. Carol T. Christ, *The Finer Optic* (New Haven, Conn.: Yale University Press, 1975), 47.

28. Jan Marsh, *The Pre-Raphaelite Sisterhood* (London: Quartet Books, 1985), 316.

29. The Inchbold and Whistler limericks are quoted by W. M. Rossetti in *Rossetti Papers, 1862 to 1870* (London: Sands, 1903), 495; the Rossetti limerick appears on page 497.

1. THE EARLY YEARS
(pages 31–39)

1. The name Rossetti means "Redkins" (or "little

red one") in English, possibly a reference to the dark auburn hair that was a family trait. W. M. Rossetti, *Family Letters*, vol. 1, 4.

2. Ibid., 22.

3. R. D. Waller, *The Rossetti Family 1824–1854* (Manchester, England: Manchester University Press, 1932), 57.

4. W. M. Rossetti, "The Portraits of Dante Gabriel Rossetti," *Magazine of Art* 12 (1889): 22.

5. Ibid., 22–23.

6. Doughty and Wahl, *Letters*, vol. 1, 20.

7. Dante G. Rossetti, *The Valuable Contents of the Residence of Dante G. Rossetti to Be Sold at Auction . . . July 5, 6, & 7* (London: T. G. Wharton Martin, [1882]), no. 507. For a reproduction of *The First Madness of Ophelia*, see Surtees, *Catalogue*, no. 169.

8. D. G. Rossetti, in Alexander Gilchrist, *Life of William Blake*, vol. 1 (London: Macmillan, 1863), 372.

9. F. G. Stephens, *Dante Gabriel Rossetti* (New York: E. P. Dutton, 1908), 27–28.

10. W. M. Rossetti, "Notes on Rossetti," 149.

11. Dante Gabriel Rossetti, *The Collected Works*, ed. W. M. Rossetti (London: Ellis and Elvey, 1887), vol. 1, xxiii.

12. W. M. Rossetti, *Family Letters*, vol. 1, 94.

13. Ibid., 405.

14. William Michael Rossetti, *Dante Gabriel Rossetti as Designer and Writer* (London: Cassell, 1889), 30.

15. William Allingham, *A Diary*, ed. H. Allingham and D. Radford (Norwich, England: Penguin Books, 1985), 161.

16. Doughty and Wahl, *Letters*, vol. 2, 581.

17. Surtees, *Catalogue*, no. 34.

18. W. M. Rossetti, *Family Letters*, vol. 1, 123.

2. THE PRE-RAPHAELITE BROTHERHOOD (pages 41–67)

1. Doughty and Wahl, *Letters*, vol. 1, 36.

2. Hunt, *Pre-Raphaelitism*, vol. 1, 207–8.

3. William Holman Hunt, "The Pre-Raphaelite Brotherhood: A Fight for Art," *Contemporary Review* 49 (April 1886): 480.

4. Hunt, *Pre-Raphaelitism*, vol. 1, 100–101.

256. The London Stereotype and Photograph Company
William Holman Hunt, n.d.
Photograph
Delaware Art Museum, Wilmington;
Bancroft Archives

5. Rossetti owned an 1828 edition of Lasinio's *Campo Santo di Pisa*, which is labeled "The Celebrated Volume of Engravings," no. 595, in Rossetti, *Valuable Contents*.

6. Hunt, "Pre-Raphaelite Brotherhood," 480–81.

7. W. M. Rossetti, *Family Letters*, vol. 1, 135.

8. Robert Rosenblum, "British Painting vs. Paris," *Partisan Review* 24 (Winter 1957): 95–100.

9. See George P. Landow, *William Holman Hunt and Typological Symbolism* (New Haven, Conn.: Yale University Press, 1979); and Landow, "'Life Touching Lips with Immortality': Rossetti's Typological Structures," *Studies in Romanticism* 17 (Summer 1978): 247–66; see also Herbert L. Sussman, *Fact into Figure: Typology in Carlyle, Ruskin and the Pre-Raphaelite Brotherhood* (Columbus: Ohio State University Press, 1979).

10. One of the most important commentators on social conditions in England at mid-century was Henry Mayhew, whose influential four-volume

London Labour and the London Poor was published in 1851–52; two volumes of it were in Rossetti's library in 1882 (D. G. Rossetti, *Valuable Contents*, no. 615).

11. A. I. Grieve, *The Art of Dante Gabriel Rossetti: 1. Found 2. The Pre-Raphaelite Modern Subject* (Norwich, England: Real World Publications, 1976), section 2, 21.

12. Hunt, *Pre-Raphaelitism*, vol. 1, 125.

13. Robert de la Sizeraine, *English Contemporary Art*, trans. H. M. Poynter (London: Archibald Constable, 1898), 33.

14. John Seward [F. G. Stephens], "The Purpose and Tendency of Early Italian Art," *Germ*, no. 2 (1850): 61.

15. Doughty and Wahl, *Letters*, vol. 1, 65.

16. Ibid., 71.

17. Ibid., 84–85.

18. Rossetti's ownership of Anna Jameson's *Sacred and Legendary Art* is cited by John Christian, *The Oxford Union Murals* (Chicago: University of Chicago Press, 1981), 16.

19. Rubens had desacralized the tradition with his *Education of Marie de' Medici* (Medici Cycle, Louvre, 1622–23); Rossetti *re*-sacralized it in this example.

20. I am indebted to Professor Paul Meyvaert of Harvard University for the discovery of the article . by E. James Mundy, "Gerard David's *Rest on the Flight to Egypt*; Further Additions to Grape Symbolism," *Simiolus: Netherland Quarterly for the History of Art* 12, no. 4 (1981–82): 211–22. This article, which revealed that *Canticum canticorum* (IB46) was the source of Mary's pose in front of a grape arbor in David's painting, enabled me to identify it as Rossetti's source as well.

21. Stanley Weintraub, *Four Rossettis* (New York: Weybright and Talley, 1977), 36.

22. W. M. Rossetti, *Pre-Raphaelite Diaries*, 272.

23. John Bryson and Janet Camp Troxell, *Dante Gabriel Rossetti and Jane Morris, Their Correspondence* (Oxford: Clarendon Press, 1976), 14.

24. Another source for the pervading white tonality may have been Lord Houghton's description of Benjamin Haydon's visit to Keats in 1820: "The very colouring of the scene struck forcibly on the painter's imagination; the white curtains, the white sheets, the white shirt, and the white skin of his friend, all contrasted with the bright hectic flush on his cheek." This description appears in

Lord Houghton [Richard Monckton Milnes], *The Life of John Keats* (London, 1848), which Rossetti owned.

25. D. G. Rossetti to F. G. Stephens, April 25, 1874; in Surtees, *Catalogue*, no. 44.

26. Michael Baxandall, *Painting and Experience in Fifteenth-Century Italy* (London: Oxford University Press, 1974), 51–55; my thanks to Leslie Parris of the Tate Gallery for suggesting this source to me.

27. Dorothy L. Sayers, trans., *Dante, The Divine Comedy, 2: Purgatory* (Harmondsworth, England: Penguin Books, 1955), 144, lines 41–44.

28. W. M. Rossetti, *Pre-Raphaelite Diaries*, 260–70.

29. Doughty and Wahl, *Letters*, vol. 1, 124.

30. Brian and Judy Dobbs, *Dante Gabriel Rossetti: An Alien Victorian* (London: MacDonald and James, 1977), 68. The review is included by William Rossetti in the 1911 edition of D. G. Rossetti's works, p. 572, so his brother may well have written the review himself. It is devastating.

31. Surtees, *Catalogue*, no. 44.

32. W. M. Rossetti, "Notes on Rossetti," 151.

33. Surtees, *Catalogue*, no. 48. Her beribboned gown may have come from Camille Bonnard's *Costumes historiques des XIIe, XIIIe, XIVe, et XV siècles* (which Rossetti owned), Bonnard having copied the dress from a fresco by Bernardino Luini in Milan. See Leonée Ormond, "Dress in the Painting of Dante Gabriel Rossetti," *Costume* 8 (1974): 28.

34. Hunt, "Pre-Raphaelite Brotherhood," 479. Rossetti's association of the salutation of Beatrice with Ghiberti's gates may have to do with the fact that Beatrice, like the Baptistry doors, was from Florence (even though the doors did not yet exist in Dante's time, an anachronism not surprising for Rossetti, who was not strong on history). Beatrice is also identified in Dante's *Divine Comedy* with his final vision of her in Paradise, and Ghiberti's doors bore the popular title "the Gates of Paradise."

35. W. M. Rossetti, "Notes on Rossetti," 151.

36. Doughty and Wahl, *Letters*, vol. 1, 49.

37. This source was first published by John Christian, "Early German Sources for Pre-Raphaelite Designs," *Art Quarterly* 36 (Spring–Summer 1973): 58.

38. Doughty and Wahl, *Letters*, vol. 1, 122–23.

39. Valentine Prinsep, a young artist recruited for the Oxford murals campaign of 1857, may be the model for Giotto.

40. Hunt, *Pre-Raphaelitism* (1913 ed.), vol. 2, 2.

41. Rowland Elzea, *The Samuel and Mary R. Bancroft, Jr., and Related Pre-Raphaelite Collections* (Wilmington: Delaware Art Museum, 1984), 100.

42. D. G. Rossetti to William Allingham, November 1854; in Doughty and Wahl, *Letters*, vol. 1, 231.

43. Paull Franklin Baum, *Dante Gabriel Rossetti: An Analytical List of Manuscripts in the Duke University Library* (New York: AMS Press, 1966), 126.

44. Doughty and Wahl, *Letters*, vol. 4, 1635.

45. Thomas Hall Caine, *Recollections of Rossetti* (London: Cassell, 1928), 221.

46. Linda Nochlin, "Lost and *Found*: Once More the Fallen Woman," *Art Bulletin* 60 (March 1978): 152–53; and Doughty and Wahl, *Letters*, vol. 3, 1175.

3. CRITICISM, SUCCESS, AND DISSOLUTION (pages 69–83)

1. *Punch or the London Charivari* 18 (June 1850): 198.

2. W. M. Rossetti, *Family Letters*, vol. 1, 168.

3. George P. Landow, "Your Good Influence on Me: The Correspondence of John Ruskin and William Holman Hunt," *Bulletin of the John Rylands University Library of Manchester* 59 (1976–77): 376–77.

4. For the entire text of Ruskin's lecture, see John Ruskin, *The Works of John Ruskin*, ed. E. T. Cook and Alexander Wedderburn (London: George Allen, 1903–12), vol. 12, 164.

5. There was nothing in the Pre-Raphaelite aesthetic that conflicted with Catholic beliefs, but Collinson may have been distressed by critics' perceptions of sacrilege in the Pre-Raphaelites' various down-to-earth portrayals of the Holy Family.

6. Doughty and Wahl, *Letters*, vol. 1, 163.

7. Millais had been a child prodigy, entering the Royal Academy at age eleven, the youngest student ever accepted. Three years later he won a silver medal in drawing from the antique and in 1847, the gold medal in painting, for *The Crusader's Return*. Millais was by far the most naturally talented artist of the Pre-Raphaelite Brotherhood, a born painter who was to become an associate of the Royal Academy in 1853, a member in 1863, president in 1896, and the first English artist to be created a baronet, in 1885. His work made after his association with the Pre-Raphaelite Brotherhood ended is generally little esteemed today. The source of his problem is evident in a letter he wrote to Hunt, "The difficulty of finding a subject is so great that I am quite at a stand still about the next design." (John Everett Millais to William Holman Hunt, c. 1850, Huntington Library and Art Gallery, San Marino, Calif., MS HH329.) Millais, though a brilliant technician, lacked the inner resources and imagination to create original works on his own. He needed the strength and integrity of Hunt and the imagination and literary acumen of Rossetti to provide him with the conception and intellectual background for his paintings.

8. Jeremy Maas, *Victorian Painters* (New York: Abbeville Press, 1984), 14.

9. Violet Hunt, *The Wife of Rossetti* (New York: E. P. Dutton, 1932), xx.

10. W. M. Rossetti, *Family Letters*, vol. 1, 175.

11. Marion R. Edwards, "Elizabeth Eleanor Siddal—The Age Problem," *Burlington Magazine* 119 (February 1977): 112; and Deborah Cherry and Griselda Pollock, "Woman as Sign in Pre-Raphaelite Literature: A Study of the Representation of Elizabeth Siddal," *Art History* 7 (June 1984): 211.

12. Marsh, *Pre-Raphaelite Sisterhood*, 18.

13. Hunt, *Pre-Raphaelitism*, vol. 1, 198.

14. W. M. Rossetti, *Family Letters*, vol. 1, 171 and 174.

15. Sandra M. Donaldson, "'Ophelia' in Elizabeth Siddal Rossetti's Poem 'A Year and a Day,'" *Journal of Pre-Raphaelite Studies* 2 (November 1981): 127–28.

16. John Guille Millais, *The Life and Letters of Sir John Everett Millais*, vol. 1 (New York: Frederick A. Stokes, 1899), 144.

17. W. M. Rossetti, *Family Letters*, vol. 1, 173.

18. Surtees, *Catalogue*, no. 62.

19. Roger C. Lewis and Mark Samuels Lasner, *Poems and Drawings of Elizabeth Siddal* (Wolfville, Nova Scotia: Wombat Press, 1978), ix. Other

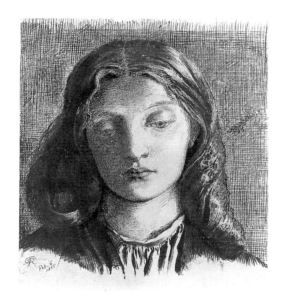

257. Elizabeth Siddal, February 6, 1855
Pen and brown ink and black ink
on paper, 4¾ x 4¼ in.
Ashmolean Museum, Oxford, England

sources to consult about Siddal's career as an artist are: David Brown, "Pre-Raphaelite Drawings in the Bryson Bequest to the Ashmolean Museum," *Master Drawings* 16 (Autumn 1978): 287–93; Wolfgang Löttes, *Wie ein goldener Traum: Die Rezeption des Mittelalters in der Kunst der Prä-Raffaeliten* (Munich: Wilhelm Fink Verlag, 1984); Marsh, *Pre-Raphaelite Sisterhood*; and W. M. Rossetti, "Dante Rossetti and Elizabeth Siddal," *Burlington Magazine* 1 (May 1903): 273–95.

20. Doughty and Wahl, *Letters*, vol. 1, 153. Siddal's self-portrait is reproduced in Jan Marsh, *Pre-Raphaelite Women* (New York: Harmony Books, 1987), 22.

21. W. M. Rossetti, "Dante Rossetti and Elizabeth Siddal," 273.

22. Doughty and Wahl, *Letters*, vol. 1, 200.

23. V. Hunt, *Wife of Rossetti*, 203.

24. W. M. Rossetti, *Some Reminiscences*, vol. 1 (London: Brown Langham, 1906), 195.

4. MEDIEVALISM
(pages 85–103)

1. Among special exhibitions of medieval material that Rossetti could have seen were the *Spring Ex-*

hibition of Old Masters at the British Institution in 1848; *Ancient and Medieval Art,* at the Society of Arts in London, 1850; the *South Kensington Loan Exhibition,* 1862; and the *Leeds Exhibition,* 1868.

2. Ruskin and Morris were members of the Arundel Society (founded in 1848), so Rossetti had access to this material. He also mentioned seeing Arundel Society copies of works by Benozzo Gozzoli and Giotto in April 1856 (Doughty and Wahl, *Letters,* vol. 1, 298–99).

3. W. M. Rossetti, *Family Letters,* vol. 1, 92–93.

4. Robert Southey, *The Byrth, Lyf and Actes of King Arthur,* vol. 2 (London, 1817), 447–48.

5. D.M.R. Bentley, "Rossetti and the *Hypnerotomachia Poliphili,*" *English Language Notes* 14 (June 1977): 279. The young Rossetti's perusal of the book is recorded in W. M. Rossetti, *Family Letters,* vol. 1, 62; his purchase of it is noted in Caine, *Recollections of Rossetti* (1882 ed.), 261, and also in an inventory of the auction of his estate.

6. D. G. Rossetti, *Valuable Contents,* no. 486.

7. R. L. Mégroz, *Dante Gabriel Rossetti* (New York: Haskell House Publishers, 1971), 300.

8. Surtees, *Catalogue,* nos. 75A–E.

9. Doughty and Wahl, *Letters,* vol. 1, 304 n. 8.

10. Ibid., 238.

11. Ibid., 239.

12. Ibid., 243.

13. J. Dalziel, *The Brothers Dalziel,* vol. 2 (London, 1901), 86.

14. George Birbeck Hill, ed., *Letters of Dante Gabriel Rossetti to William Allingham, 1854–1870* (London: T. Fisher Unwin, 1897), 112.

15. Doughty and Wahl, *Letters,* vol. 1, 318.

16. R. H. and L. H. Loomis, *Arthurian Legends in Medieval Art* (London, 1938), 97.

17. George Somes Layard, *Tennyson and His Pre-Raphaelite Illustrators* (London: E. Stock, 1894), 56.

18. W. M. Rossetti, "Dante Rossetti and Elizabeth Siddal," 295; and H. C. Marillier, *Dante Gabriel Rossetti: An Illustrated Memorial of His Art and Life* (London: George Bell and Sons, 1899), 57.

19. Ronald W. Johnson, "Dante Rossetti's *Beata Beatrix* and the New Life," *Art Bulletin* 57 (December 1975): 550.

20. Harry Quilter, "The Art of Rossetti," *Contemporary Review* 43 (February 1883); in Layard, *Tennyson,* 59.

21. Christian, "Early German Sources," 57–58.

22. Ruskin, *Works,* vol. 15, 79.

23. W. M. Rossetti, ed., *Ruskin: Rossetti: PreRaphaelitism Papers, 1854 to 1862* (New York: Dodd, Mead and Company; London: George Allen, 1899), 45.

24. Doughty and Wahl, *Letters,* vol. 1, 245.

25. The musician's costume from which the artist's was taken is reproduced (without the gold trim on his hat) in Henry Shaw's *Dresses and Decorations of the Middle Ages,* vol. 2 (London, 1843), no. 58. Shaw did not reproduce the woman with the black headdress in the right foreground of the *Dance of Mirth,* which was the model for Saint Catherine's costume. Therefore, it is likely that Rossetti copied these from the original manuscript.

26. Stephens, *Dante Gabriel Rossetti,* 110–11.

5. NEW FRIENDS
(pages 105–21)

1. Doughty and Wahl, *Letters,* vol. 1, 293.

2. Ibid., 337.

3. Ibid.

4. Coventry Patmore, "Walls and Wall-Painting at Oxford," *Saturday Review,* December 26, 1857, 583–84.

5. Georgiana Burne-Jones, *Memorials of Edward Burne-Jones,* vol. 1 (New York: Macmillan, 1904), 164.

6. Patmore, "Walls and Wall-Painting at Oxford," 583–84.

7. W. M. Rossetti, *Family Letters,* vol. 1, 199.

8. Jan Marsh, *Jane and May Morris* (London and New York: Pandora, 1986), 1–5.

9. See, for example, the *Psalter of Queen Philippa,* Harley MS 2899, fol. 64; Arundel MS 83, fol. 55v.; and Arundel MS 83, fol. 266.

10. John Christian, entry in Alan Bowness, *The Pre-Raphaelites* (London: Tate Gallery, 1984), 170.

11. D. G. Rossetti to William Allingham, December 18, 1856; in Doughty and Wahl, *Letters,* vol. 1, 312.

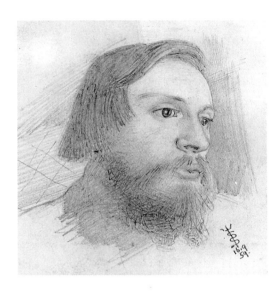

258. Simeon Solomon (1840–1905)
Edward Burne-Jones, 1859
Pencil on paper, 4⅝ x 4⅝ in.
Ashmolean Museum, Oxford, England

12. D. G. Rossetti to Charlotte Lydia Polidori, June 25, 1864; ibid., vol. 2, 508.

13. Jacopo Robusti, called Tintoretto by most and Tintoret by John Ruskin, was Ruskin's favorite painter at this time. Both the *Annunciation* and *Nativity* (1577–84) are shown in symbolic ruined dwellings, and the *Nativity* has a second floor where light can be seen coming through the rafters, as in Rossetti's preliminary and final paintings. It should be remembered that this important commission was secured for Rossetti by Ruskin's aid, and his approval of the work would have been important to the artist. In 1852 Ruskin himself did three drawings of Tintoretto's *Adoration of the Magi* (1583–87, Scuola di San Rocco, Venice) and one of Tintoretto's *Annunciation* (see Ruskin, *Works*, vol. 38, 287), which he would undoubtedly have shared with Rossetti. A comparison of Rossetti's central panel with Ruskin's watercolor of Tintoretto's *Adoration of the Magi* (now at the Ruskin Galleries, Bembridge School, Bembridge, Isle of Wight, Great Britain) reveals great similarities in composition and poses.

6. ROSSETTI AND RUSKIN
(pages 123–37)

1. Doughty and Wahl, *Letters*, vol. 1, 133–34.

2. John Ruskin to Francis MacCracken, April 10, 1854; in Janet Camp Troxell, ed., *Three Rossettis* (Cambridge, Mass.: Harvard University Press, 1937), 25.

3. Doughty and Wahl, *Letters*, vol. 1, 185.

4. W. M. Rossetti, *Ruskin: Rossetti: PreRaphaelitism*, 2–3.

5. J. L. Davies, ed., *The Working Men's College 1854–1904* (London: Macmillan, 1904), 45–46.

6. John Ruskin, from his *Praeterita* of 1885–89; in Ruskin, *Works*, vol. 35, 486.

7. W. M. Rossetti, *Family Letters*, vol. 1, 182.

8. W. M. Rossetti, *Ruskin: Rossetti: PreRaphaelitism*, 94.

9. D. G. Rossetti to Frances Rossetti, July 1, 1855; in Doughty and Wahl, *Letters*, vol. 1, 259.

10. W. M. Rossetti, *Ruskin: Rossetti: PreRaphaelitism*, 140.

11. Algernon Charles Swinburne to Richard Monckton Milnes, October 15, 1860; in Edmund Gosse, *Life of Algernon Charles Swinburne* (London, 1917), 75.

12. W. M. Rossetti, *Ruskin: Rossetti: PreRaphaelitism*, 76. Thomas Hall Caine, a later friend of Rossetti, also believed it was Ruskin's influence that caused the artist to go ahead with a marriage he recognized as a duty. Thomas Hall Caine to George Bernard Shaw, September 24, 1928, Add MS 50531, British Library, London.

13. Oswald Doughty, *A Victorian Romantic: Dante Gabriel Rossetti* (London: Oxford University Press, 1960), 174.

14. D. G. Rossetti to William Allingham, March 17, 1855; in Doughty and Wahl, *Letters*, vol. 1, 244.

15. W. M. Rossetti, *Ruskin: Rossetti: PreRaphaelitism*, 63.

16. Ruskin, *Works*, vol. 36, 216–17.

17. W. M. Rossetti, *Ruskin: Rossetti: PreRaphaelitism*, 183–84.

18. Ruskin's interference could damage weak artists, as it did John Brett, or even destroy them, as it did William James Stillman, who contracted temporary blindness from Ruskin's criticizing his work during a trip they took together in Switzerland; Stillman then gave up art for a diplomatic career. John Christian, "'A Serious Talk': Ruskin's Place in Burne-Jones's Artistic Development,"
in Leslie Parris, ed., *Pre-Raphaelite Papers* (London: Tate Gallery, 1984), 205.

19. Troxell, *Three Rossettis*, 28–29.

20. W. M. Rossetti, *Ruskin: Rossetti: Pre-Raphaelitism*, 184.

21. Ibid., 253.

22. Graham Robertson, letter dated August 14, 1938; in Kerrison Preston, *Letters from Graham Robertson* (London: Hamish Hamilton, 1953), 398–99.

23. Grylls, *Portrait of Rossetti*, 48.

24. Patrick Conner, *Savage Ruskin* (Detroit: Wayne State University Press, 1979), 126–27.

7. THE END OF A DREAM
(pages 139–45)

1. Doughty and Wahl, *Letters*, vol. 1, 364–65.

2. Grylls, *Portrait of Rossetti*, 78.

3. Hoxie Neale Fairchild, *Religious Trends in English Poetry*, vol. 4 (New York: Columbia University Press, 1957), 399.

4. Doughty and Wahl, *Letters*, vol. 1, 384.

5. D. G. Rossetti to William Allingham, July 23, 1854; in Doughty and Wahl, *Letters*, vol. 1, 209.

6. Joanna Banham and Jennifer Harris, *William Morris and the Middle Ages* (Manchester, England: Manchester University Press, 1984), 121. This miniature does not appear to have been reproduced in any books on manuscript illumination or costumes, so it is probable that the source was the original manuscript in the British Museum.

7. Grylls, *Portrait of Rossetti*, 87; V. Hunt, *Wife of Rossetti*, 297; Mrs. Belloc Lowndes, *I Too Have Lived in Arcady* (London: Macmillan, 1941), 255–56.

8. W. M. Rossetti, in William E. Fredeman, "The Letters of Pictor Ignotus: William Bell Scott's Correspondence with Alice Boyd, 1859–1884," *Bulletin of the John Rylands University Library of Manchester* 58 (1976): 339.

8. VENETIAN PAINTINGS AND LILLIPUTIAN PATRONS
(pages 147–69)

1. Gale Pedrick, *Life with Rossetti, or No Peacocks Allowed* (London: MacDonald, 1964), 88.

2. Ruskin, *Works*, vol. 16, 198.

3. D. G. Rossetti to W. M. Rossetti, June 9, 1860; in Doughty and Wahl, *Letters*, vol. 1, 367.

4. Ibid., vol. 2, 576–77.

5. Frederic Shields, "Some Notes on D. G. Rossetti," *Century Guild Hobby Horse* 1 (1886): 141–42.

6. Hunt, *Pre-Raphaelitism*, vol. 2, 143.

7. William Holman Hunt to Thomas Combe, February 12, 1860; in Surtees, *Catalogue*, no. 114. The oil of *Bocca Baciata* is known in two versions, one (plate 159) at the Museum of Fine Arts, Boston, the other in a private collection. Available evidence suggests that the Museum of Fine Arts version is the original, the other an excellent replica, perhaps by Rossetti himself.

8. W. M. Rossetti, *Family Letters*, vol. 2, 43.

9. Sarah Phelps Smith, "Dante Gabriel Rossetti's 'Lady Lilith' and the Language of Flowers," *Arts Magazine* 53 (February 1979): 143.

10. Doughty and Wahl, *Letters*, vol. 2, 424.

11. Virginia Surtees, ed., *The Diaries of George Price Boyce* (Norwich, England: Real World Publications, 1980), 103.

12. A. I. Grieve, in Bowness, *Pre-Raphaelites*, 211.

13. Charles Augustus Howell often acted as an agent for both Rossetti and Whistler in the collecting of Nankin blue-and-white porcelain. Once when he had acquired a perfect example he invited both Whistler and Rossetti to view it. Rossetti coveted it so much that he spirited it away in the folds of his Inverness cape, and then invited the same group to dine with him later that week. Howell suspected what had happened, found the pot where Rossetti had hidden the piece, and substituted another one. When Rossetti went to uncover his "find" at the end of dinner, he discovered an old blue dish, cracked and disreputable. "Confound it! See what the spirits have done!" he muttered while the others roared with laughter, and Rossetti, seeing Howell's impassive face, realized what had happened and joined in. (This story is told by Rosalie Glynn Grylls in *Portrait of Rossetti*, 102.)

14. William Gaunt, *The Aesthetic Adventure* (New York: Harcourt, Brace and Company, 1945), 42.

15. W. M. Rossetti, *Rossetti Papers*, 495.

16. Stephens, *Dante Gabriel Rossetti*, 165.

17. Fennell, *Rossetti-Leyland Letters*, xxiv.

18. W. M. Rossetti, *Family Letters*, vol. 1, 203.

19. Shields, "Some Notes on D. G. Rossetti," 143.

20. Doughty and Wahl, *Letters*, vol. 1, 164. The Tennyson original reads as follows, as quoted by D. G. Rossetti, ibid.:

The Kraken
Below the thunders of the upper deep,
Far far beneath in the abysmal sea,
His ancient, dreamless, uninvaded sleep
The Kraken sleepeth. Fainter sunlights flee
About his shadowy sides; above him swell
Huge sponges of millennial growth and height;
And far away into the sickly light,
From many a wondrous grot and secret cell
Unnumber'd and enormous polypi
Winnow with giant arms the slumbering green.
There hath he lain for ages, and will lie
Battening upon huge sea-worms in his sleep,
Until the latter fire shall heat the deep;
Then once by man and angels to be seen,
In roaring he shall rise and on the surface die.

21. Doughty and Wahl, *Letters*, vol. 3, 929.

22. William Graham had such an extensive collection that it required a five-day sale at auction by Christie, Manson and Woods, April 2–3 and 8–10, 1886, with a seventy-two-page catalog.

9. JANE MORRIS
(pages 171–97)

1. Caine, *Recollections of Rossetti*, 200–201; Mégroz, *Dante Gabriel Rossetti*, 66–68.

2. Graham Ovenden, *Pre-Raphaelite Photography* (New York: St. Martin's Press, 1972), 20, 21, 24.

3. Doughty and Wahl, *Letters*, vol. 2, 600.

4. For interpretations of flower imagery, see Kate Greenaway, *Language of Flowers* (reprint, New York: Merrimack, n.d.), 37; and Claire Powell, *The Meaning of Flowers* (Boulder, Colo.: Shambhala, 1979), 56, 112.

5. Ormond, "Dress in the Painting of Dante Gabriel Rossetti," 28; and Doughty and Wahl, *Letters*, vol. 3, 1384.

6. Doughty and Wahl, *Letters*, vol. 4, 1815.

7. J. W. Mackail, *The Life of William Morris* (London, 1901), 215.

259. Mrs. William Morris, *1865*
Black chalk on cream paper,
16⅝ x 13¾ in.
The Harvard University Art Museums
(Fogg Art Museum),
Cambridge, Massachusetts;
Bequest of Grenville L. Winthrop

8. William Morris to James Mavor, c. 1884–96; in James Mavor, *My Windows on the Street of the World*, vol. 1 (London, 1923), 201.

9. Doughty and Wahl, *Letters*, vol. 2, 670.

10. William E. Fredeman, "Prelude to the Last Decade: Dante Gabriel Rossetti in the Summer of 1872," *Bulletin of the John Rylands University Library of Manchester* 53 (1970–71): 100–101.

11. D. G. Rossetti to Jane Morris, February 4, 1870; in Bryson and Troxell, *Dante Gabriel Rossetti and Jane Morris*, 34.

12. W. M. Rossetti, *Family Letters*, vol. 1, 244.

13. R. E. Francillon, *Mid-Victorian Memories* (London: Hodder and Stoughton, [1914]), 172.

14. Doughty and Wahl, *Letters*, vol. 3, 951.

15. Ibid., 950.

16. D. G. Rossetti to Jenny and May Morris, December 22, 1875, Add MSS 45353, Morris Papers, vol. 16, British Library, 18 and 19.

17. Doughty and Wahl, *Letters*, vol. 3, 954.

18. Ibid., vol. 2, 712.

19. S. N. Ghose, *Dante Gabriel Rossetti and Contemporary Criticism* (Strasbourg, France, 1929; reprinted by Folcroft Library Editions, 1970), 149; and Robert Buchanan, *The Fleshly School of Poetry* (London: Strahan, 1872), 67.

20. See William Gaunt, "Two Portrait Drawings by Dante Gabriel Rossetti," *Connoisseur* 110 (December 1942): 140–41, 158.

21. J. Lemprière, *Bibliotheca Classica, or A Classical Dictionary* (London: T. Cadell Jun. and W. Davies, 1801).

22. Fennell, *Rossetti-Leyland Letters*, 44.

23. Doughty and Wahl, *Letters*, vol. 1, 291.

24. Aubrey De Vere, *The Search after Proserpina* (Oxford: John Henry Parker, 1843), 24.

25. Cesare Ripa, *Iconologia* (1593; reprinted New York: Dover, 1971), no. 154.

26. Filippo Pistrucci, *Iconologia ovvero imagini di tutte le cose principia...* (Milan: Presso Paolo Antonio Tosi e comp., 1819), plates 6, 24, and 107.

27. Doughty and Wahl, *Letters*, vol. 4, 1476.

28. Ibid., 1636.

29. Bryson and Troxell, *Dante Gabriel Rossetti and Jane Morris*, 68.

30. Jane Morris, in Peter Faulkner, *Wilfrid Scawen Blunt and the Morrises* (London: William Morris Society, 1981), 30.

10. The Late Work (pages 199–215)

1. D. G. Rossetti to Thomas Hall Caine, c. 1880–82; Caine, *Recollections of Rossetti*, 112.

2. W. M. Rossetti, *Family Letters*, vol. 1, 412.

3. Ernestine Mills, "Rossetti's Method of Oil Painting," *Apollo* 49 (February 1949): 49. For a description of Rossetti's drawing methods, see Frederic Shields, "A Note upon Rossetti's Method of Drawing in Crayons," *Century Guild Hobby Horse* 5 (1890): 70–73.

4. Mills, "Rossetti's Method," 49.

5. Barbara Charlesworth Gelpi, "The Image of the Anima in the Work of Dante Gabriel Rossetti," *Victorian Newsletter* 45 (Spring 1974): 7; and

F.W.H. Myers, *Rossetti and the Religion of Beauty* (Portland, Maine: Thomas B. Mosher, 1902), 356.

6. Rossetti was not alone in joining or even confusing religious and secular passion. This merging is evident in the works of John Donne, the Metaphysical Poets, and Edmund Spenser.

7. Julian Treuherz, *Pre-Raphaelite Paintings from the Manchester City Art Gallery* (London: Lund Humphries, 1980), 109.

8. W. M. Rossetti, *Rossetti Papers*, 484.

9. Smith, "Rossetti's 'Lady Lilith,'" 144.

10. Algernon Charles Swinburne, *A Record of a Friendship* (London: Privately printed, 1910), 46.

11. F. G. Stephens, "Pictures by Mr. Rossetti," *Athenaeum*, August 15, 1875, 220.

12. Elzea, *Bancroft and Related Pre-Raphaelite Collections*, 124.

13. Doughty and Wahl, *Letters*, vol. 3, 1369.

14. D. G. Rossetti to W. M. Rossetti; ibid., vol. 2, 664–65. Rossetti was one of the first admirers of Botticelli in England. He purchased a *Portrait of Smeralda Bandinelli*, attributed to Botticelli, now in the Victoria and Albert Museum, London. In 1880 he wrote a sonnet on Botticelli's *Primavera*. Botticelli's *Mystical Nativity* entered the National Gallery in London in 1871, so he may have seen it there as well as in Leeds, and he requested a photograph of it from Charles Fairfax Murray (letter no. 644, Rossetti's letters, Harry Ransom Humanities Research Center, University of Texas at Austin).

15. Doughty and Wahl, *Letters*, vol. 4, 1564, 1566.

16. Ibid., vol. 3, 1435–36, and vol. 4, 1632.

17. Surtees, *Catalogue*, no. 226.

18. Peter Faulkner, ed., *Jane Morris to Wilfrid Scawen Blunt* (Exeter, England: University of Exeter, 1986), 89. This comes from an entry of August 14, 1894, in Wilfrid Scawen Blunt's unpublished secret memoirs at the Fitzwilliam Museum, Cambridge, England (Blunt MS 33, 304).

19. Many of the Pre-Raphaelites were devotees of Keats's *Hyperion*. Hunt made drawings related to it in the spring of 1848, Rossetti bought Richard Monckton Milnes's *Life of Keats* in 1848, and Stephens quoted from Keats's *Hyperion*, beginning with "Knowledge enormous makes a God of me," in the *Crayon* of February 1858. In 1880 Rossetti

wrote a sonnet on Keats, and in a letter to Henry Buxton Forman of February 10, 1880, he inquired about a manuscript of Keats's *Endymion* (Doughty and Wahl, *Letters*, vol. 4, 1709). Rossetti promoted a subscription in 1880 for Keats's only surviving sister, Madame de Llanos, and was prominent among its contributors. In May 1881 Rossetti was reading a copy of Keats's letters to Fanny Brawne.

There are 124 unpublished letters from Rossetti to Thomas Hall Caine dating from 1879 to 1881 in the Manx Museum and National Trust, Douglas, Isle of Man (MD 676). In this correspondence, which spans the period when Rossetti was working on *Mnemosyne*, Keats was a major topic. It is clear that Rossetti was deeply involved with Keats's material when he was creating the iconography of *Mnemosyne*, and the poem provides the key to the painting's meaning.

20. Harold Bloom, *Poetry and Repression: Revisionism from Blake to Stevens* (New Haven, Conn., and London: Yale University Press, 1976), 6.

21. D. G. Rossetti to Frances Rossetti, April 27, 1880; in Doughty and Wahl, *Letters*, vol. 4, 1760.

22. The Caine comment comes from his *Recollections of Dante Gabriel Rossetti* (Boston: Roberts Brothers, 1883), 140. W. M. Rossetti's comment is from W. M. Rossetti, *Family Letters*, vol. 1, 382. However, William himself was an agnostic, so he may have had some bias in the matter. A friend who had known Dante Gabriel well in the 1870s, William James Stillman, remarked, "Rossetti, with all his irregularities, never could escape from his religious feeling, which was the part of his constitution he possessed in common with his sisters." William James Stillman, *The Autobiography of a Journalist*, vol. 2 (Boston: Houghton Mifflin, 1901), 477.

11. Summing Up (pages 217–27)

1. W. M. Rossetti, ed., *The Collected Works of Dante Gabriel Rossetti*, vol. 1 (London, 1886), 511.

2. Roger Fry, "Rossetti's Water Colours of 1857," *Burlington Magazine* 29 (June 1916): 100. For a reproduction of *Chapel before the Lists*, see Surtees, *Catalogue*, no. 99.

3. Joan Rees, *The Poetry of Dante Gabriel Rossetti: Modes of Self-Expression* (Cambridge: Cambridge University Press, 1981), 94.

4. Millais, *Life and Letters of Sir John Everett Millais*, vol. 1, 52.

5. Helen Rossetti Angeli, *Dante Gabriel Rossetti: His Friends and Enemies* (London: Hamish Hamilton, 1949), 61–62.

6. Gleeson White, *English Illustration: "The Sixties," 1855–70* (London: Archibald Constable, 1897), 158.

7. Burne-Jones, *Memorials of Edward Burne-Jones*, vol. 2, 190.

8. Doughty and Wahl, *Letters*, vol. 2, 697–98.

9. Cameron's *And Enid Sang* of 1875 seems closely related in composition to Rossetti's oil *Joli Coeur* of 1867 in the Manchester City Art Gallery.

10. For the influence of Rossetti's poems on other artists, see Steven Kolsteren, "Rossetti's Writings as a Source of Inspiration for Victorian Artists," *Victorian Poetry* 20 (Autumn–Winter 1982): 113–43.

11. Paul Verlaine, *Poésies complètes*, vol. 7 (Paris: Editions de la Banderole, 1926), 60–61.

12. See Edith Hoffman, "Some Sources for Munch's Symbolism," *Apollo* 81 (February 1965): 87–93. For a comparison between *The Kiss* and *Paolo and Francesca*, see *Edvard Munch: Liebe, Angst, Tod* (Oslo: Munch Museum, 1980), 427.

13. John Ruskin, *The Lamp of Beauty*, ed. Joan Evans (Ithaca, N.Y.: Cornell University Press, 1980), 158.

ACKNOWLEDGMENTS

I would like first to acknowledge those pioneers in twentieth-century Pre-Raphaelite scholarship without whose work no writing on Dante Gabriel Rossetti could proceed: William E. Fredeman, whose seminal *Pre-Raphaelitism: A Bibliocritical Study* of 1965 (now in the process of revision) is a landmark in Pre-Raphaelite research; Virginia Surtees, whose 1971 catalogue raisonné of the paintings and drawings of Dante Gabriel Rossetti is a necessity for any study of his art; and Oswald Doughty and John Wahl, for the publication of four volumes of Rossetti's letters, which, though incomplete, are nonetheless a vital source of information.

Next I would like to thank those in the museum field who have been unfailingly helpful, knowledgeable, and patient: particularly Leslie Parris, Tate Gallery, London; Christopher Lloyd, Surveyor of the Queen's Pictures; Mary Bennett, Walker Art Gallery, Liverpool, England; Lionel Lambourne, Victoria and Albert Museum, London; Susan Casteras, Yale Center for British Art, New Haven, Connecticut; A. R. Dufty, Kelmscott Manor and the Society of Antiquarians, London; Lady Mander of Wightwick Manor, Wolverhampton, England; Odette Rogers, Department of Manuscripts, Fitzwilliam Museum, Cambridge, England; Sir Benedict Read, Witt Library, London; William Bradford, Courtauld Institute, London; Tessa Sidey, Department of Drawings, Birmingham City Art Museum, Birmingham, England; Julian Treuherz, City of Manchester Art Museum, Manchester, England; Anthony Griffiths, Department of Drawings and Prints, British Museum, London; Janet Barnes, Ruskin Gallery, Sheffield, England; and Rowland Elzea, Delaware Art Museum, Wilmington.

My thanks also go to Artemis Kirk, director of the Simmons College Library, Boston; Janet Backhouse, British Library, London; Catherine Johnson, New York Public Library; Helene Roberts, Fogg Art Library, Cambridge, Massachusetts; Ann M. Harrison, archivist of the library, Manx Museum and National Trust, Douglas, Isle of Man; Cathy Henderson, research librarian, Harry Ransom Humanities Research Center, University of Texas at Austin; and the librarians at the Huntington Library and Art Gallery, San Marino, California.

I also owe a debt of thanks to many academic colleagues and Pre-Raphaelite enthusiasts who have encouraged my work, especially George Landow, Brown University, Providence, Rhode Island; Liana Cheney, University of Lowell, Lowell, Massachusetts; Leonée Ormond, University of London; Judith Bronkhurst and Malcolm Warner, Courtauld Institute, London; Susan Ashbrook; Gail Weinberg; Francis and Barbara Golffing; Jeremy Maas; Janet Faure-Munro; and my colleagues at Simmons College.

Finally, I would like to thank Imogen Denis and Helen Guglielmini, who shared so many Rossetti family memories and treasures with me; my editor, Nancy Grubb, who guided the book through publication; and my husband, Richard, and my family, whose support of this project has been enlightening and empowering.

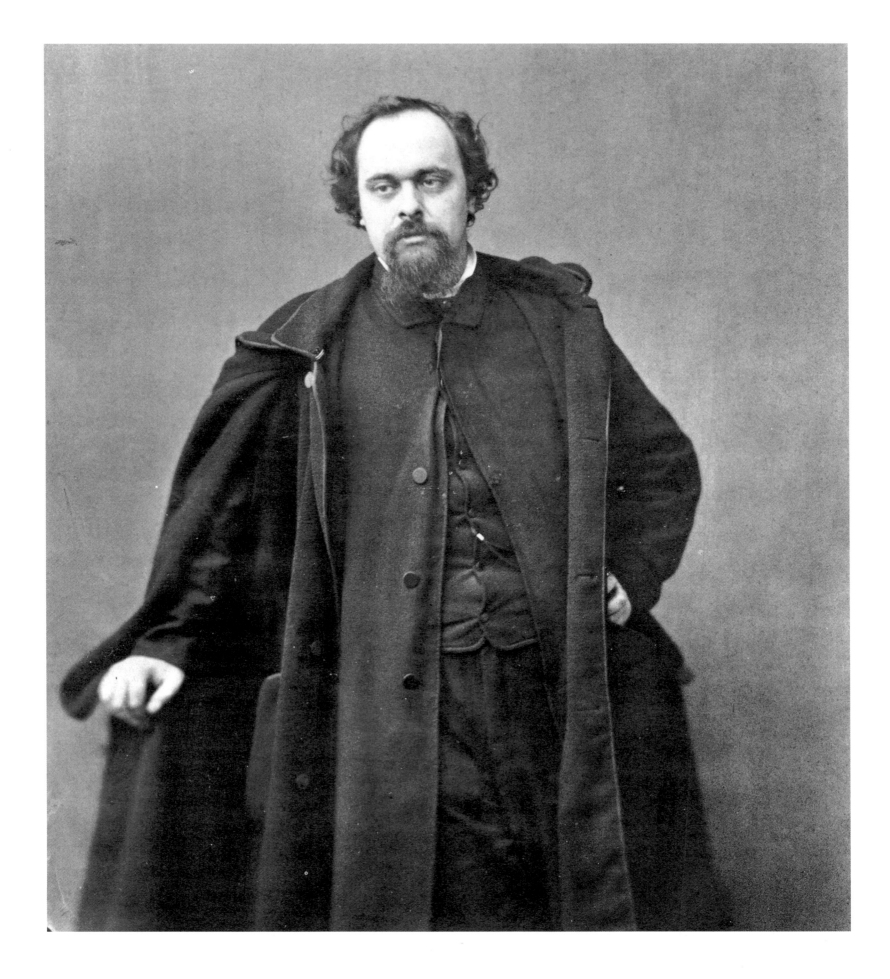

238

CHRONOLOGY

1828
May 12—Gabriel Charles Dante Rossetti is born at 38 Charlotte Street, Portland Place, London. His father is Gabriele Rossetti (1783–1854), a political refugee from Vasto d'Ammone, Abruzzi, Italy, who arrived in England in 1824. His mother is Frances Polidori Rossetti, a governess and daughter of Gaetano Polidori, a Tuscan who had married an Englishwoman. He has three siblings: Maria Francesca Rossetti (1827–1876); William Michael Rossetti (1829–1919); and Christina Georgina Rossetti (1830–1894).

1836
The family moves to less cramped quarters at 50 Charlotte Street. Late summer—Dante Gabriel starts attending the Reverend Mr. Paul's school on Foley Street.

1837
Both boys attend King's College School, where their father is professor of Italian.

260. W. and D. Downey
Dante Gabriel Rossetti, December 1862
Cabinet portrait print
Delaware Art Museum, Wilmington;
Bancroft Archives

1842
Having decided to be an artist, Dante Gabriel attends Cary's Academy of Art, popularly known as Sass's.

1843
Sir Hugh the Heron, a knightly romance by Dante Gabriel, is privately printed by his grandfather Gaetano Polidori. October–November—Dante Gabriel visits the Giuseppe Maenza family in Boulogne, France.

1844
Summer—Dante Gabriel enters the Royal Academy Antique School. November–January 1845—returns to the Maenza family in Boulogne.

1847
April—purchases an original Blake manuscript for ten shillings from George Palmer, a British Museum attendant.

1848
March—bored by the routine of the Antique School drawing exercises, becomes a pupil of Ford Madox Brown. April—starts drawing from the model at the Maddox Street Evening Academy. August—leaves Brown's tutelage to share a studio with William Holman Hunt at 7 Cleveland Street, Fitzroy Square, and becomes Hunt's student, painting *The Girlhood of Mary Virgin* under his guidance. September—James Collinson,

William Holman Hunt, John Everett Millais, Dante Gabriel Rossetti, William Michael Rossetti, F. G. Stephens, and Thomas Woolner establish the Pre-Raphaelite Brotherhood (PRB) in a meeting at Millais's house at 83 Gower Street.

1849
March—exhibits *The Girlhood of Mary Virgin* at the *Free Exhibition* at Hyde Park Corner Gallery and receives encouraging reviews. September–October—travels with Hunt to France and Belgium; at the Louvre sees works by contemporary French artists such as Paul Delaroche, Hippolyte-Jean Flandrin, and Jean-Auguste-Dominique Ingres, and by Giorgione, Mantegna, Leonardo da Vinci, Raphael, Titian, and Jan van Eyck; also admires work by van Eyck and Hans Memling in Belgium. December—takes a studio at 72 Newman Street and probably meets Elizabeth Eleanor Siddal in late December through his friend the painter Walter Deverell.

1850
January—the first issue of the *Germ*, a Pre-Raphaelite journal, is published. Two more issues are published this year, under the name *Art and Poetry*, before the journal ends due to lack of financial support. April—exhibits *"Ecce Ancilla Domini!" (The Annunciation)* at the National Institution exhibition at the Portland Gallery. The

secret of the Pre-Raphaelite Brotherhood becomes known and triggers hostile criticism of Rossetti's painting and of paintings by Hunt and Millais at the Royal Academy exhibition. December 10—Rossetti begins drawing from a live model at the North London School of Design, founded earlier that year by his friend the artist Thomas Seddon. Winter—exhibits at a show organized by Seddon to raise money for his school.

1851

Shares a studio at 17 Red Lion Square with Walter Deverell. The Rossetti family moves to 38 Arlington Street. May—shares studio at 17 Newman Street with Ford Madox Brown.

1852

November 22—moves to 14 Chatham Place, Blackfriars Bridge, which remains his residence for ten years. December–January 8, 1853—exhibits at the *Winter Exhibition*, 121 Pall Mall.

1854

Meets John Ruskin, who becomes an important patron, influence, and friend, and who makes Rossetti's work known to other patrons. Rossetti works on a number of biblical and medieval subjects, chiefly in

261. Dr. Johnson at the Mitre, 1860
Pen and ink on paper, 8½ x 8¼ in.
Fitzwilliam Museum, Cambridge, England

watercolors; he also makes drawings of *The Maids of Elfen-mere* for woodcuts to illustrate William Allingham's *Day and Night Songs*. April 26—Gabriele Rossetti dies.

1855

January 22—Dante Gabriel begins teaching art at the Working Men's College. With money supplied by Ruskin, goes to Paris to join Elizabeth Siddal; sees Robert and Elizabeth Browning there and visits the Louvre again.

1856

Probably meets Fanny Cornforth, who is to serve as model for *Found, Bocca Baciata,* and a number of other important paintings by Rossetti. December—meets Edward Burne-Jones, who sees Rossetti teaching at the Working Men's College and is later introduced to him by Vernon Lushington.

1856–57

Does five drawings for woodcuts to illustrate Edward Moxon's edition of poems by Alfred, Lord Tennyson.

1857

July—exhibits at the *The Pre-Raphaelite Exhibition*, 4 Russell Place, Fitzroy Square. Works on murals for the Oxford Union Debating Hall with a number of young artists: Edward Burne-Jones, William Morris, Arthur Hughes, Valentine Prinsep, John Hungerford Pollen, and J. R. Spencer Stanhope. These murals, brilliantly colored at first, fade fast due to faulty technical execution. Meets Jane Burden, whom he draws as a model for Guinevere; she marries William Morris in 1859.

1858

Exhibits at the *Liverpool Exhibition*.

1859

Paints first "Venetian" painting, *Bocca Baciata*, with Fanny Cornforth as model.

1860

May 23—marries ailing Elizabeth Siddal at Saint Clement's Church, Hastings, and they go to the Hôtel Meurice, Paris, for their honeymoon. July—they return to London.

1861

January—joins in founding the Firm (later Morris and Company), a limited company with partners William Morris, Edward

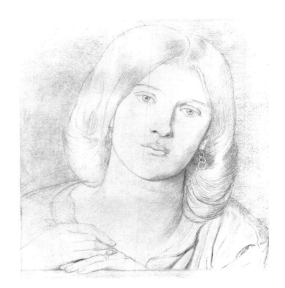

262. Fanny Cornforth, 1860
Pencil on paper, 9¼ x 8⅜ in.
Fitzwilliam Museum, Cambridge, England

Burne-Jones, Philip Webb, Peter Paul Marshall, Ford Madox Brown, and Charles Faulkner. Works on stained-glass and furniture designs. Publishes *The Early Italian Poets*, translations of works by Dante and his contemporaries, supported by a loan from John Ruskin to the publishers Smith and Elder. May 2—Elizabeth Siddal Rossetti bears a stillborn child. September—Rossetti exhibits finished studies for *The Seed of David* altarpiece at the Liverpool Academy.

1862

February 10—Elizabeth Siddal Rossetti takes an overdose of laudanum, dies the next morning. Dante Gabriel, grief stricken, inters the sole manuscript of his original poems in her coffin. October—moves to Tudor House, 16 Cheyne Walk, Chelsea, which he shares at first with his brother, the poet Algernon Charles Swinburne, and the novelist George Meredith. Hires his first painting assistant, Walter John Knewstub. Exhibits in the *Royal Scottish Academy Exhibition* and the *International Exhibition*.

1863

Spring—Fanny Cornforth becomes housekeeper at Tudor House. September—Rossetti travels to Belgium with his brother, William.

1864

Finishes *The Seed of David*, a major triptych altarpiece commissioned for Llandaff Cathedral in Cardiff, Wales; Jane and William Morris are models for it. Also works on *Beata Beatrix*, in memory of his wife, which is finished in 1870. November—visits Paris with Fanny Cornforth to see a large Eugène Delacroix retrospective and is introduced to Edouard Manet by Henri Fantin-Latour; visits Manet's studio and sees his painting *Olympia*. Exhibits at the Liverpool Academy.

1865

Starts using Jane Morris and Alexa Wilding regularly as models. Becomes a friend of Charles Augustus Howell.

1866

February—exhibits at the Arundel Club.

1867

Begins suffering from eye trouble, which he fears will result in blindness. Henry Treffry Dunn replaces Knewstub as his painting assistant and secretary.

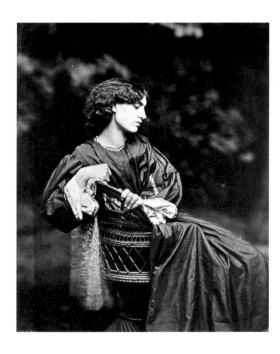

263. Jane Morris, 1865
Photograph
Victoria and Albert Museum, London

1868

Starts painting *La Pia de' Tolomei*, a subject from Dante's *Purgatory*, with Jane Morris as model.

1869

Begins writing poetry again, especially sonnets for a series called *The House of Life*. October 5—has Charles Augustus Howell exhume his manuscript of early poems from Elizabeth Siddal Rossetti's coffin.

1870

April–May—he and Jane Morris stay at Scalands, home of Barbara Leigh Smith Bodichon; another visitor is William James Stillman, who introduces him to chloral as a cure for insomnia. April 25—Rossetti's collection of poems is published by F. S. Ellis.

1870–76

Charles Augustus Howell works as his agent, selling sixty-eight paintings and drawings for him by 1873.

1871

July—with William Morris takes joint tenancy of Kelmscott Manor, splitting the sixty-pound annual rent. Morris goes to Iceland to study Nordic sagas and scenery; Rossetti and Jane Morris stay at Kelmscott Manor. October—Rossetti's book is attacked in an article entitled "The Fleshly School of Poetry" by Robert Buchanan, writing pseudonymously as "Thomas Maitland" in the *Contemporary Review*. Exhibits in *Benefit Exhibition for Henry J. Hodding*, Manchester.

1872

June—abnormally sensitive to criticism, and with his fears aggravated by the use of chloral, he suffers a nervous breakdown and attempts suicide by taking laudanum, as a result of criticism by Buchanan and others; particularly fears that his liaison with Jane Morris will be discovered. September 24—returns to Kelmscott Manor to recuperate.

1872–74

Remains at Kelmscott, painting large oils such as *La Ghirlandata* and *The Bower Meadow* for important new patrons. Meets Theodore Watts-Dunton. Jane Morris visits frequently.

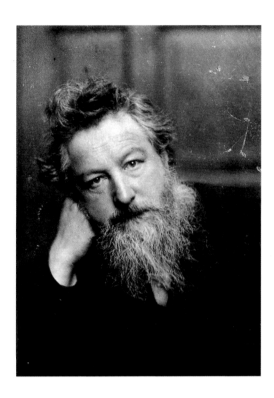

264. Frederick Hollyer
William Morris, c. 1885
Photograph
Delaware Art Museum, Wilmington;
Bancroft Archives

1874

July—leaves Kelmscott Manor and returns to London when William Morris ends their joint tenancy.

1875

William Morris buys out the other partners in the Firm; Rossetti signs his 1,000-pound share over to Jane Morris. October—goes to Aldwick Lodge, Bognor Regis, Sussex, where Jane Morris visits him from November to March 1876 and sits for *Astarte Syriaca*; she discovers the extent of his chloral addiction.

1876

April—exhibits in the *Glasgow Exhibition*. June 26—returns to 16 Cheyne Walk and works on a number of large oil paintings, including *Astarte Syriaca*, *The Blessed Damozel*, and *Mnemosyne*. August—to escape the summer heat visits his patrons the William Cowper-Temples at Broadlands, Sussex, and works on *The Blessed Damozel*.

1877

Suffers recurring illnesses. Works on *La Pia de' Tolomei* and completes *The Blessed Damozel* and *Astarte Syriaca*.

1878

Paints *A Vision of Fiammetta*, with Maria Spartali Stillman as model. Exhibits in the *Manchester Exhibition*.

1879

Paints Jane Morris in *The Day-Dream* and returns to work on *Mnemosyne*. Epistolary friendship begins with Thomas Hall Caine, a young Liverpool writer originally from the Isle of Man. April 26–May 5—exhibits at the German Gymnasium.

1880

Writes *The Sonnet* as an introduction to *The House of Life* and makes a drawing illustrating it for his mother. August 30—meets Thomas Hall Caine.

1881

April—invites Thomas Hall Caine to live at 16 Cheyne Walk; August—Caine moves in. August—Rossetti exhibits at the Liverpool

265. Christina Rossetti
and Mrs. Gabriele Rossetti, *1877*
Colored chalks on paper, 6¾ x 9 in.
National Portrait Gallery, London

Academy. October—publishes two volumes of poetry, *Poems* and *Ballads and Sonnets*, the latter containing his 102-sonnet sequence *The House of Life* and a number of other new works. Finishes *Mnemosyne* and sells it to his chief patron, Frederick Richard Leyland; also completes *La Pia de' Tolomei*. Health deteriorates further. November—calls for a priest to give him absolution. December—partially paralyzed by a seizure.

1882

February 4—goes to Westcliff Bungalow, Birchington-on-Sea, to convalesce. His mother, Christina, and William nurse him. April 9—dies on Easter Sunday. April 14—buried in the All Saints Parish Church Graveyard at Birchington-on-Sea. Memorial window designed by Frederic Shields is given in his memory by Rossetti's mother, and the memorial cross on his grave is made by his old friend Ford Madox Brown.

1883

Major retrospectives of his work are held at the Burlington Fine Arts Club, the Royal Academy of Arts, and the Rossetti Gallery (run by Fanny Cornforth and her husband, John Schott), at which the extent of Rossetti's accomplishments as an artist become publicly known and praised.

BIBLIOGRAPHY

BOOKS ABOUT DANTE GABRIEL ROSSETTI

Ainsworth, Maryan Wynn. *Dante Gabriel Rossetti and the Double Work of Art*. New Haven, Conn.: Yale University Art Gallery, 1976.

Angeli, Helen Rossetti. *Dante Gabriel Rossetti: His Friends and Enemies*. London: Hamish Hamilton, 1949.

Baum, Paull Franklin. *Dante Gabriel Rossetti: An Analytical List of Manuscripts in the Duke University Library*. New York: AMS Press, 1966.

Baum, Paull Franklin, ed. *Dante Gabriel Rossetti's Letters to Fanny Cornforth*. Baltimore: Johns Hopkins Press, 1940.

Beaux Arts Gallery. *Drawings and Paintings by Dante Gabriel Rossetti*. London, 1940.

Beerbohm, Max. *Rossetti and His Circle*. London: William Heinemann, 1922. A new edition, with additional plates by Beerbohm and introduction by N. John Hall, was published by Yale University Press in 1987.

Benedetti, Maria Teresa. *Dante Gabriel Rossetti disegni*. Florence: La Nuova Italia Editrice, 1982.

——— . *Dante Gabriel Rossetti*. Florence: G. C. Sansoni, 1984.

Boos, Florence Saunders. *The Poetry of Dante Gabriel Rossetti*. The Hague: Mouton, 1976.

Bryson, John, and Janet Camp Troxell. *Dante Gabriel Rossetti and Jane Morris, Their Correspondence*. Oxford: Clarendon Press, 1976.

Burlington Fine Arts Club. *Pictures, Drawings, Designs and Studies by the Late Dante Gabriel Rossetti*. London, 1883. Contains 153 works and a short biography by H. Virtue Tebbs.

Caine, Thomas Hall. *Recollections of Rossetti*. London: Cassell, 1928.

Christie, Manson and Woods. *Catalogue of the Remaining Works of the Poet and Painter Dante Gabriel Rossetti. . .Sold by Auction, Saturday, May 12, 1883*. London, 1883.

Cline, C. R., ed. *The Owl and the Rossettis*. University Park: Pennsylvania State University Press, 1978.

Cooper, Robert M. *Lost on Both Sides: Dante Gabriel Rossetti, Critic and Poet*. Athens, Ohio: Ohio University Press, 1970.

Dobbs, Brian and Judy. *Dante Gabriel Rossetti: An Alien Victorian*. London: MacDonald and James, 1977.

Doughty, Oswald. *A Victorian Romantic: Dante Gabriel Rossetti*. London: Oxford University Press, 1960.

Doughty, Oswald, and John Robert Wahl. *Letters of Dante Gabriel Rossetti*. 4 vols. Oxford: Clarendon Press, 1965–67.

Dunn, Henry Treffry. *Recollections of Dante Gabriel Rossetti and His Circle*. London: Elkin Matthews, 1904.

Dupré, Henri. *Un Italien d'Angleterre: Le Poète-peintre Dante Gabriel Rossetti*. Paris: J. H. Dent et Fils, 1921.

Fennell, Francis L., Jr. *The Rossetti-Leyland Letters*. Athens, Ohio: Ohio University Press, 1978.

——— . *Dante Gabriel Rossetti: An Annotated Bibliography*. New York: Garland Publishing, 1982.

Fleming, G. H. *Rossetti and the Pre-Raphaelite Brotherhood*. London: Rupert Hart-Davis, 1967.

——— . *That Ne'er Shall Meet Again: Rossetti, Millais, Hunt*. London: Michael Joseph, 1971.

Gere, John. Introduction to *Dante Gabriel Rossetti: Painter and Poet*. London: Royal Academy of Arts, 1973.

Ghose, S. N. *Dante Gabriel Rossetti and Contemporary Criticism*. Strasbourg, France, 1929. Reprinted by Folcroft Library Editions, 1970.

Gizzi, Corrado. *Dante Gabriel Rossetti.* Milan: Academia di Belle Arti di Brera, 1984.

Gray, Nicolette. *Rossetti, Dante and Ourselves.* London: Faber and Faber, 1947.

Grieve, A. I. Introduction to *Dante Gabriel Rossetti.* Newcastle upon Tyne, England: Laing Art Gallery, 1971.

————. *The Art of Dante Gabriel Rossetti: The Pre-Raphaelite Period.* Hingham, England: Real World Publications, 1973.

————. *The Art of Dante Gabriel Rossetti. 1. Found; 2. The Pre-Raphaelite Modern Subject.* Norwich, England: Real World Publications, 1976.

————. *The Art of Dante Gabriel Rossetti: The Watercolors and Drawings of 1850–1855.* Norwich, England: Real World Publications, 1978.

Grylls, Rosalie Glynn. *Portrait of Rossetti.* London: MacDonald, 1964.

Haward, Lawrence. Introduction to *D. G. Rossetti and Madox Brown: Family Portraits.* Manchester, England: City Art Gallery, 1920.

Henderson, Marina. *D. G. Rossetti.* London: Academy Editions, 1973.

Hill, George Birbeck, ed. *Letters of Dante Gabriel Rossetti to William Allingham, 1854–1870.* London: T. Fisher Unwin, 1897.

Howard, Ronnalie Roper. *The Dark Glass: Vision and Technique in the Poetry of D. G. Rossetti.* Athens, Ohio: Ohio University Press, 1972.

Hueffer {Ford}, Ford Madox. *Rossetti: A Critical Essay on His Art.* London: Duckworth, 1902.

Jessen, Jarno. *Rossetti.* Bielefeld, Germany: Delhagen und Klasing, 1905.

Knight, Joseph. *The Life of Dante Gabriel Rossetti.* London: Walter Scott, 1887.

Macleod, Dianne Sachko. "Dante Gabriel Rossetti: A Critical Analysis of the Late Work, 1859–1882." Ph.D. diss., University of California, Berkeley, 1981.

Marillier, H. C. *Dante Gabriel Rossetti: An Illustrated Memorial of His Art and Life.* London: George Bell and Sons, 1899.

McMillan, Connie Beth. "Catalogue of the Letters of Dante Gabriel Rossetti at the University of Texas at Austin." Ph.D. diss., University of Texas at Austin, 1975.

Mégroz, R. L. *Dante Gabriel Rossetti.* New York: Haskell House Publishers, 1971.

Museum of Art, University of Kansas. *Dante Gabriel Rossetti and His Circle.* Lawrence, 1958.

New Gallery. *Pictures Ancient and Modern by Artists of the British and Continental Schools, Including a Special Selection from the Works of Dante Gabriel Rossetti.* London, 1897–98.

Nicoll, John. *Dante Gabriel Rossetti.* London: Studio Vista, 1975.

Peterson, Carl Adrien. "The Poetry and Painting of Dante Gabriel Rossetti." Ph.D. diss., University of Wisconsin, 1961.

Pissarro, Lucien. *Rossetti.* London: T. C. and E. C. Jack, n.d.

Rees, Joan. *The Poetry of Dante Gabriel Rossetti: Modes of Self-Expression.* Cambridge: Cambridge University Press, 1981.

Riede, David G. *Dante Gabriel Rossetti and the Limits of Victorian Vision.* Ithaca, N.Y., and London: Cornell University Press, 1983.

Ritucci-Chinni, Florindo. *Dante Gabriel Rossetti, pittore.* Vasto, Italy: Museo Rossettiano, 1954.

Rose, Andrea. *Pre-Raphaelite Drawings: Dante Gabriel Rossetti, Birmingham Museum and Art Gallery.* Chicago: University of Chicago Press, 1977.

Rossetti, Dante G. *The Valuable Contents of the Residence of Dante G. Rossetti to Be Sold at Auction. . .July 5, 6, & 7.* London: T. G. Wharton Martin, {1882}.

The Rossetti Gallery. *Pictures, Drawings, Designs and Studies by the Late Dante Gabriel Rossetti.* London, 1883.

Rossetti, Helen M. M. *The Life and Work of Dante Gabriel Rossetti.* London: Art Journal, 1902.

Rossetti, William Michael. *Dante Gabriel Rossetti as Designer and Writer.* London: Cassell, 1889.

————. *Some Reminiscences.* 2 vols. London: Brown Langham, 1906.

Rossetti, William Michael, ed. *Dante Gabriel Rossetti: His Family Letters with a Memoir.* 2 vols. London: Ellis and Elvey, 1895.

————. *Ruskin: Rossetti: PreRaphaelitism Papers, 1854 to 1862.* New York: Dodd, Mead and Company; London: George Allen, 1899.

————. *Pre-Raphaelite Diaries and Letters.* London: Hurst and Blackett, 1900.

————. *Rossetti Papers 1862 to 1870.* London: Sands, 1903.

————. *The Works of Dante Gabriel Rossetti.* London: Ellis, 1911.

Rowley, Charles. Chapter on Rossetti in *Fifty Years of Work without Wages.* London: Hodder and Stoughton, {1911}.

Royal Academy of Arts. *Works by the Old Masters, Including a Special Selection from the Works of John Linnell and Dante Gabriel Rossetti.* London, 1883.

Sharp, William. *Dante Gabriel Rossetti.* London: Macmillan, 1882.

Sonstroem, David. *Rossetti and the Fair Lady.* Middleton, Conn.: Wesleyan University Press, 1970.

Stein, Richard L. *The Ritual of Interpretation: The Fine Arts as Literature in Ruskin, Rossetti and Pater.* Cambridge, Mass.: Harvard University Press, 1975.

Stephens, F. G. *Dante Gabriel Rossetti.* London: Seeley, 1894.

Surtees, Virginia. *The Paintings and Drawings of Dante Gabriel Rossetti (1828–1882): A Catalogue Raisonné.* 2 vols. Oxford: Clarendon Press, 1971.

Symons, Arthur. Chapter on Rossetti in *Dramatis Personae.* Indianapolis: Bobbs Merrill, 1923.

Tirebuck, William. *Dante Gabriel Rossetti, His Work and Influence*. London: Elliot Stock, 1882.

Troxell, Janet Camp, ed. *Three Rossettis*. Cambridge, Mass.: Harvard University Press, 1937.

Villard, Leonie. *The Influence of Keats on Tennyson and Rossetti*. Saint-Etienne, France: Société Anonyme de l'Imprimère Mulcey, 1914.

Waller, R. D. *The Rossetti Family 1824–1854*, Manchester, England: Manchester University Press, 1932.

Waugh, Evelyn. *Rossetti: His Life and Works*. London: Duckworth, 1928.

Weintraub, Stanley. *Four Rossettis*. New York: Weybright and Talley, 1977.

Wood, Esther. *Dante Gabriel Rossetti and the Pre-Raphaelite Movement*. London: Sampson, Low, Marston, 1894.

Wood, T. Martin. *Drawings of Rossetti*. London: George Newnes, n.d.

ARTICLES ABOUT DANTE GABRIEL ROSSETTI

Amayo, Mario. "Dante Gabriel Rossetti and the Double Work of Art." *Art in America* 65 (March–April 1977): 90–93.

Bentley, D.M.R. "Rossetti and the *Hypnerotomachia Poliphili*." *English Language Notes* 14 (June 1977): 279–83.

Bock, Carol. "D. G. Rossetti's *Found* and *The Blessed Damozel* as Explorations in Victorian Psychosexuality." *Journal of Pre-Raphaelite Studies* 1 (May 1981): 83–90.

Colvin, Sydney. "Rossetti as a Painter." *Magazine of Art* 6 (1883): 177–83.

Fredeman, William E. "Prelude to the Last Decade: Dante Gabriel Rossetti in the Summer of 1872." *Bulletin of the John Rylands University Library of Manchester* 53 (1970–71): 75–121, 272–328.

——— . "'Fundamental Brainwork': The Correspondence between Dante Gabriel Rossetti and Thomas Hall Caine." *AUMLA* 52 (November 1979): 209–31.

Fredeman, William E., ed. *Victorian Poetry* 20 (Autumn–Winter 1982). Entire issue devoted to Rossetti, with introduction by Fredeman.

Fritzche, Mary Wayne. "Problems and Successes in the Mutual Development of D. G. Rossetti's Paintings and Sonnets." *Journal of Pre-Raphaelite Studies* 1 (May 1981): 104–17.

Fuchs, Miriam. "Dante Gabriel Rossetti: Caught between Two Centuries." *Victorian Newsletter* 63 (Spring 1983): 3–7.

Gaunt, William. "Two Portrait Drawings by Dante Gabriel Rossetti." *Connoisseur* 110 (December 1942): 140–41, 158.

Gelpi, Barbara Charlesworth. "The Image of the Anima in the Work of Dante Gabriel Rossetti." *Victorian Newsletter* 45 (Spring 1974): 1–7.

Grieve, A. I. "Rossetti's Illustrations to Poe." *Apollo* 97 (February 1973): 142–45.

Johnson, Ronald W. "Dante Rossetti's *Beata Beatrix* and the *New Life*." *Art Bulletin* 57 (December 1975): 548–58.

Johnson, Wendell Stacy. "D. G. Rossetti as Painter and Poet." *Victorian Poetry* 3 (Winter 1965): 9–18.

Landow, George P. "'Life Touching Lips with Immortality': Rossetti's Typological Structures." *Studies in Romanticism* 17 (Summer 1978): 247–66.

Macleod, Dianne Sachko. "Dante Gabriel Rossetti and Titian." *Apollo* 121 (January 1985): 36–39.

Mander, Rosalie. "Rossetti's Models." *Apollo* 78 (July 1963): 18–22.

McGowan, John P. "Rossetti's Significant Details." *Victorian Poetry* 7 (Spring 1969): 41–54.

——— . "'The Bitterness of Things Occult': D. G. Rossetti's Search for the Real." *Victorian Poetry* 20 (Autumn–Winter 1982): 45–60.

Miles, Frank. "Rossetti's Schooldays." *Journal of Pre-Raphaelite Studies* 2 (May 1982): 71–77.

Mitchell, Scott J. "D. G. Rossetti's *The House of Life*: Allegory, Symbolism and Courtly Love." *Journal of Pre-Raphaelite Studies* 6 (November 1985): 47–54.

Nochlin, Linda. "Lost and *Found*: Once More the Fallen Woman." *Art Bulletin* 60 (March 1978): 139–53.

Oberhauser, Judy. "Rossetti's *Found*." *Delaware Art Museum Occasional Papers No. 1*. Wilmington: Delaware Art Museum, 1976.

Ormond, Leonée. "Dress in the Painting of Dante Gabriel Rossetti." *Costume* 8 (1974): 26–29.

Paden, William D. "'La Pia de' Tolomei' by Dante Gabriel Rossetti." *Register of the Museum of Art* (University of Kansas) 2 (November 1958): 3–48.

Pittman, Philip M. "The Strumpet and the Snake: Rossetti's Treatment of Sex as Original Sin." *Victorian Poetry* 12 (Spring 1974): 45–54.

Prinsep, Val. "Rossetti and His Friends." *Art Journal* 54 (May 1892): 129–34.

Roberts, Helene E. "The Dream World of Dante Gabriel Rossetti." *Victorian Studies* 17 (June 1974): 371–93.

Rossetti, William Michael. "Notes on Rossetti and His Works." *Art Journal* 46 (1884): 148–52, 165–68, 204–8.

——— . "The Portraits of Dante Gabriel Rossetti." *Magazine of Art* 12 (1889): 21–26, 57–61, 138–41.

——— . "Dante Rossetti and Elizabeth Siddal." *Burlington Magazine* 1 (May 1903): 273–95.

Shields, Frederic. "Some Notes on D. G. Rossetti." *Century Guild Hobby Horse* 1 (1886): 140–54.

——— . "A Note upon Rossetti's Method of Drawing in Crayons." *Century Guild Hobby Horse* 5 (1890): 70–73.

Smith, Sarah Phelps. "Dante Gabriel Rossetti's 'Lady Lilith' and the Language of Flowers." *Arts Magazine* 53 (February 1979): 142–45.

Stephens, F. G. "Mr. Rossetti's Pictures." *Athenaeum* (October 21, 1865): 545–46.

——— . "Pictures by Mr. Rossetti." *Athenaeum* (August 14, 1875): 219–21.

——— . "'Ecce Ancilla Domini!' by Dante Gabriel Rossetti." *Portfolio* 19 (1888): 125–27.

Surtees, Virginia. "Portrait Head of Jane Morris by Dante Gabriel Rossetti." *Philadelphia Museum Bulletin* 73 (1977): 12–17.

Trickett, Rachel. "Rossetti's Justification for the Legend." *Studio International* 185 (January 1973): 19–22.

Warner, Janet. "D. G. Rossetti: Love, Death and Art." *Hartford Studies in Literature* 4 (1972): 228–40.

GENERAL REFERENCES

Allingham, William. *A Diary*. Edited by H. Allingham and D. Radford. Harmondsworth, England: Penguin Books, 1985.

Banham, Joanna, and Jennifer Harris. *William Morris and the Middle Ages*. Manchester, England: Manchester University Press, 1984.

Bate, Percy. *The English Pre-Raphaelite Painters*. London: George Bell and Sons, 1901.

Bell, Quentin. *A New and Noble School, the Pre-Raphaelites*. London: MacDonald, 1982.

Blunt, Wilfrid Scawen. Manuscripts of "General Diary" and "Secret Memoirs." Fitzwilliam Museum, Cambridge.

Bornand, Odette, ed. *The Diary of W. M. Rossetti 1870–1873*. Oxford: Clarendon Press, 1977.

Bowness, Alan. Introduction to *The Pre-Raphaelites*. London: Tate Gallery, 1984.

Brown, David. "Pre-Raphaelite Drawings in the Bryson Bequest to the Ashmolean Museum." *Master Drawings* 16 (Autumn 1978): 287–93.

Brown, Ford Madox. *Diary*. Edited by Virginia Surtees. New Haven, Conn.: Yale University Press, 1981.

Burne-Jones, Georgiana. *Memorials of Edward Burne-Jones*. 2 vols. New York: Macmillan, 1904.

Cherry, Deborah, and Griselda Pollock. "Woman as Sign in Pre-Raphaelite Literature: A Study of the Representation of Elizabeth Siddal." *Art History* 7 (June 1984): 206–27.

Christian, John. *The Pre-Raphaelites in Oxford*. Oxford: Ashmolean Museum, 1974.

——— . *The Oxford Union Murals*. Chicago: University of Chicago Press, 1981.

Coley, Curtis G. *The Pre-Raphaelites*. Indianapolis: Herron Museum of Art, 1964.

Dalziel, George and Edward. *The Brothers Dalziel*. 2 vols. London: Methuen, 1901.

Davies, J. L., ed. *The Working Men's College 1854–1904*. London: Macmillan, 1904.

Dearden, James S. "John Ruskin, the Collector." *Library* 21, 5th series (June 1966): 124–54.

Destrée, Olivier Georges. *Les Préraphaelites*. Paris: Fischbacker, 1897.

Duval, M. Susan. "F. R. Leyland: A Maecenas from Liverpool." *Apollo* 124 (August 1986): 110–15.

Elzea, Rowland. *The Samuel and Mary R. Bancroft, Jr., and Related Pre-Raphaelite Collections*. Wilmington: Delaware Art Museum, 1984.

Faulkner, Peter. *Wilfrid Scawen Blunt and the Morrises*. London: William Morris Society, 1981.

Faulkner, Peter, ed. *Jane Morris to Wilfrid Scawen Blunt*. Exeter, England: University of Exeter, 1986.

Fredeman, William E. *Pre-Raphaelitism: A Bibliocritical Study*. Cambridge, Mass.: Harvard University Press, 1965.

——— . *The P.R.B. Journal*. Oxford: Clarendon Press, 1975.

Goff, Barbara Munson. "The Politics of Pre-Raphaelitism." *Journal of Pre-Raphaelite Studies* 2 (May 1982): 57–70.

Grieve, A. I. "The Pre-Raphaelite Brotherhood and the Anglican High Church." *Burlington Magazine* 111 (May 1969): 294–95.

Hunt, Violet. *The Wife of Rossetti*. New York: E. P. Dutton, 1932.

Hunt, W. Holman. "The Pre-Raphaelite Brotherhood: A Fight for Art." *Contemporary Review* 49 (April 1886): 471–88; (May 1886): 737–50; (June 1886): 820–34.

——— . *Pre-Raphaelitism and the Pre-Raphaelite Brotherhood*. 2 vols. New York: Macmillan, 1905.

Lago, Mary, ed. *Burne-Jones Talking*. London: John Murray, 1982.

Lasner, Mark Samuels. "A BBC Interview with Helen Rossetti Angeli." *Journal of Pre-Raphaelite Studies* 2 (May 1982): 7–19.

Layard, George Somes. *Tennyson and His Pre-Raphaelite Illustrators*. London: E. Stock, 1894.

Lewis, Roger C., and Mark Samuels Lasner, eds. *Poems and Drawings of Elizabeth Siddal*. Wolfville, Nova Scotia: Wombat Press, 1978.

Lindsay, Jack. *William Morris: His Life and Work*. New York: Taplinger Publishing, 1979.

Lockett, Richard. Introduction to *Pre-Raphaelite Art from the Birmingham Museum and Art Gallery*. Hong Kong: Urban Council, 1984.

Longford, Elizabeth. *A Pilgrimage of Passion: The Life of Wilfrid Scawen Blunt*. New York: Alfred A. Knopf, 1980.

Löttes, Wolfgang. *Wie ein goldener Traum: Die Rezeption des Mittelalters in der Kunst der Prä-Raffaeliten*. Munich: Wilhelm Fink Verlag, 1984.

Marsh, Jan. *The Pre-Raphaelite Sisterhood*. London: Quartet Books, 1985.

——— . *Jane and May Morris*. London and New York: Pandora, 1986.

Millais, John Guille. *The Life and Letters of Sir John Everett Millais*. 2 vols. New York: Frederick A. Stokes, 1899.

Mongan, Agnes. Introduction to *Paintings and Drawings of the Pre-Raphaelites and Their Circle*. Cambridge, Mass.: Fogg Museum of Art, 1946.

Parris, Leslie. *The Pre-Raphaelites*. London: Tate Gallery, 1966.

Parris, Leslie, ed. *Pre-Raphaelite Papers*. London: Tate Gallery, 1984.

Quilter, Harry. *Preferences in Art, Life and Literature*. London: Swan Sonnenschein, 1892.

Rose, Andrea. *Pre-Raphaelite Portraits*. Sparkford, England: Oxford Illustrated Press, 1981.

Ruskin, John. *Pre-Raphaelitism*. New York: John Wiley, 1851.

———. *Works*. Edited by E. T. Cook and Alexander Wedderburn. 39 vols. London: George Allen, 1903–12.

Stevenson, Lionel. *The Pre-Raphaelite Poets*. New York: W. W. Norton, 1974.

Stillman, William James. *The Autobiography of a Journalist*. 2 vols. Boston: Houghton Mifflin, 1901.

Surtees, Virginia, ed. *The Diaries of George Price Boyce*. Norwich, England: Real World Publications, 1980.

Sussman, Herbert L. *Fact into Figure: Typology in Carlyle, Ruskin and the Pre-Raphaelite Brotherhood*. Columbus: Ohio State University Press, 1979.

Warner, Malcolm. *The Drawings of John Everett Millais*. London: Arts Council of Great Britain, 1979.

Watts-Dunton, Theodore. *Old Familiar Faces*. London: Herbert Jenkins, 1916.

White, Gleeson. *English Illustration: "The Sixties," 1855–70*. London: Archibald Constable, 1897.

Wood, Christopher. *The Pre-Raphaelites*. New York: Viking Press, 1981.

INDEX

PICTURE CREDITS

The photographers and sources of photographic material other than those indicated in the captions are as follows: